Depression Era
ART DECO GLASS

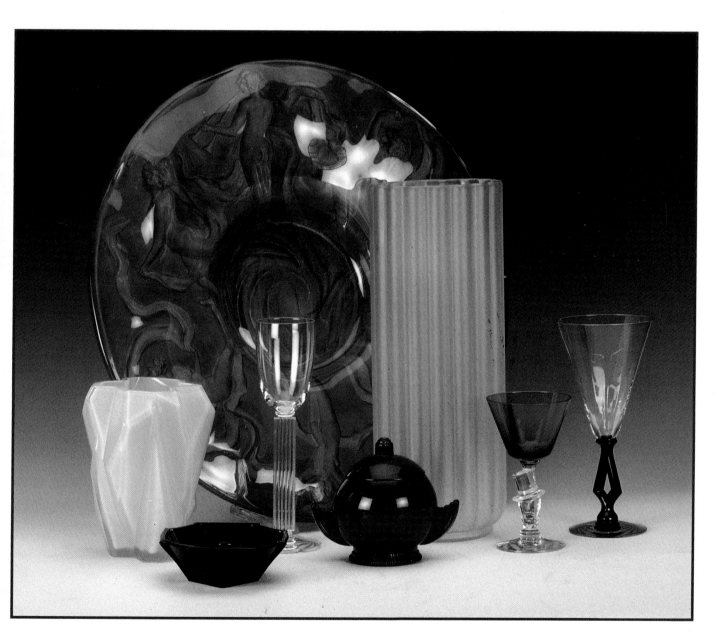

Schiffer Publishing Ltd

Leslie Piña & Paula Ockner

4880 Lower Valley Road, Atglen, PA 19310 USA

Designed by Leslie Piña
Layout by Bonnie M. Hensley
Photographs by Leslie & Ramón Piña
Type set in UniverstyRoman Bd BT/ClassGarmnd BT

ISBN: 0-7643-0718-5
Printed in China
1 2 3 4

Published by Schiffer Publishing Ltd.
4880 Lower Valley Road
Atglen, PA 19310
Phone: (610) 593-1777; Fax: (610) 593-2002
E-mail: Schifferbk@aol.com
Please visit our web site catalog at
www.schifferbooks.com

This book may be purchased from the publisher.
Please include $3.95 for shipping. Please try your book-
store first. We are interested in hearing from authors
with book ideas on related subjects.
You may write for a free catalog.

In Europe, Schiffer books are distributed by
Bushwood Books
6 Marksbury Rd.
Kew Gardens
Surrey TW9 4JF England
Phone: 44 (0)181 392-8585; Fax: 44 (0)181 392-9876
E-mail: Bushwd@aol.com

Contents

Acknowledgments

We would like to express our gratitude to the following for sharing information or photographs and/or allowing us to photograph glass: David and Mary Ann Gaydos; Ed Goshe; Ruth and Lyman Hemminger; Chuck Kaplan; Kevin Kiley; Leora and James Leasure; Robin Mansfield; Dee and Tony Mondloch; Constance Novak; Kelly O'Kane; Bill Reyer; Joanna Brace, Maureen Miller, and Robert Rockwell, Jr. of the Rockwell Museum in Corning, New York; Skinner, Inc. Auctioneers and Appraisers of Antiques and Fine Arts, Boston and Bolton; Paul Williams; Chuck Zuccarini; and several collectors who wish to remain anonymous.

Once again we would like to thank the many libraries that were so helpful to us, especially Judith Berzinsky at the Ursuline College Library, Jeff Martin at the Cleveland Public Library, and the Rakow Library at the Corning Museum of Glass.

Special thanks to Steve Ockner and Ramón Piña for their support and help in many ways, and to Peter Schiffer, Douglas Congdon-Martin, Jennifer Lindbeck, Bonnie Hensley, and the Schiffer staff.

Introduction

Depression Era Glass: Art Deco is about the overlapping area of two distinct categories: 1) the American glassware produced by many companies during the years of the Great Depression, plus and minus some additional years, roughly the 1920s to the 1940s; and 2) objects in the modern style(s) associated with those years, popularly known as Art Deco.

Art Deco represents a range of styles that developed in Europe as early as 1910. Because it coincided with other modern art movements – the end of the preceding French style, Art Nouveau; the Austrian Wiener Werkstätte; the German Bauhaus – plus the extremely modern work of individuals like Frank Lloyd Wright, Gerrit Rietveld, and Charles Rennie Mackintosh, Art Deco absorbed aspects of these as well.

Most European Art Deco, especially French, is characterized by elitist handcrafted objects, many of which were made of exotic and costly materials. In its more traditional mode, the design had the flavor of classicism, with its symmetry, simplicity, and proportion. It is well known that the milestone event most associated with this European style was the 1925 Paris International Exposition. Germany (which was not invited) and the United States were not represented. When Secretary of Commerce Herbert Hoover received the French invitation to show American modern art, he declined, assuming that America had none to show. He then appointed a group of delegates from manufacturing, retail, and decorating fields to visit the show and report back on what America was missing. Both Parisian hospitality and modern design impressed the American delegates, and their return home late in 1925 marked the introduction of a transformed, commercialized, Americanized Art Moderne, or as it was later called, Art Deco.

Art Deco began to reach America via display windows of major New York department stores. Fashion – clothing, accessories, perfume bottles, and furnishings used as props – caught the eye and the imagination of the American designers and consumers. Where French Art Moderne had been intended to be relatively inaccessible and absolutely costly, items made for the American market were now desired more for their appearance than for rare materials and painstaking crafting

techniques. The new look was not necessarily any more costly to produce than the pseudo-historic and bland generic "styles" it soon replaced. The simple Art Deco style was well suited to the industrial design of useful objects. Infatuated by mass-production, speed, metallic sparkle, and the new age that they represented, American designers took elements of French, German, and Austrian modern art and Americanized them. From architecture to plastic jewelry, from furniture to glassware, American Art Deco, especially applied to industrial design, became a distinct style.

The 1925 Paris Exposition represented the pinnacle, while also signaling the end, of the European style. By that time France and the rest of Europe had grown tired of its design clichés like gazelles and nudes. In the late 1920s and 1930s, the United States found its own clichés and symbols – rounded corners and three parallel lines signifying streamlining, a stepped or tiered pattern resembling a skyline of skyscrapers, and the fashion-conscious flapper. The geometry of Cubism easily replaced the representational motifs of tradition. With added ingredients from ancient Egypt, Pre-Columbian Mexico, some less-explainable European peasant art, and the austere simplicity of the German Bauhaus, the American Art Deco mixture was ready for mass consumption. This meant, of course, that mass, or at least factory, production and marketing were needed. The new field of industrial design with its pioneer designers George Sakier, Walter Dorwin Teague, Walter von Nessen, and others would influence glass companies and the public with their modern, even radical, Art Deco designs.

The period in American history known as the Great Depression began immediately after the stock market crash of 1929 and ended approximately at the start of World War II. Of course the "end" was not abrupt like the beginning, and the decade of the 1930s is generally referred to as the Depression Era. During this time, a specific and easily recognizable type of inexpensive pressed glass was produced by a number of companies. It was usually made into tableware in one of several soft pastel colors, and it sold for pennies. Sets were popular in retail stores, and pieces were used as premiums to promote other products. Depression glass was popular, because the idea to make large quantities of inexpensive

glass was a good one. It provided color and imitated the elegance of dinner tables that many Americans could not afford. Pretty colors and patterns were more important than the fact that it was not made, decorated, or finished by hand. The cheapness of Depression glass was a major reason for its success; but, when it began to intrigue collectors, it ceased to be inexpensive.

Not all Depression glass was made during the Depression – some was made years later. Neither is all the glass that was produced during the Depression 'Depression glass.' Another major category is "Depression Era" glass, also called "elegant" or "classic" and a number of other equally imprecise and arbitrary names. Dictionary definitions of the term elegant include words like "refined, tasteful, luxurious, dignified," and "graceful." It is also defined as "polished." Although this is in reference to manners, the process of polishing glass to provide a finish also happens to be one of the distinguishing characteristics of Depression Era glass. Where Depression glass was left unpolished, the so-called elegant Depression Era glass was given a fine finish by methods of firing, acid, or abrasion.

These finishing techniques, and production methods in general, in large well-organized glass factories were very efficient by the 1930s. Many people became accustomed to using a higher quality glassware and continued to use it for gifts and to set their tables. These glassware buyers also represented a significant market, and demand for handmade blown and molded glassware was high enough to support the major factories, located primarily in the tri-state area of Ohio, Pennsylvania, and West Virginia.

Their combined output was enormous. For example, one line or one stemware pattern could include six or more different stems, from large water goblets to small cordials. This single line might be made in four or five different colors and combinations, such as crystal bowl and colored stem or the reverse, meaning that there could easily be forty different items in one stem line before any decoration was added. With choices like etchings, cuttings, optics, and gold or silver bands, the line may have had another four or five different decorations added, bringing the possible number of distinctly different, identifiable, and collectible items in one stem line to about 200! Multiply this by dozens of major lines, and it becomes apparent how complex the production of one glass factory would have been. If there were about a dozen of these major companies plus many more smaller ones, then the variety of glassware produced, even in one decade, is mind-boggling! All of this handmade glassware is collectively referred to as "Depression Era" glass. In addition, as much Depression Era glass may have been made after the Depression as during the 1930s.

The products of these companies spanned the stylistic gamut from traditional to modern. The actual years of the Depression are focal years for the production of American Art Deco glass and the subject of this book. Our intent is to show a sampling of both common and rare glassware known by glass collectors as Depression Era glass (plus a few examples of Depression glass by companies such as Anchor Hocking and Dunbar) and recognized by modernism collectors as Art Deco. Neither all of the participating companies nor all of the Art Deco lines are included, but the pieces chosen represent the style and the period.

Most pieces are from the 1930s, some from the 1920s and 1940s, and a few are as late as the 1950s. Although the Art Deco style in America is most associated with the '30s and early '40s, it did not suddenly disappear. Rather, as the postwar modern, or the fifties, style developed, this new mid-century look incorporated aspects of earlier Art Deco. For example, the Burmese bookends made by Tiffin in frosted crystal or black appear to be Art Deco in subject matter, color, and style. However, they are also consistent with both forties and fifties modern style. Although the bookends were produced in 1952, we are using them to represent that transitional phase of Art Deco where it became part of a later modern idiom. Besides, they are just too wonderful to omit!

Some American Art Deco glass is easily recognized for its bold geometric form – Consolidated's Ruba Rombic, Duncan's Terrace, and New Martinsville's Modernistic. Other companies made sculptural Art Deco subjects into stems – Morgantown's Top Hat or Cambridge's Statuesque. Some of the glass is important for its surface decoration – Tiffin's geometric Echec pattern on black glass and several Morgantown etchings, though undeniably Deco, are not necessarily placed on equally modern forms. Some companies made "classic modern" neo-Neoclassical items using architectural columns as vases or stemware – Fostoria's Lotus vases, Libbey's Embassy stems, Heisey's New Era. Other types, like Catalonian, the rustic asymmetrical molded textures made by Consolidated, are less obvious. What they all share is a newness warranting the term "modern," a connection to Art Deco style as it was used in other materials, and an Americanism that makes no excuses for democratization of design. Rather than denote lack of quality, visible seams are interpreted as showing integrity in manufacturing methods. American Art Deco glass is a testimony to the belief that a good design should cost no more to make than a bad one.

Each of these Art Deco designs can be placed into one of three categories, with emphasis moving from three to two-dimensional: 1) design based on form that can be identified by its outline or silhouette; 2) design in which a molded relief pattern or texture is significant; and 3) design in which an etched or cut surface decoration is the dominant feature. Some items may overlap two categories, such as Sakier's Fostoria square-footed

stems, identified as Art Deco by their form, while also displaying a modern cutting like Whirlpool or Comet. Curiously, some of these modern forms are also found with the most traditional fussy etchings and decorations. These unlikely marriages are not included here, because, although they might please collectors of particular etching patterns, they are distracting to those looking for pure uncluttered Art Deco.

As glass collectors and researchers know, new information is continually being discovered. Names and/or numbers of lines, patterns, decorations, and colors may have variations even in company catalogs and other "official" printed material. In some cases, collectors have provided alternates or nicknames that supersede company designations. Where a pattern name is reasonably certain, we have capitalized the first letter and written it in **Bold**. Unofficial names are in quotation marks and "**Bold**." Although the first letter of company designations for color is usually capitalized in glass literature, color names are the least consistent. Some are obviously official standardized color names – Empire Green, Smokey Topaz, Ruby. But many colors are without names or unknown – green, brown, red. For the sake of uniformity, we have simply written all color names in lower case – empire green and green, ruby and red. Morgantown collectors know Morgantown colors, and Tiffin collectors know Tiffin colors, and these colors were surprisingly consistent over their years of production.

The focus of this book is commercial production glass. There were, of course, outstanding examples of American Art Deco art glass – for example, by Frederick Carder for Steuben. These, plus colorless crystal designs by Walter Dorwin Teague and other modernists for Steuben, are worthy of in-depth study and admiration, but fall outside the parameters of this book. We have, however, included a sample of Steuben's Art Deco, mainly because it is too good to miss. Our aim is to present a neatly definable, easily recognizable, highly collectible, and mostly beautiful category of glass that, for the moment, is also still available, and with some exceptions, still affordable.

Value is tied to supply and demand, and as demand increases for any fixed number of items, values and prices rise. Factors including geographic region, organized clubs and newsletters, and fashion will also influence value. Ranges listed at the end of each caption represent items in perfect condition as found for sale in the marketplace of shows, malls, shops, trade papers, and online. This range is only a guide. Naturally, collectors try to purchase an item for less and sell it for more, but the range is in the current ballpark or marketplace. Our only guarantee is that there will be plenty of glass that changes hands at prices *outside* this range. The primary purpose of a guide is not to set a specific value or price, but to distinguish between the common and rare piece – the relatively inexpensive and the costly. *Neither the authors nor publisher can take any responsibility for your transactions,* but we do wish for your successes to far outnumber your mistakes. Monetary considerations aside, real success is the acquisition and enjoyment of these small historic documents and objects of aesthetic delight.

Companies

Anchor Hocking

The Hocking Glass Co. opened in 1905 in Lancaster, Ohio. When it merged with the Anchor Cap and Closure Corp. of Long Island City, New York, in 1937, it had already absorbed Lancaster Glass Co., Standard Glass Co., and Monongah Glass Co. and become Anchor Hocking Glass Corp. They were known primarily for utilitarian and Depression glass, including the famous Miss America line and the wonderful Art Deco Manhattan pattern.

Cambridge

Incorporated in 1901 in Cambridge, Ohio, their color spectrum, their figural flower-frogs, and patterns such as Caprice, Rose Point, and Tally Ho led them to great popularity. Cambridge closed the business in 1958 and sold some of their molds to Imperial Glass Co.

Central

Wheeling, West Virginia, became home to Central Glass Co. in the 1860s, and then it became known as "Factory O," a part of U.S. Glass Co. It again changed its name, becoming Central Glass Works. Closed temporarily in the early 1930s, it continued until its official demise in 1939, when some of its molds were sold to Imperial Glass. Central was distinguished for being the glassmaker for President Warren G. Harding and West Virginia Governor Morgan.

Consolidated

Consolidated Lamp and Glass Co. was incorporated in 1894 in Coraopolis, Pennsylvania, a few miles up the Ohio River from Phoenix. They are noted for their reverse painted lampshades. In the late 1920s, designer Reuben Haley introduced a Lalique-like line he named "Martele." Closed for four years (1932-1936), the company loaned some molds to Phoenix, where Reuben's son, Kenneth, was a designer. The Martele line (from the French for hand wrought) consisted of vases, trays, cigarette boxes, candlesticks, and decanter sets. The Lovebirds vase is almost identical to Lalique's Les Perruches. The Catalonian line followed, and in 1928 the Ruba Rombic line made its debut. Designed by Reuben Haley, the line consisted of 35-40 pieces. When Consolidated reopened in 1936, Ruba Rombic was no longer made. Because of its design, it is easily chipped and is considered rare today. After a plant fire, the company closed in 1964.

Co-Operative Flint

Co-Operative Flint Glass Co. was organized in 1879 in Beaver Falls, Pennsylvania. In the mid thirties, the factory, which had been renamed Beaver Falls Co-Operative Glass Co. in 1889, fell victim to the Depression. Among their well-known production items were colored glass animal figures and the Sunset line. Some of their molds were sold to the Phoenix Glass Co.

Dunbar

The Dunbar Flint Glass Corp., founded in 1913 in Dunbar, West Virginia, removed the Flint from its name in 1930, and in 1953 ended its business. They were known for beverage sets and giftware.

Duncan-Miller

The company was originally named George Duncan and Sons and was formed in 1865 in Pittsburgh by George Duncan, his sons, Harry and James, and son-in-law, Augustus H. Heisey. Following destruction by fire in 1892, John E. Miller, a major stockholder, joined Harry and James in a venture that became Duncan and Miller Glass Co., located in Washington, Pennsylvania. Noted for Early American Sandwich, Hobnail, and Teardrop patterns, as well as the popular Swans, the company became a part of U.S. Glass Co. in 1955, producing glass under the Tiffin label. Fenton purchased some of their molds in the 1960s.

Fenton

Still producing art glass in Williamstown, West Virginia, the company began in 1907 thanks to the efforts of Frank L. and John W. Fenton. It developed from their cutting shop in Martin's Ferry, Ohio. Renowned for their Carnival, Stretch, and Off Hand Art Glass, the business is now run by second and third generation Fenton family members.

Fostoria

In August of 1887, Fostoria Glass Company organized and incorporated in Wheeling, West Virginia. Plans were made to open in Fostoria, Ohio, where the factory began operating in December, specializing in lamps and pressed pattern glass. After closing the Ohio factory, they reopened in Moundsville, West Virginia, on January 1, 1892. By 1900, blown stemware was made, and in 1924 colored tableware was introduced. In 1965, Fostoria purchased the Morgantown Glass Guild, which it continued to operate until 1971. Then in 1983, Fostoria was sold to Lancaster Colony Corp. of Columbus, Ohio, and although the factory closed in 1986, Viking Glass of New Martinsville, West Virginia, subcontracted with Lancaster Colony to produce American, Coin, Argus, and other popular patterns from original molds.

Most of the Art Deco lines were designed by industrial designer George Sakier, who can be credited with some of the best designs during a 50-year span, beginning in the late 1920s. His Lotus and other geometric vases, the #4020 square-footed stems, Flame, Sunray, and other Deco candleholders, and the geometric bowls and candleholders are among his most desirable items.

Fry

Henry Clay Fry was president of the Rochester Tumbler Co. in Rochester, Pennsylvania, before the turn of the century. Following a large fire, he and two of his sons, formed the Rochester Glass Co., which soon became the H. C. Fry Glass Co. The firm closed its doors in 1933. They are noted for their Pearl oven glass and Foval art glass.

Heisey

Augustus H. Heisey's glass company began production in 1896 and manufactured numerous memorable animal figurines and Art Deco patterns, including Pyramid, Ridgeleigh, Saturn, and Stanhope, which was designed by industrial designer Walter von Nessen. Wilhelm Hunt Diederich (grandson of American artist William Morris Hunt) came to the United States from Germany at the age of fifteen. Working primarily in metal, Diederich also used ceramic and glass. His Nimrod design for Heisey is a striking example of Art Deco carving. Eva Zeisel designed Heisey's Town and Country line shortly before they closed in 1957.

Imperial

Bellaire, Ohio, across the Ohio River from Wheeling, West Virginia, was the home of Imperial Glass Co., which began production in 1904. Their art glass line, "Free-Hand Ware," and their Cape Cod and Candlewick patterns kept them in business until 1985. The Cathay Crystal line, which was produced for only two years, was designed in the forties by Virginia B. Evans with 28 different pieces done in a satin frosted combination.

Across a twenty-year span, from the forties on, they obtained the molds and assets of Central (1940s), Heisey (1950s), and Cambridge (1960s) glass companies.

Indiana

Located in Dunkirk, Indiana, since 1904, the Indiana Glass Co. separated from the National Glass Co. group. It is still producing, and is now owned by the Lancaster Colony conglomerate. Among their extremely popular Art Deco lines are Tea Room, Pyramid, and Cracked Ice.

Kopp

Nicholas Kopp Jr., an American resident since 1882, began his career at Hobbs Glass Co. in Wheeling, West Virginia. Kopp moved to Fostoria Lamp and Shade Co. in 1890, and then became color maker at Consolidated Lamp and Glass Co. in Coraopolis, Pennsylvania. Kopp Glass Co., established in Swissvale, Pennsylvania, had limited production of artistic glassware and lamps but specialized in traffic lights —green, yellow, and the red that Kopp initially created.

Libbey

The New England Glass Co., formed in Boston in 1818, was moved to Toledo, Ohio, in 1888. In 1892, it became the Libbey Glass Co., under the leadership of Edward Libbey. In the early 1930s, A. Douglas Nash was named head of design, and the H.C. Fry Co. was purchased. Owens-Illinois Glass Co. of Toledo purchased Libbey in 1935 and kept the Libbey name. The last handmade glass Libbey produced was the Modern American series in 1940. They are still in business making drinkware and tableware.

Among their Art Deco lines are American Prestige, Monticello, Knickerbocker, Embassy, and Syncopation. Embassy was designed specifically for the United States Pavilion at the 1939 New York World's Fair. This special Fair edition had an etched eagle and thirteen stars. Syncopation, with its "ice cube" stem, was made only as a cocktail for a short time and is among the rarest of all Art Deco stems.

Lotus

Lotus Glass Co. was established in Barnesville, Ohio, in 1912 as a cutting company. It expanded in the mid-1920s and changed its name to the current Lotus Decorating Co. Rather than manufacture glass, Lotus purchased blanks from other companies such as Duncan and Miller, Cambridge, Heisey, Morgantown, Fostoria, and Paden City. Lotus used their own designs to decorate the glass, especially light and heavy etchings and gold and silver.

McKee

The McKee Glass Co., founded in 1843 in Pitts-

burgh, Pennsylvania, began pressed glass production in 1852. In 1888, the factory was moved to Jeannette, Pennsylvania, and before closing in 1951, it produced large quantities of Depression Glass and kitchen wares. Their Danse De Lumiere boudoir lamp design is after Lalique's statuette "Suzanne." Their Bottoms Up tumbler with coaster brings as much as $275 on the market. The patent number "77725" on the base of the tumbler is assurance that you own an original, not a reproduction.

Morgantown

The Morgantown Glassworks was established in 1899, and initial production began in 1901. Two years later, as part of a reorganization, it became the Economy Tumbler. In 1923, the Tumbler was dropped, leaving the Economy Glass Co., soon to be renamed the Morgantown Glassworks. It closed in 1937 and was reopened and operated by workers in 1939 as Morgantown Glassware Guild. In 1965, Fostoria purchased the company, and production ceased in 1971. Their most popular stem is the Golfball, and they are also noted for Art Deco open stems such as Art Moderne and Paragon and their Sunrise Medallion and Faun patterns. The figural stems, Mai-Tai, Top Hat, and Jockey, were originally produced from private molds for restaurants and hotels. The President's House was the crystal chosen by Jacqueline Kennedy for the White House.

New Martinsville

Moondrops, Radiance, and Modernistic are three popular patterns of the New Martinsville Glass Co. of New Martinsville, West Virginia. It opened in 1901 and was purchased and renamed Viking Glass Co. in 1944. The factory continued production until 1985, when it was purchased and became Dalzell-Viking, still in operation. The smoking and liquor sets are among the most collectible New Martinsville items.

Paden City

Paden City Glass Manufacturing Co. opened in late 1916 and closed in 1951. Their glassware lines were produced for decorating companies, and they clearly advertised that one of their specialties was doing private mold work. Their most popular etchings are Cupid and Nora Bird, and their best known pattern lines are Penny and Crow's Foot.

Phoenix

Established in 1880 in Monaca, Pennsylvania, the Phoenix Co. was noted for colored cut glass and art glass designed by Joseph Webb. They are recognized for their lighting glass, including reverse-painted shades and Gone-with-the-Wind style oil lamps. Their "Sculptured Artware" line was first made in the early 1930s and was designed by Kenneth Haley, the son of Reuben Haley,

designer for Consolidated Lamp and Glass Co. When Consolidated closed temporarily (1932-1936), they loaned some of their Martele molds to Phoenix, which then reproduced and labeled them as a separate line — the Reuben line. They have been a part of the Anchor Hocking group since 1970.

Steuben

Founded in 1903 in Corning, New York, by glass designers/artists Frederick Carder and Thomas Hawkes, they began making colored Art Nouveau art glass. The firm was purchased by the Corning Glass Co. in 1918. Carder was also responsible for many of their Art Deco designs before the company ceased production of all colored glass in 1933. Industrial designers, such as Walter Dorwin Teague, then designed colorless crystal Art Deco pieces noted for their engraved decoration.

Tiffin

The Tiffin Glass Co. began in Tiffin, Ohio, in 1889 as a pressed tumbler operation. They merged with the United States Glass Co. on January 1, 1892, and the Tiffin works was subsequently known as Factory R, one of nineteen factories owned by the huge U.S. Glass conglomerate. Pressed tableware gradually lost favor with the American homemaker, and by 1914 Tiffin offered blown stemware and cut crystal patterns, and in the 1920s they began producing satin glass. Among the Art Deco patterns produced during this period are Velva, Basquette, and Cascade and decorations such as Echec. The pressed patterns, though referred to as Tiffinware, may have been actually made at another U.S. Glass factory.

In 1937, the main office of the U.S. Glass Co. was moved from Pittsburgh, Pennsylvania, to Tiffin, Ohio. Modern lines, developed by Swedish glass artists at Tiffin, were popular in the 1940s, followed by the freeform art glass Empress Line, introduced in 1959. In 1955, the Duncan and Miller Glass Co. of Washington, Pennsylvania, discontinued operations, and Tiffin purchased many of their molds. The Tiffin factory closed for several months, but reopened in 1963 as the Tiffin Art Glass Company, which acquired the assets of the T. G. Hawkes Co. of Corning, New York, in 1964. The company was sold several more times until 1980 when the factory closed permanently.

Verlys

Established in France by the Societe Anonyme Holophane, of Les Andelys, France, makers of prismatic lighting glassware, Verlys decorative glass was first made in 1931. In 1935, Holophane formed a separate company, Verlys of America, Inc. and they used the designs and molds of the French Verlys. The American company produced only molded glass (the French had made both blown and molded).

A Verlys decorative glass price list from October 1939 shows listings for the "Chinese Chippendale line," composed of several designs by prominent Americans such as Carl Schmitz, Ted Mehrer, and Viktor Schreckengost. American Verlys used some applied color. In 1955, Heisey leased some Verlys molds, which they used for two years in crystal etch and limelight. Verlys of America production ceased in 1961, and the molds were sold to Fenton, which used different colors and markings.

American pieces are signed in script. French Verlys is mold impressed with the word "France" as part of the mark.

Westmoreland

The Westmoreland Glass Co. was founded in 1899 in Grapeville, Pennsylvania. They were well known for their milk glass production; their use of color on tableware began in the early 1930s. In 1984, the Grapeville home was permanently closed.

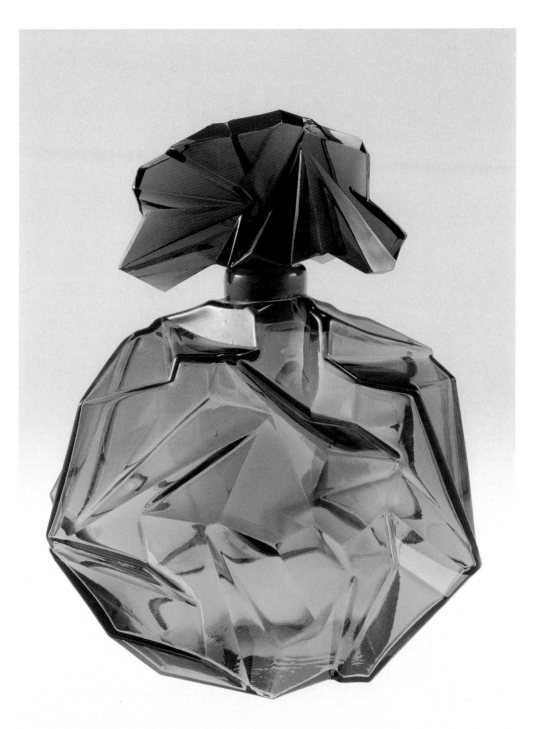

Stemware

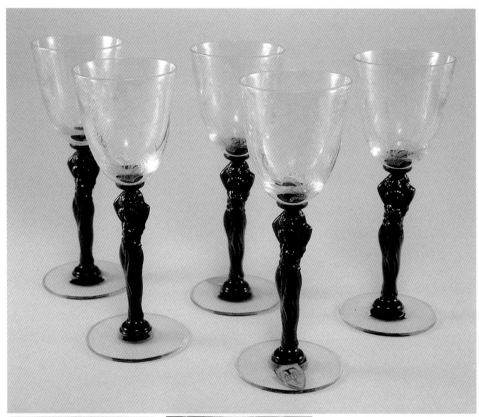

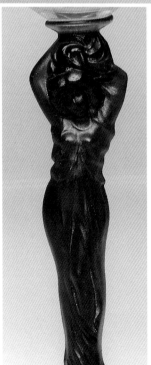

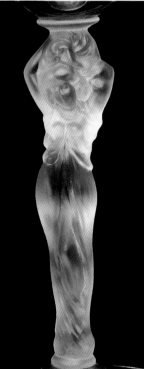

Above: Tiffin
"Draped Nudes" #15078
royal blue wine. $250-300
each

Bottom left: Detail.

Bottom right: Detail of
crystal satin finish stem.

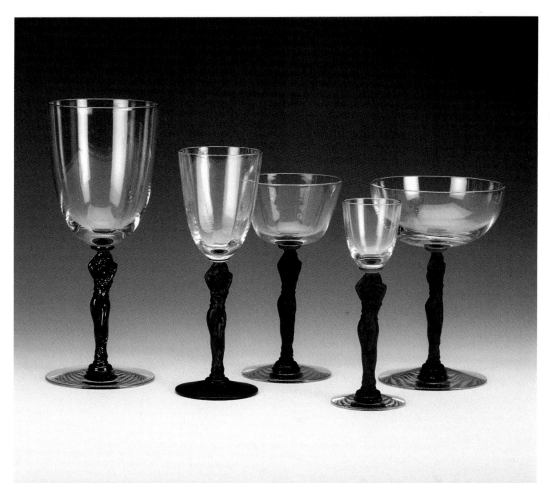

Tiffin
"Draped Nudes" #15078
royal blue satin finish (goblet
is bright finish): goblet, wine
(with royal blue foot),
cocktail, cordial, saucer
champagne. $200-300 each

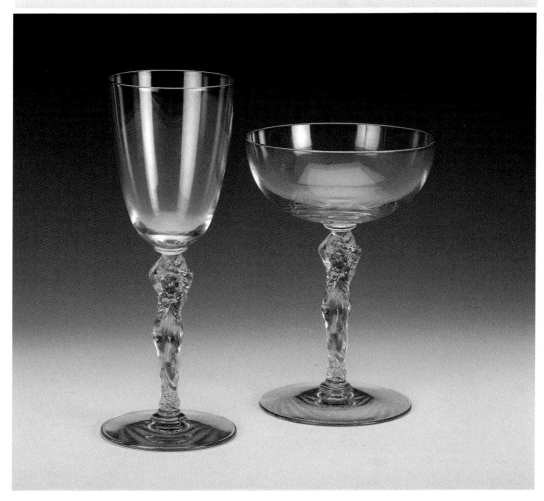

Tiffin
"Draped Nudes" in crystal
with reflex green stem: wine
and saucer champagne. $200-
250 each

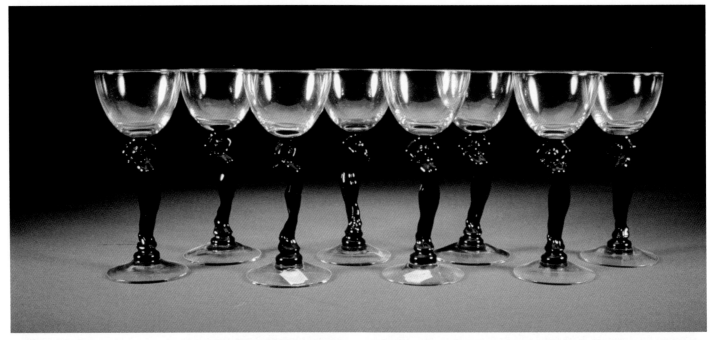

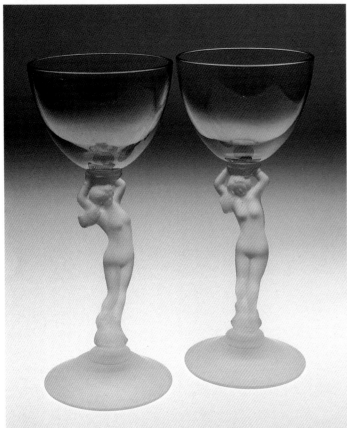

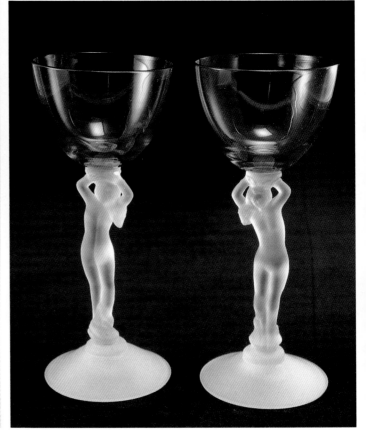

Above: Cambridge (attributed to)
Wines with **Statuesque** black glass nude stems with crystal bowls.
These black nude stems were also made by Imperial.
Photo courtesy of Skinner, Inc. $150-200 each

Back view.

Bottom left: Cambridge
Statuesque amber cocktails with frosted stems. $150-200 each

14

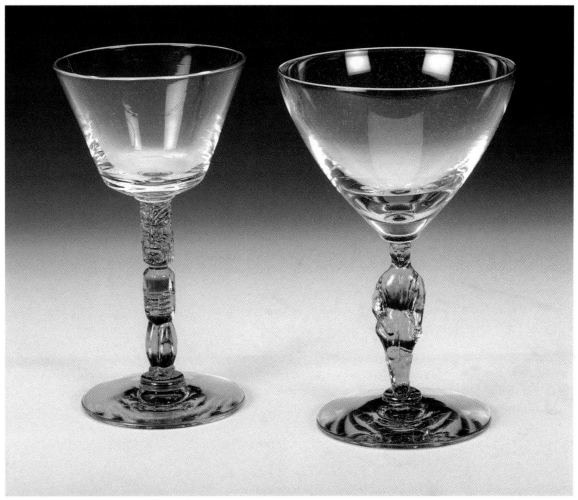

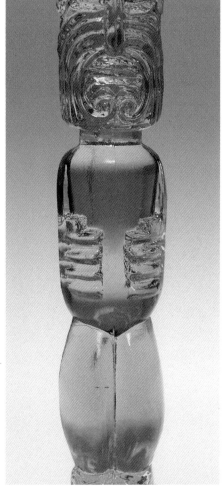

Above: Morgantown **Mai-Tai** with **Jockey**, both amber. $45-65 each

Bottom left: Detail of reverse of **Jockey**.

Bottom right: Detail of **Mai-Tai**.

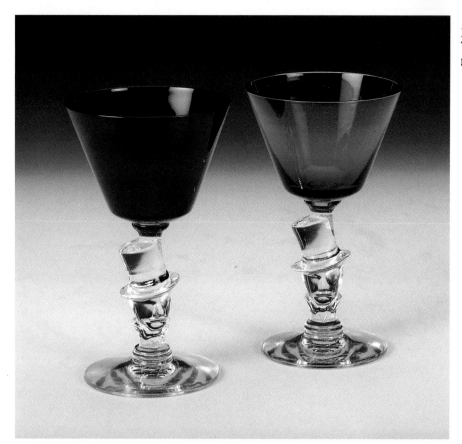

Morgantown
Top Hat cocktails with red and green bowls. $100-125; $125-150

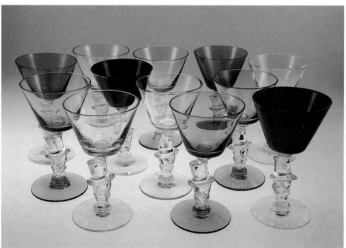

Morgantown
Assortment of **Top Hat** cocktails in various colors. Crystal $30-40 each; cobalt, ruby, Stiegel green $100-150 each; others $60-80 each

Detail.

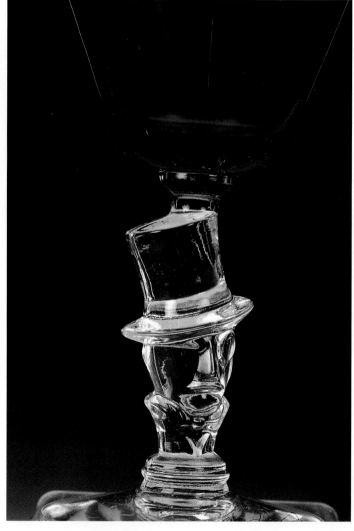

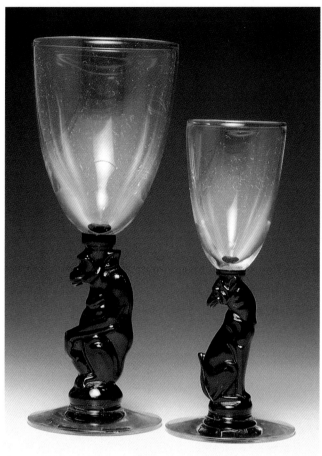

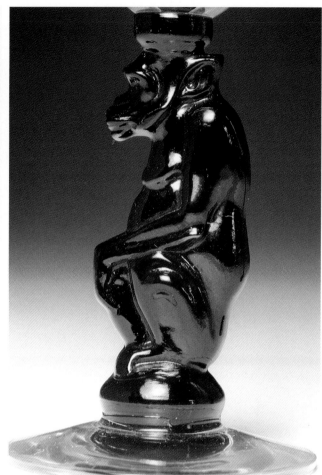

Above: Libbey
Silhouette black monkey sherry and black greyhound cordial. $150-175; $200-225

Top right: Detail of monkey.

Bottom right: Detail of greyhound.

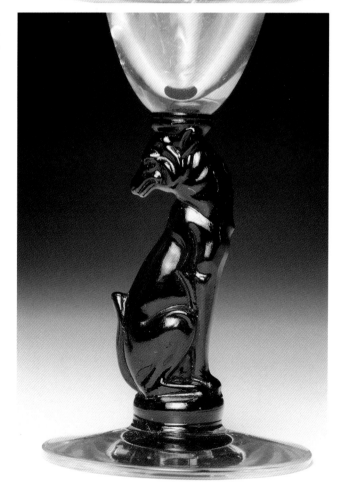

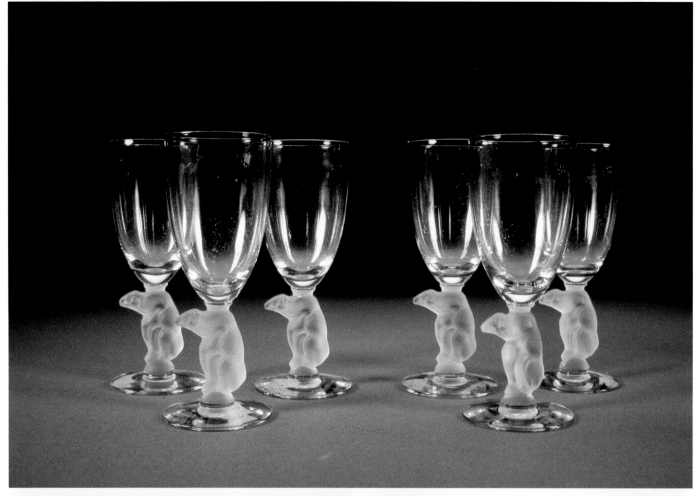

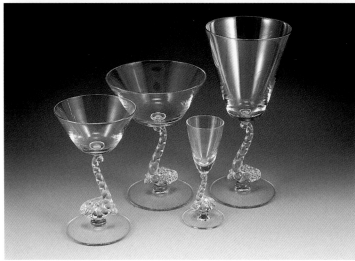

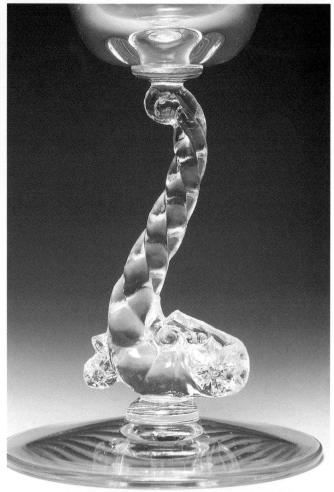

Top: Libbey
Silhouette moonstone clarets with figural bears.
Photo courtesy of Skinner, Inc. $150-175 each

Bottom left: Morgantown
Summer Cornucopia: goblet, sherbet, wine/
cocktail, cordial. $150-275 each

Bottom right: Detail.

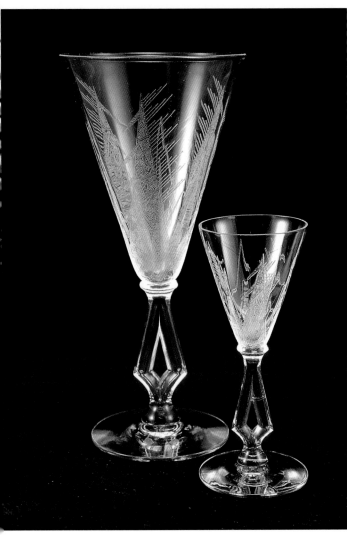

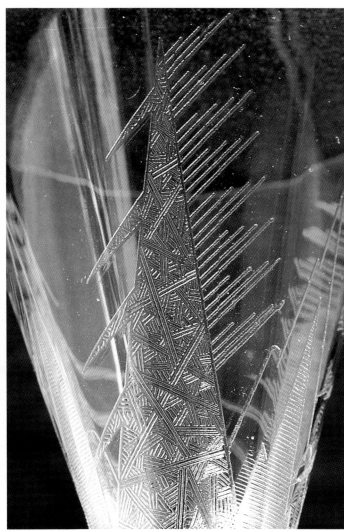

Top left: Morgantown
Art Moderne goblet and cordial, both with
Arctic etching. $125-150; $175-195

Top right: Detail.

Bottom right: United States Patent Office
drawing for Morgantown **Art Moderne** stem,
designed by George Dougherty, filed October
1, 1928.

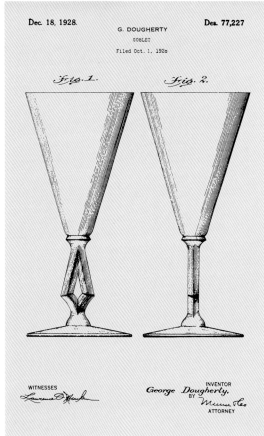

Dec. 18, 1928.

G. DOUGHERTY

GOBLET

Filed Oct. 1, 1928

Des. 77,227

Fig. 1. *Fig. 2.*

WITNESSES

INVENTOR
George Dougherty.
BY

ATTORNEY

19

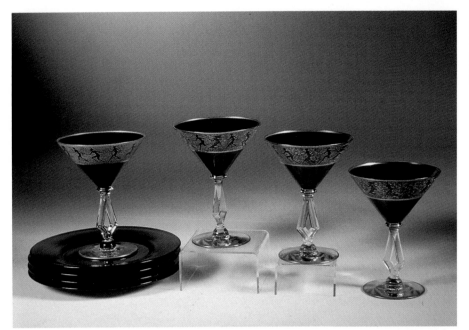

Morgantown
Crystal **Art Moderne** stems, cobalt bowls with gold encrustation and **Faun** decoration, gold rim on foot. *Photo courtesy of Skinner, Inc.* $175-200 each

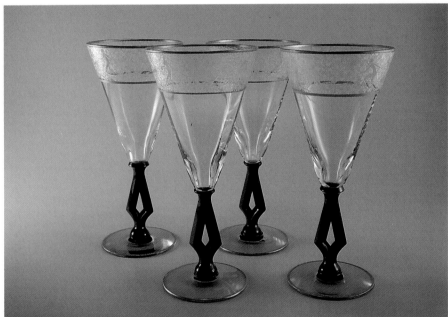

Morgantown
Black **Art Moderne** goblet with **Faun** etching surrounded by gold bands. $150-175

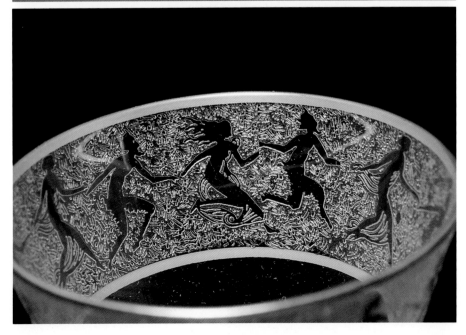

Detail of **Faun.**

20

Morgantown
Black **Paragon** goblet; **Fontanne** black filament stem; black **Paragon** champagne. $50-60; $55-65; $40-50

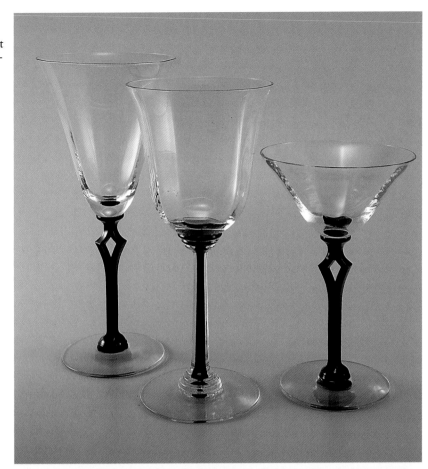

Morgantown
Champagnes: frosted square stem designed by Dorothy C. Thorpe; green square stem with **Marilyn** etched bowl; plain crystal square stem and plain bowl. $160-185; $180-200; $135-150

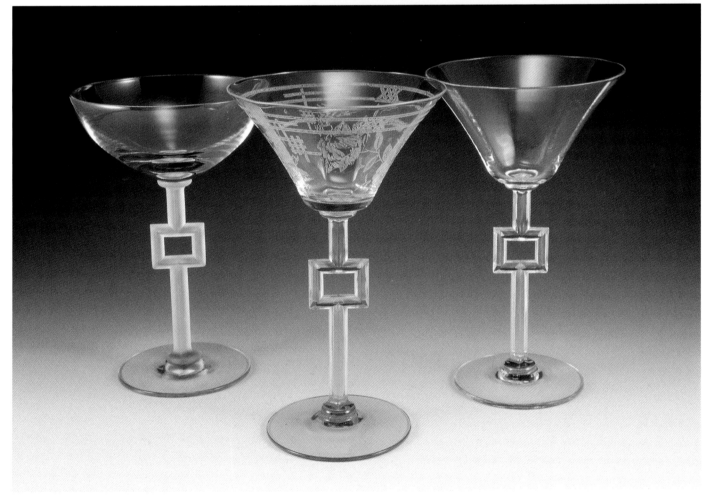

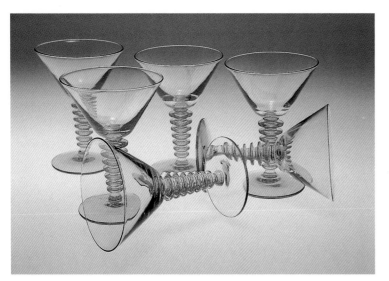

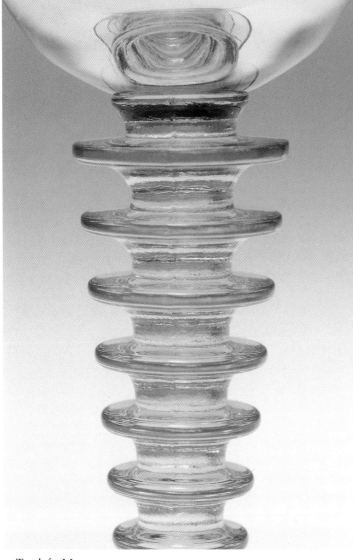

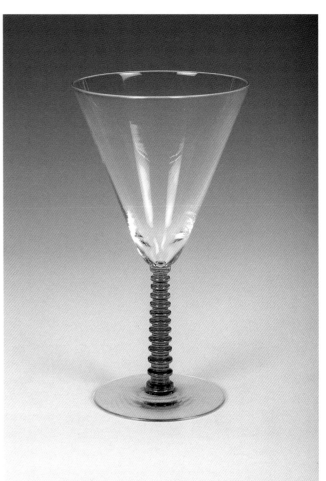

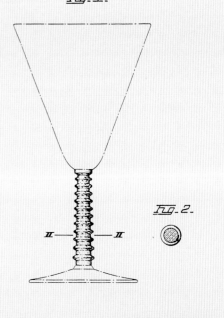

Nov. 16, 1937. E. W. NEWTON Des. 107,030
 GOBLET OR SIMILAR ARTICLE
 Filed March 9, 1937

FIG. 1.

FIG. 2.

INVENTOR.
Earl W. Newton
BY W. G. Doolich
ATTORNEY

Top left: Morgantown
Yellow **Palazzo** cocktails. $40-50 each

Bottom left: Detail.

Top right: Imperial
Goblet with crystal bowl and green ringed stem. $30-40

Bottom right: United States Patent Office drawing of Imperial goblet,
designed by Earl W. Newton, filed March 9, 1937.

22

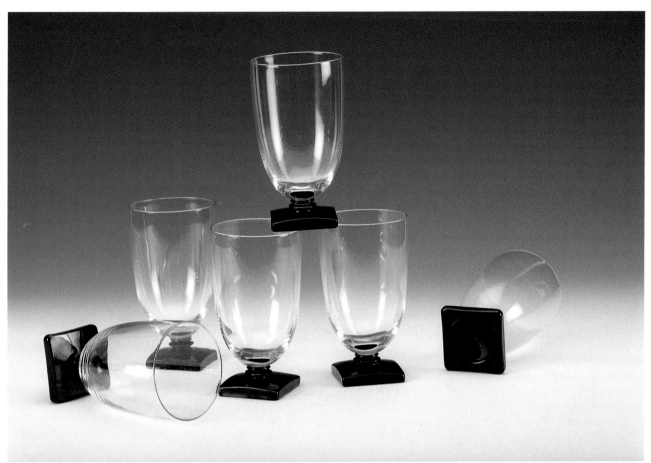

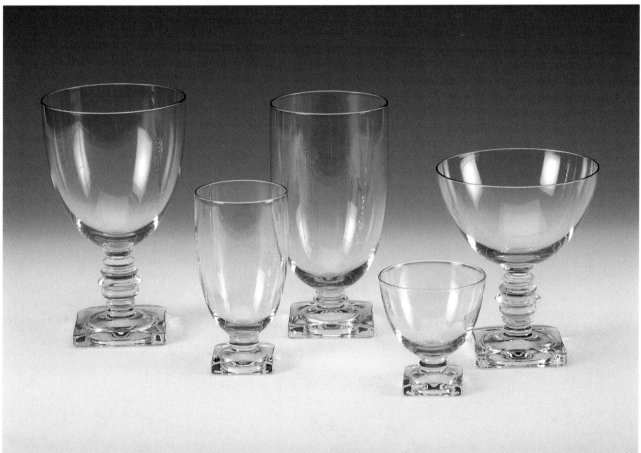

Top: Fostoria
#4020 footed tumbler with ebony foot and plain bowl, designed by George Sakier. $30-40 each

Bottom: Fostoria
#4020 goblet, footed juice, footed tumbler, cocktail, and tall sherbet in wisteria with crystal foot. $40-60 each

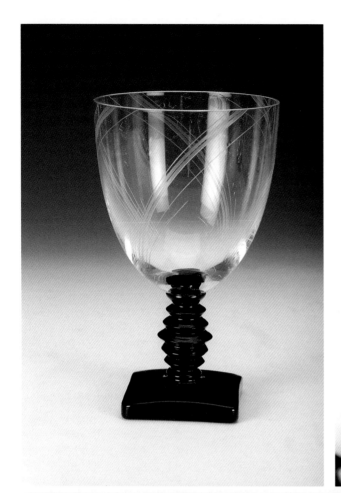

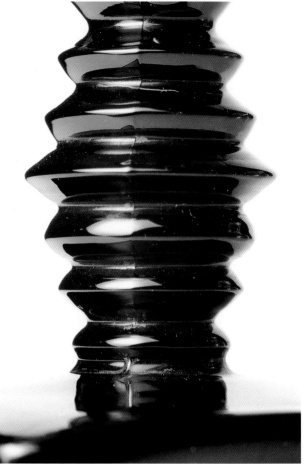

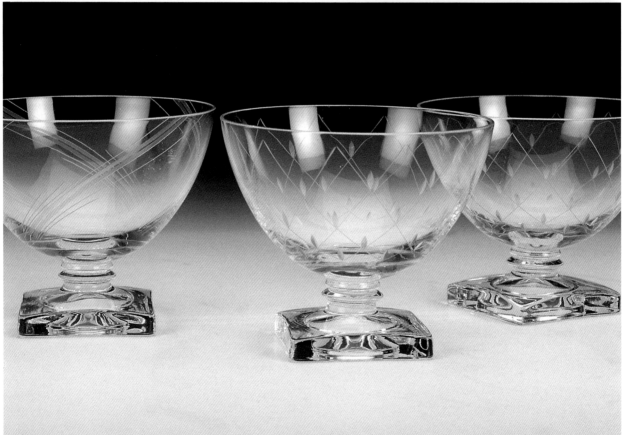

Top left: Fostoria
#4020 goblet with **Comet** cutting. $35-45

Top right: Detail.

Bottom: Fostoria
#4020 low sherbets in crystal with **Comet** cutting (left);
New Yorker/Manhattan cutting (right). $30-40 each

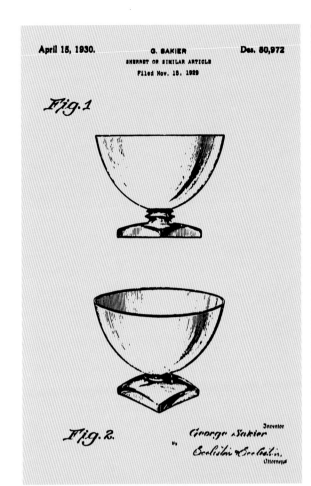

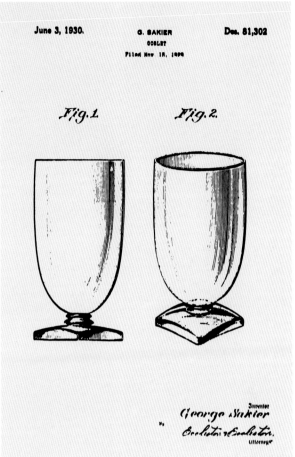

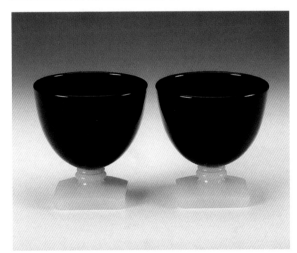

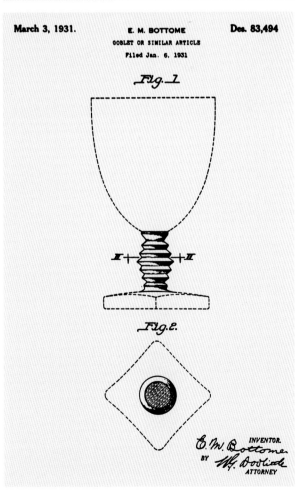

Top left: United States Patent Office drawing for Fostoria #4020 sherbet, designed by George Sakier, filed November 15, 1929.

Bottom left: Fenton
#1639 footed wine in ebony with alabaster, (with same corkscrew stem and square foot as Fostoria #4020). $25-35 each

Top right: United States Patent Office drawing for Fostoria #4020 goblet, designed by George Sakier, filed November 15, 1929.

Bottom right: United States Patent Office drawing for Fostoria #4020 goblet, designed by George Sakier, but patented by Edgar M. Bottome, filed January 6, 1931.

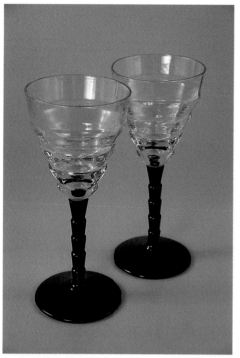
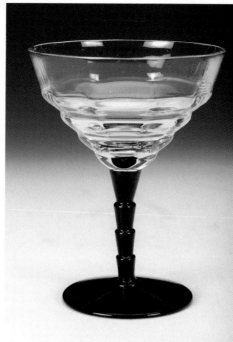
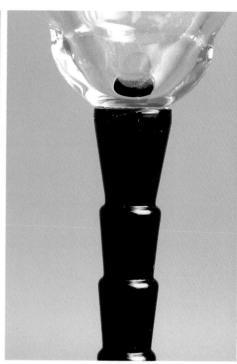
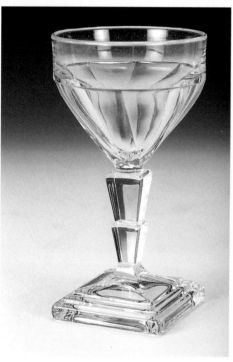
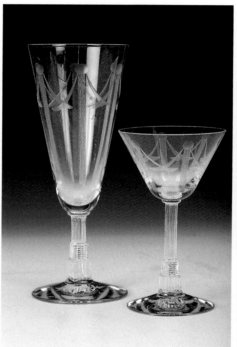
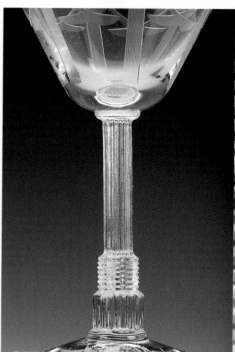

Top: Central
Moderne wines with crystal bowls and black tiered or stepped stems. $30-40 each

Bottom: Heisey
Twist cocktail, crystal with stepped stem and square foot. $20-30

Top: Central
Moderne sherbet. $25-35

Bottom: Libbey
Malmaison goblet and wine in crystal with "Skyscraper" stem. $60-80; $35-50

Top: Detail.

Bottom: Detail.

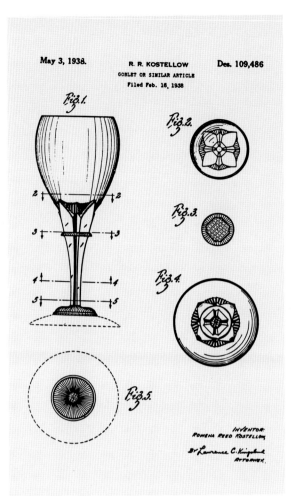

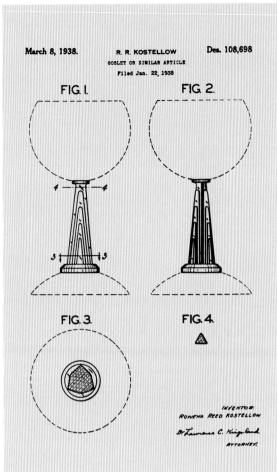

Top left: United States Patent Office drawing for Tiffin goblet, designed by Rowena Reed Kostellow, filed February 16, 1938.

Top right: United States Patent Office drawing for Tiffin goblet, designed by Rowena Reed Kostellow, filed January 22, 1938.

Bottom left: United States Patent Office drawing for Tiffin goblet, designed by Robert A. Kelly, filed December 2, 1937.

Bottom right: United States Patent Office drawing for Tiffin goblet, designed by Robert A. Kelly, filed December 2, 1937.

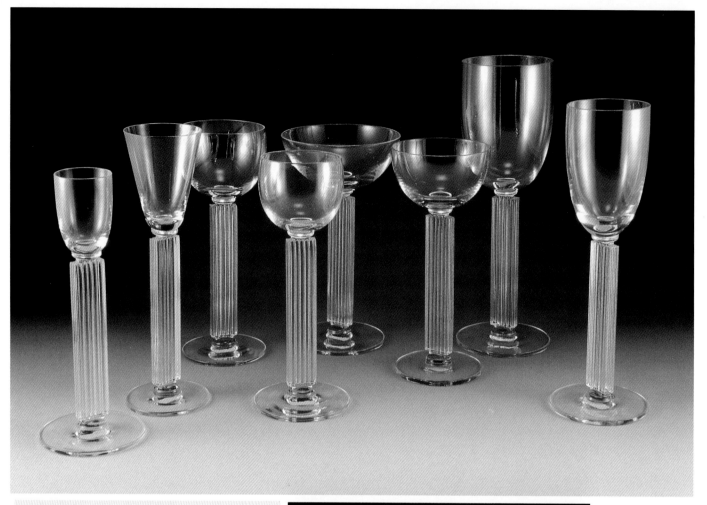

Above: Libbey **Embassy** #4900 line grouping, with all stems the same height. $200-300 each

Bottom left: United States Patent Office drawing of Libbey **Embassy** stem, designed by E. W. Fuerst and Walter Dorwin Teague, filed May 23, 1939. (Fuerst was Libbey's designer and Teague was the consultant designer for the 1939 World's Fair.)

Bottom right: Libbey **Embassy** front and side views of champagne. $200-225

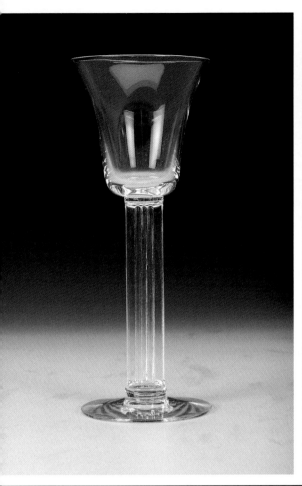

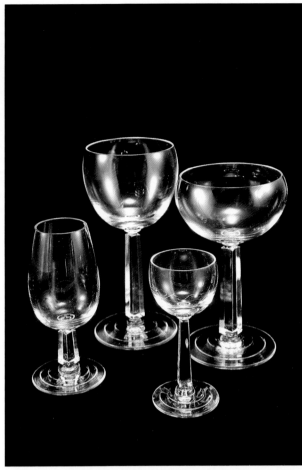

Top left: Heisey
Park Avenue wine
with stem
resembling
Libbey's Embassy.
$40-50

Top right: Libbey
American Prestige
#7000 line
grouping. $50-85
each

Bottom: Libbey
American Prestige
#7000 line
grouping of four-
sided stems with
terraced feet.
$50-85 each

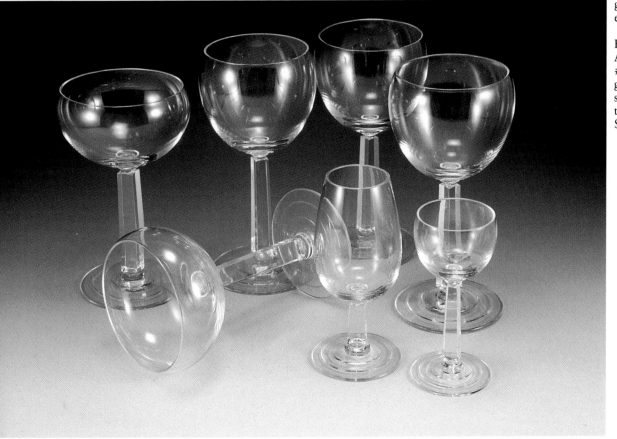

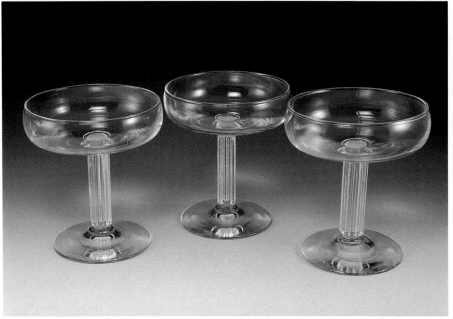

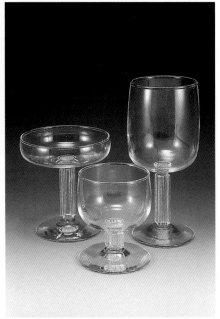

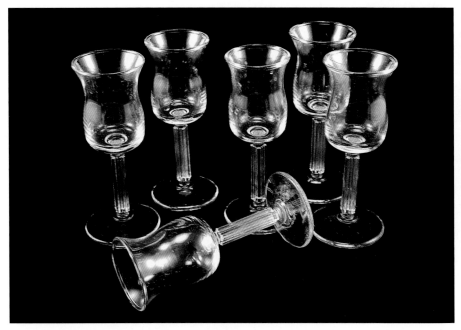

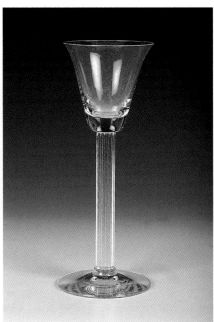

Top left: Libbey (attributed to)
Unidentified champagnes with square ribbed stem.
$30-40 each

Top right: Libbey (attributed to)
Unidentified square ribbed stems. $30-40 each

Bottom left: Libbey (attributed to)
Unidentified sherries with square ribbed stems. $30-40 each

Bottom right: Libbey
Monticello round ribbed wine. $75-100

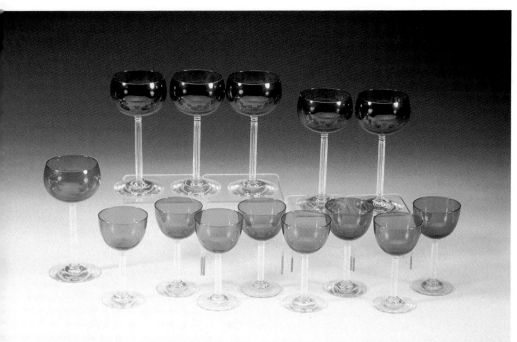

Fostoria
Neo-Classic, designed by George Sakier: cordials and wines with empire green bowls and crystal stems. *Photo courtesy of Skinner, Inc.* $30-40 each

Fostoria
Neo-Classic footed tumbler and low sherbet with **Whirlpool** cutting. $25-35 each

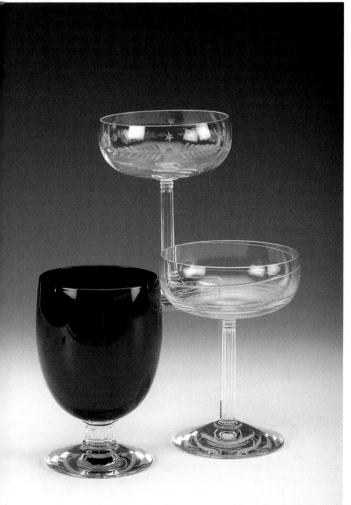

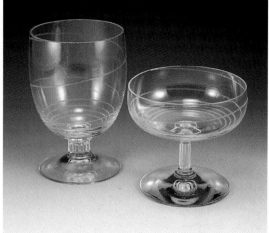

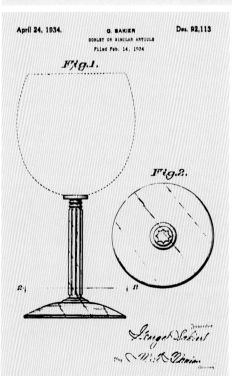

April 24, 1934. G. SAKIER Des. 92,113
GOBLET OR SIMILAR ARTICLE
Filed Feb. 14, 1934

Fig.1.

Fig.2.

Fostoria
Neo-Classic: footed tumbler with ruby bowl; saucer champagne with **Directoire** cutting; and saucer champagne with **Whirlpool** cutting. $25-40 each

United States Patent Office drawing of Fostoria **Neo-Classic** goblet, designed by George Sakier, filed February 14, 1934.

31

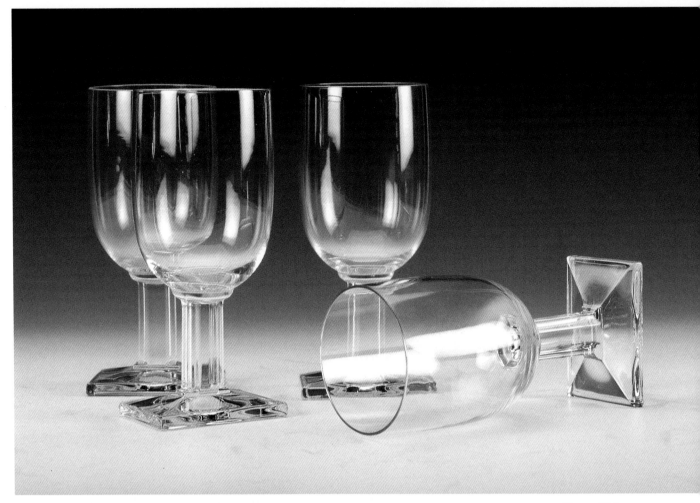

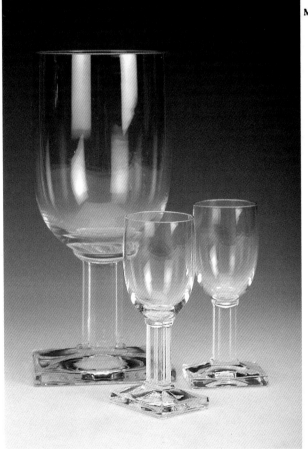

May 15, 1934. R. C. IRWIN Des. 92,247

GLASS GOBLET OR ARTICLE OF SIMILAR NATURE

Filed March 3, 1934

Fig. 1

Fig. 2

Fig 3

INVENTOR.
Rodney C. Irwin

BY
Carter & Mahoney
ATTORNEYS.

Above: Heisey **New Era** goblets. $20-25 each

Bottom left: Heisey **New Era** goblet and cordials. $20-25; $35-45 each

Bottom right: United States Patent Office drawing of Heisey **New Era** goblet, designed by Rodney C. Irwin, filed March 3, 1934.

Opposite page:
Top left: Heisey **New Era** wines. $30-40 each

Top right: Heisey **New Era** frosted stem with crystal bowl. $25-30

Bottom left: Heisey **Finesse** cocktail with **Ultronic** cutting, and label. $20-25

Bottom right: Morgantown **Octette** goblet and cordial with ruby bowls and eight-sided crystal stems. $35-40 $45-55.

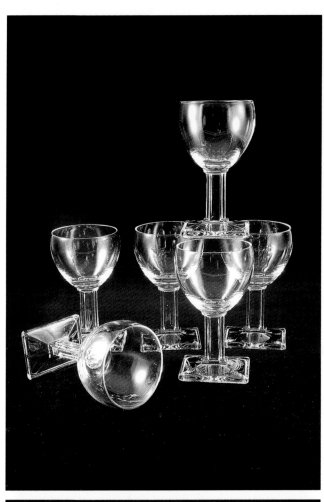

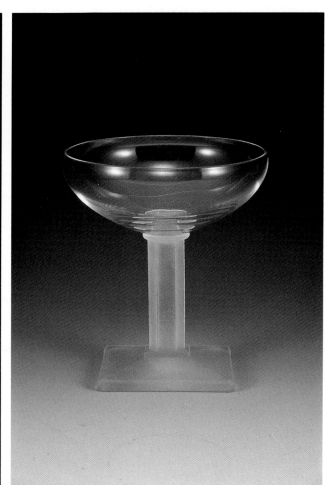

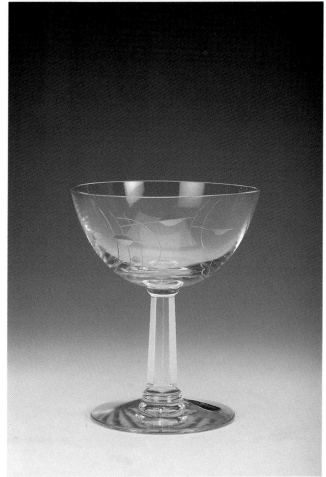

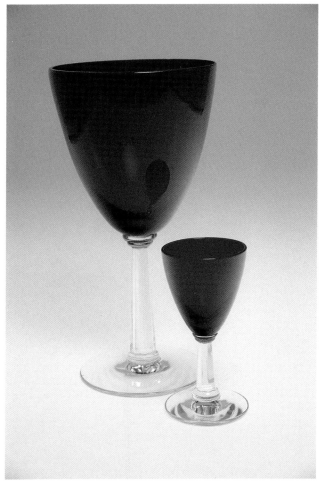

33

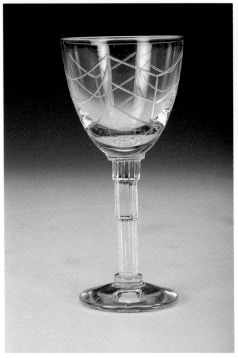
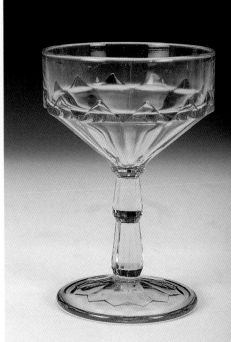
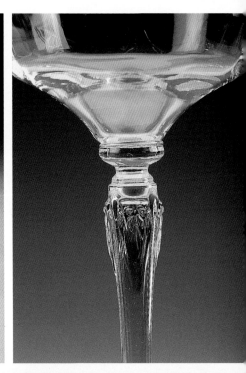

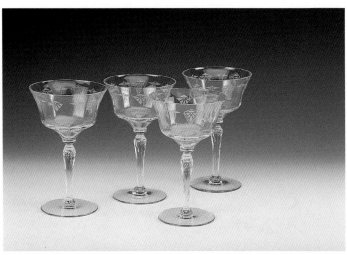
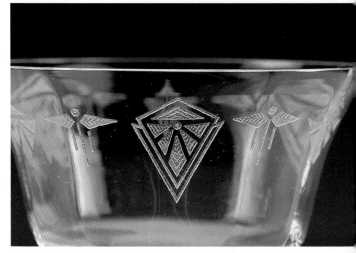

Top left: Duncan
Terrace cordial with cutting. $75-100

Top center: Cambridge
#3300 pink institutional/hotel sherbet. $20-25

Top right: Detail of **Deauville.**

Bottom left: Cambridge
Deauville etching on yellow tall sherbet with molded stem. $35-45
each

Bottom right: Detail of **Deauville.**

Opposite page:
Top: Tiffin
#15064: goblet with Festoon optic and amber stem and foot;
saucer champagne with Wide optic, **Byzantine** etching, amber stem
and foot; saucer champagne with Wide optic and black stem and
foot; wine with Festoon optic, mandarin bowl, crystal stem and
foot. $15-25 each

Center left: Fry
Cocktail in pink with **Square Diamond** stem. $30-40 each

Center: Morgantown
Goblet with golden iris bowl with **Nasreen** etching on reverse twist
stem. $75-95

Center right: Detail.

Bottom right: Fry
Cocktails with eight-sided bowls and **Square Diamond** stems, in
blue (one with crystal stem). $30-40 each

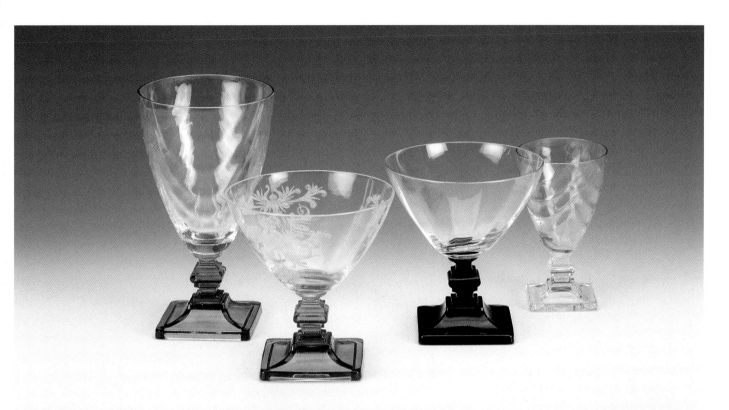

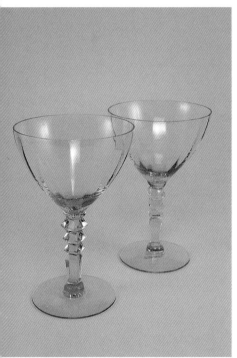

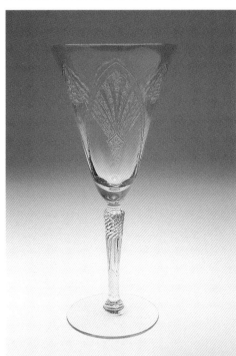

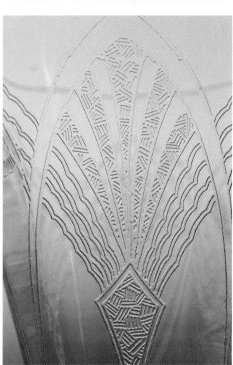

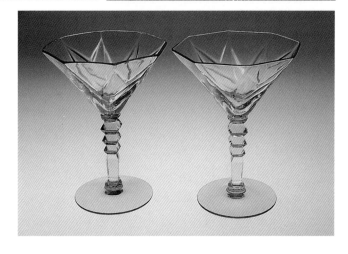

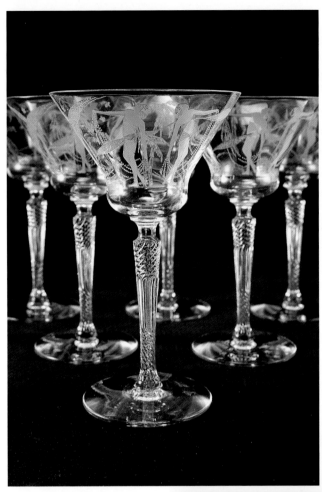

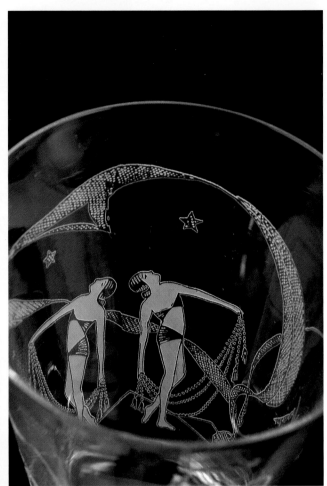

Top left: Morgantown
Champagnes with **Superba**
etching on reverse twist stem.
$150-175 each

Top right: Detail.

Bottom: Detail.

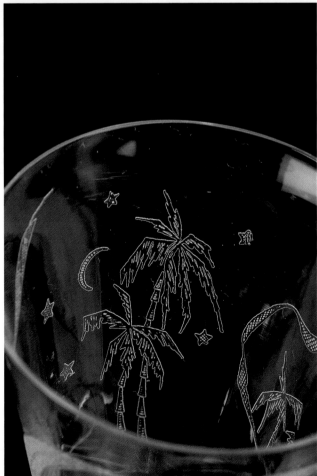

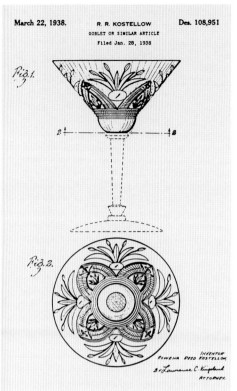

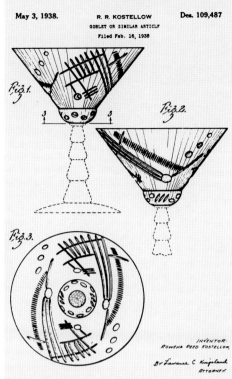

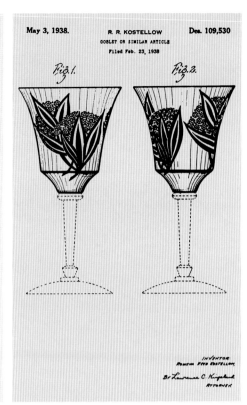

Top left: United States Patent Office drawing of Tiffin **San Rey** cutting, designed by Rowena Reed Kostellow, filed January 28, 1938.

Top center: United States Patent Office drawing of Tiffin cutting, designed by Rowena Reed Kostellow, filed February 16, 1938.

Top right: United States Patent Office drawing of Tiffin cutting, designed by Rowena Reed Kostellow, filed February 23, 1938.

Bottom left: United States Patent Office drawing of Tiffin cutting, designed by Rowena Reed Kostellow, filed January 29, 1938.

Bottom right: United States Patent Office drawing of Tiffin cutting, designed by Rowena Reed Kostellow, filed January 29, 1938.

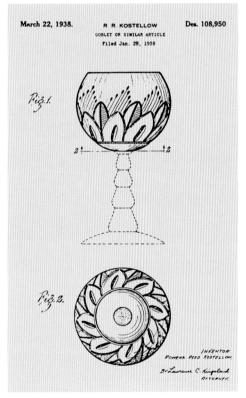

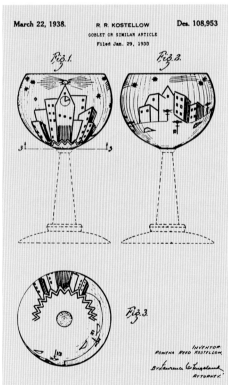

Fostoria **#6202** goblet and tumblers in gold tint, designed by George Sakier as a companion to Diadem. $35-45 each

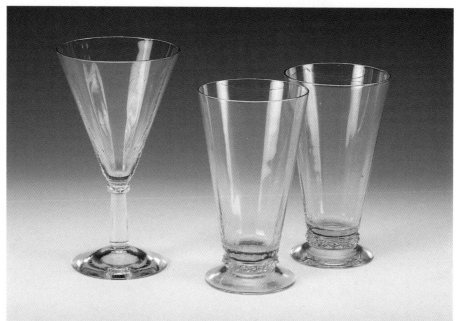

Opposite page:
Top: Fostoria **Sceptre**, designed by George Sakier: footed juice, footed water, and sherbet, with gold tint bowls and crystal feet. $25-35 each

Bottom: Morgantown **Monroe** champagnes with ruby bowls and crystal stems. $40-50 each

Detail.

United States Patent Office drawing of Fostoria **#6202** tumbler, designed by George Sakier, filed October 28, 1930.

United States Patent Office drawing of Fostoria **#6202** goblet, designed by George Sakier, filed October 28, 1930.

38

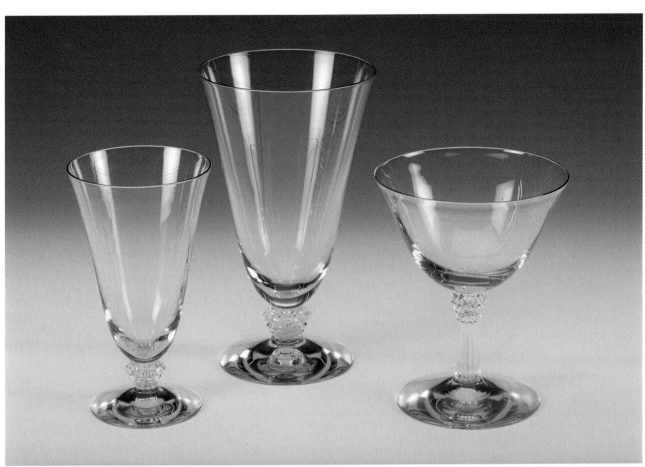

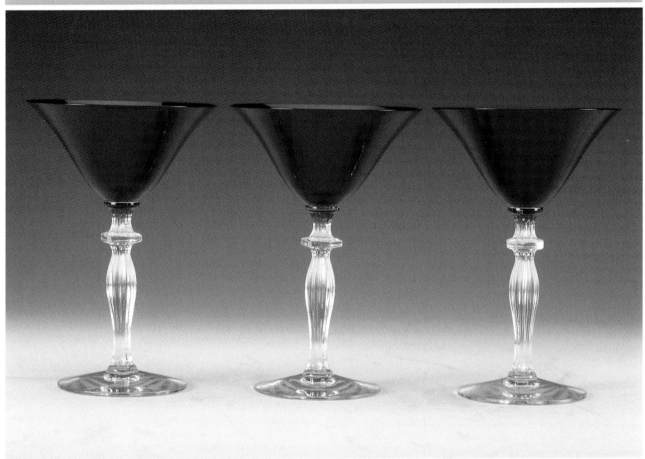

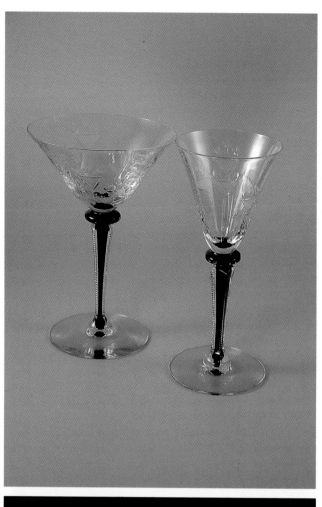

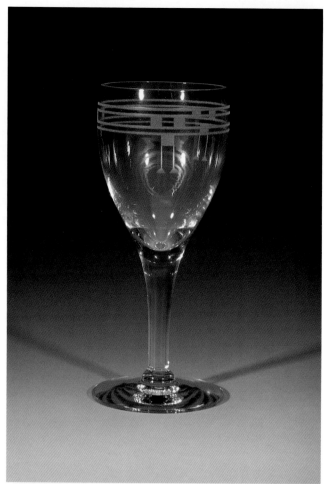

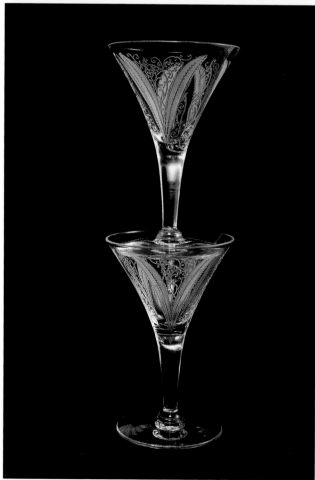

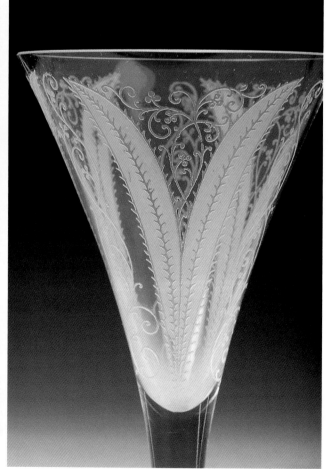

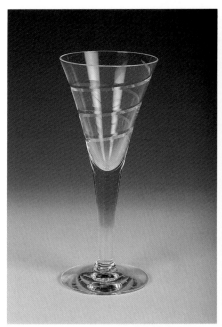

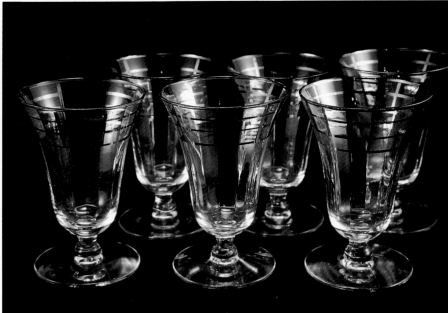

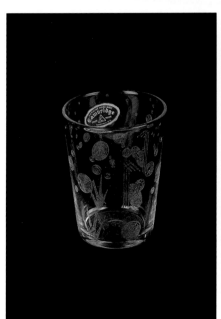

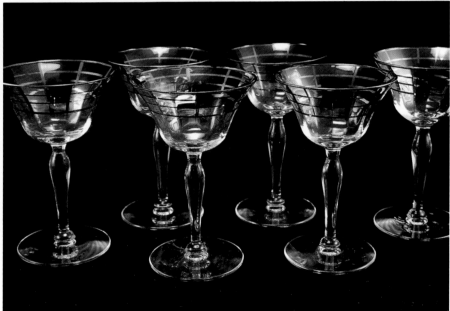

Opposite page
Top left: Morgantown
Athena champagne and wine with black cased filament stem and cut exterior, bowl with unknown cutting. $50-60; $65-75

Top right: Tiffin
Crystal **#14153**, 3-ounce wine with **#675** sand blast design. $10-20

Bottom left: Morgantown
Fernlee sherries. $30-35 each

Bottom right: Detail (goblet).

Top left: Cambridge
Rondo swirl cutting on crystal wine. $20-30

Top right: Morgantown
Lattice parfaits, platinum on crystal. $25-30 each

Bottom left: Cambridge
Vichy whiskey with unusual Deco cutting. $75-100

Bottom right: Morgantown
Lattice cocktails, platinum decoration on bowl. $20-25 each

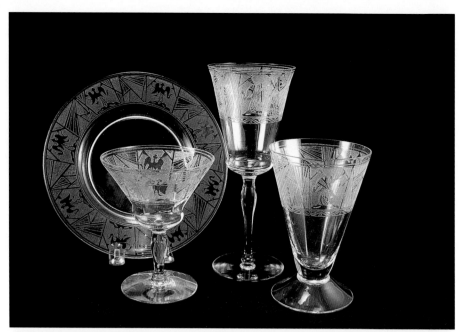

Morgantown
Morgantown blanks – plate, sherbet, water goblet, and footed tumbler – with Lotus **La Furiste** decoration. $15-20 plate; $20-35 each stem

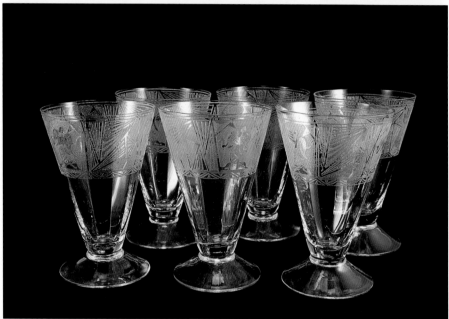

Morgantown
Belton footed tumblers with Lotus **La Furiste** decoration. $25-30 each

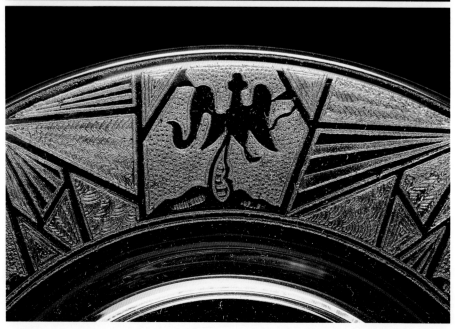

Detail of plate.

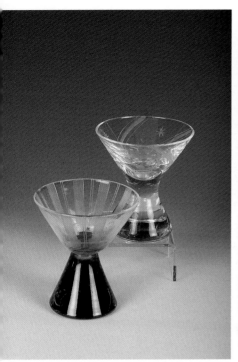
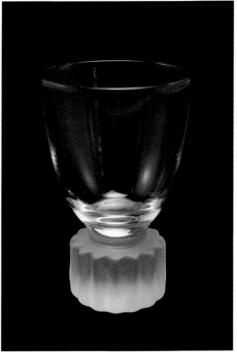
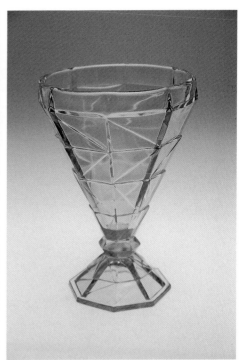
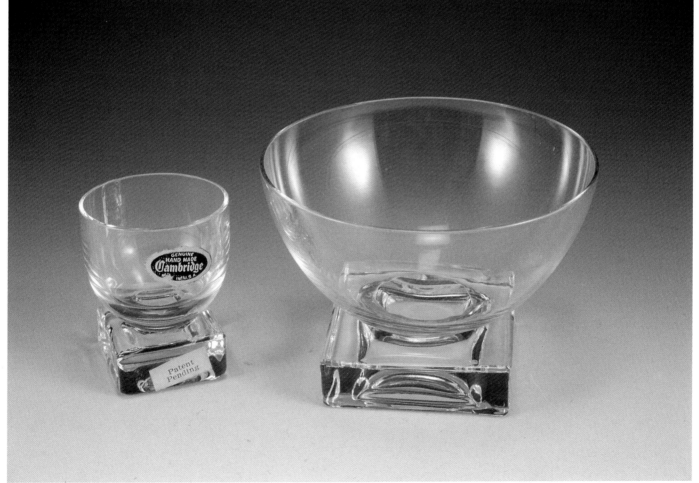

Top left: Unidentified
Green and crystal cocktail with linear cutting; and crystal cocktail with cutting similar to Fostoria Celestial. $20-25 each

Top center: Morgantown
Cog cordial with frosted base and crystal bowl. $35-45

Top right: Indiana
Cracked Ice green footed goblet. $25-30

Bottom: Cambridge
Square cordial and sherbet, crystal. $40-45; $20-25

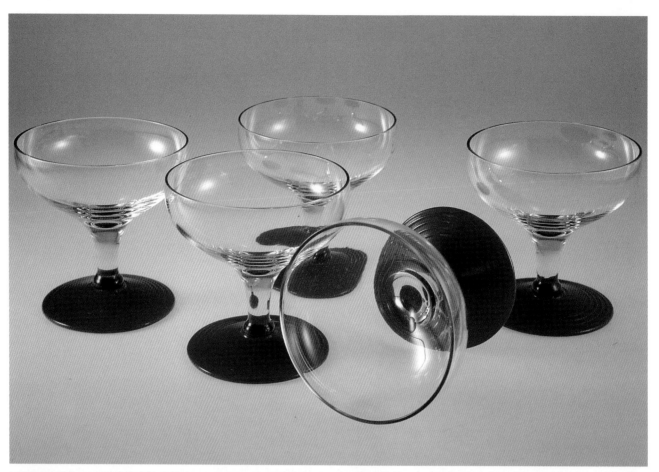

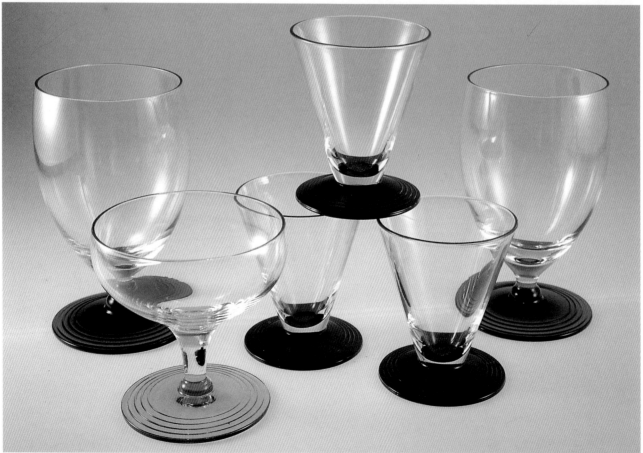

Top: Morgantown
El Patio sherbets with tangerine foot. $25-35 each

Bottom: Morgantown
El Patio water goblet with green foot; sherbet with amber foot; whiskey with cobalt foot. $30-50

44

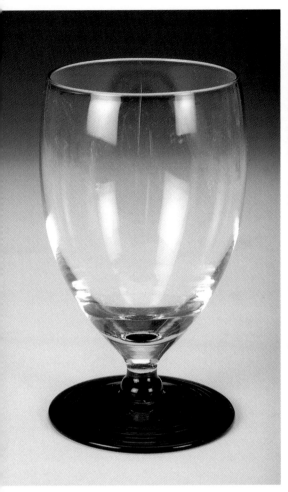

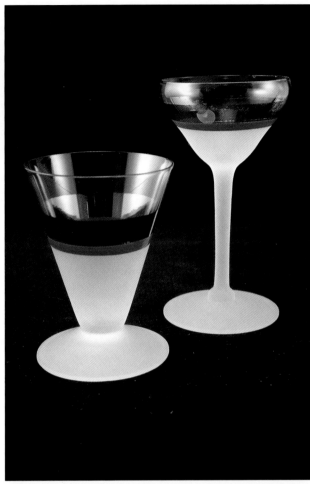

Top left:
Morgantown
El Patio water
goblet with green
foot. $30-40

Top right:
Morgantown
Hollywood footed
whiskey and
cocktail with silver
and red trim on
frosted white.
$35-45; $30-40

Bottom:
Morgantown
Shaker cocktails
with white frosted
foot, stem, and
body with
platinum trim on
top; similar to
Lattice. $30-35

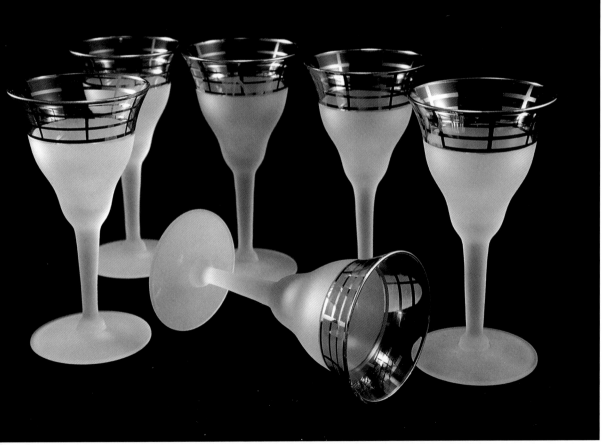

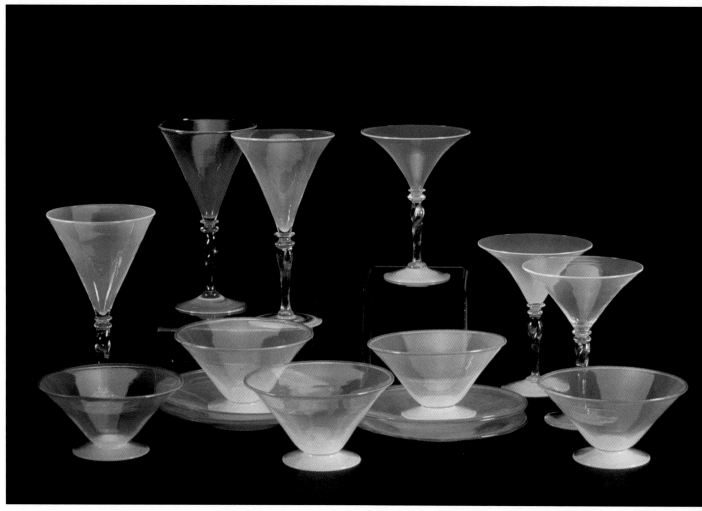

Steuben
Opal and **Cintra** table service, designed by Frederick
Carder. *Photo courtesy of Skinner, Inc.* $1500-2000 set

Opposite page:
Top left: Consolidated
Dancing Nymph, also known as **"Dance of the Nudes"** and
"Dancing Nudes," footed cocktails, in crystal, French crystal, and
white stain finishes. $40-60 each

Top right: Consolidated
Catalonian sundaes in honey color. $30-40 each

Center right: Consolidated
Catalonian footed tumblers with green wash and amethyst wash.
$30-40 each

Bottom center: Indiana
Pyramid footed goblet in black – this color was produced by Tiara
in 1974. $20-25 each

Bottom right: United States Patent Office drawing of Tiffin
Basquette #15364 tumbler, designed by Curtis B. Ilgenfritz et al,
filed June 22, 1937.

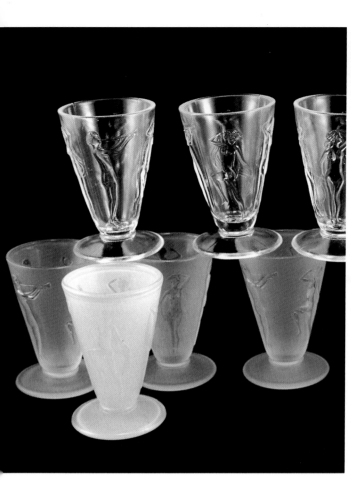

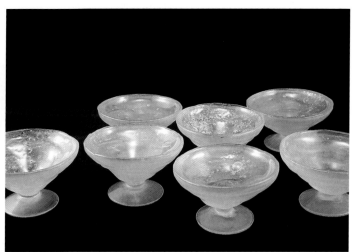

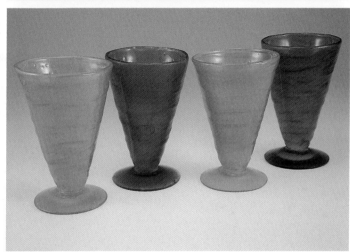

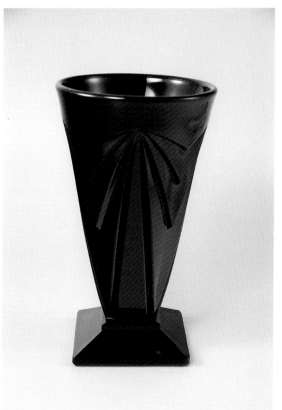

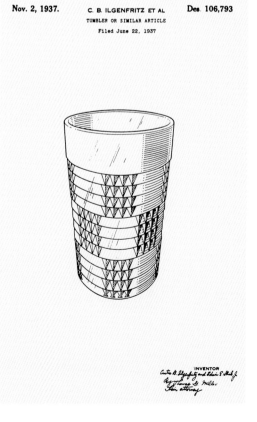

Nov. 2, 1937. C. B. ILGENFRITZ ET AL Des. 106,793

TUMBLER OR SIMILAR ARTICLE

Filed June 22, 1937

INVENTOR

Tableware

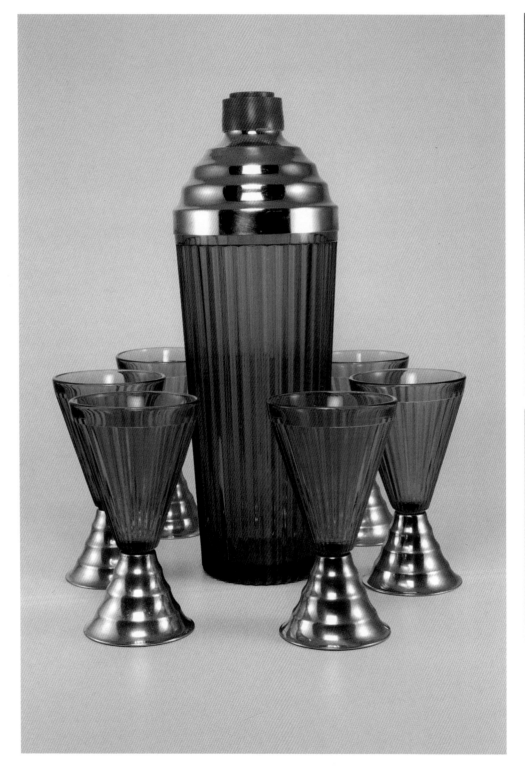

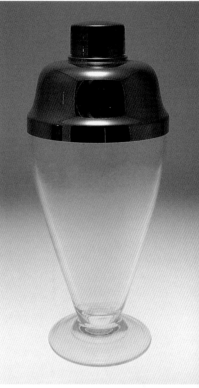

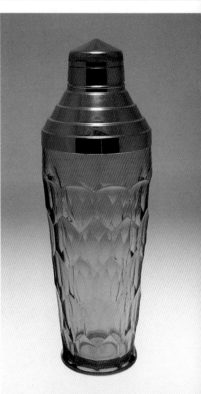

Opposite page:
Left: Unidentified Blue ribbed cocktail shaker with metal and red top, and matching glasses with metal bases. $150-200 set

Top right: Unidentified Translucent yellow cocktail shaker with metal top. $75-100

Bottom right: Paden City **Aristocrat** chromium topped cocktail shaker in amber with overall geometric pattern. $90-110

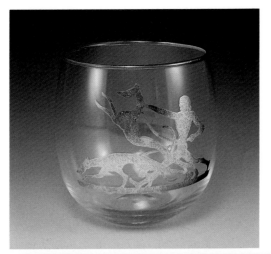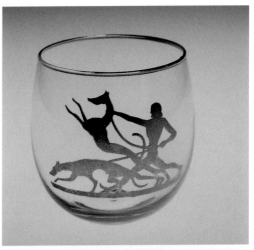

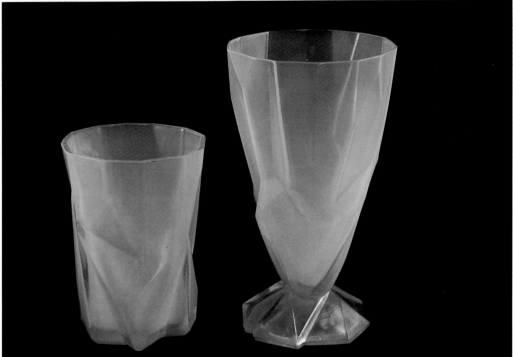

Top left: Heisey (attributed to) Roly-poly with silver resist **Nimrod** decoration, designed by Wilhelm Hunt Diederich. $70-80

Top right: Shown with different lighting – pattern is more pronounced.

Center: Consolidated **Ruba Rombic** tumbler and footed ice tea in sunshine, cased yellow. $200-225; $225-275

Bottom: McKee **"Bottoms Up"** shot glasses in caramel, showing two views, without coasters. $50-75 each

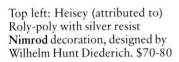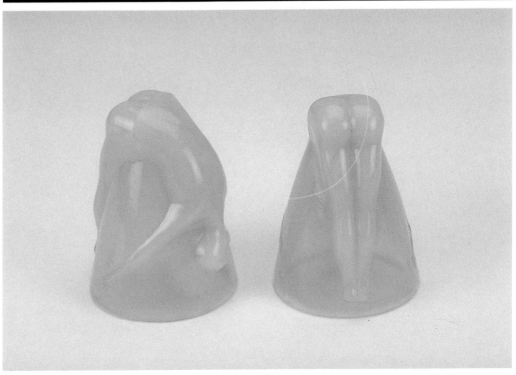

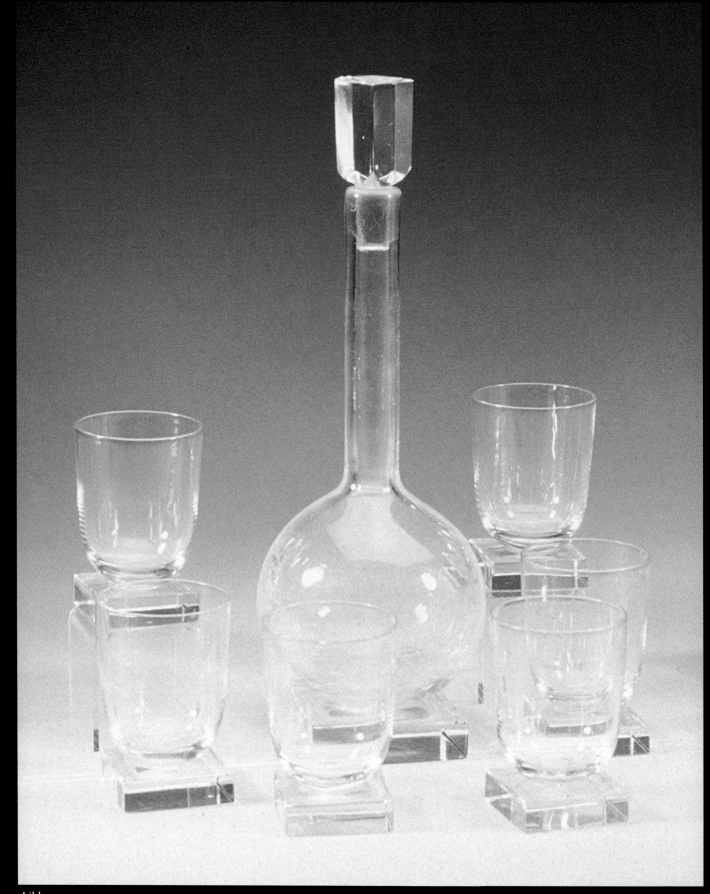

Libbey
Knickerbocker seven-piece cordial set; 11-inch decanter, 3-1/2
inch square footed glasses. *Photo courtesy of Skinner, Inc.*

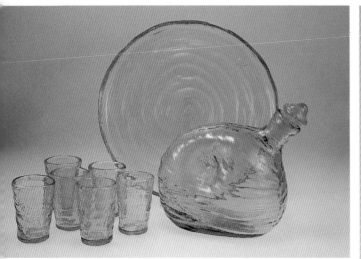

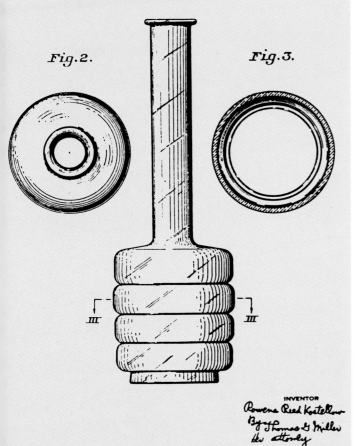

April 12, 1938. R. R. KOSTELLOW Des. 109,221
DECANTER OR SIMILAR ARTICLE
Filed Feb. 5, 1938

Fig.1.

Fig.2. Fig.3.

III III

INVENTOR
Rowena Reed Kostellow
By Thomas G. Miller
his attorney

Top: Consolidated
Catalonian decanter set in clear green: shot glasses $25-35 each;
6-1/2 inch decanter $250-275; 10-1/2 inch tray $125-150

Bottom: United States Patent Office drawing of Tiffin decanter,
designed by Rowena Reed Kostellow, filed February 5, 1938.

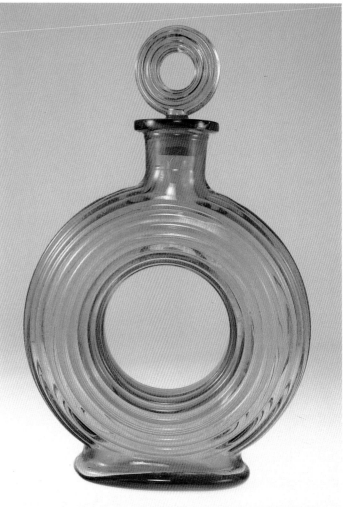

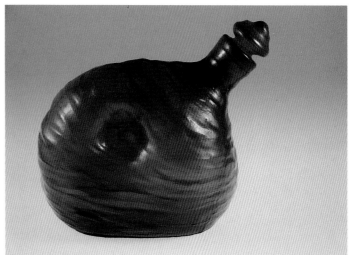

Top: McKee
"Lifesaver" decanter, ribbed amber glass with center hole.
$300-350

Bottom: Consolidated
Catalonian amethyst decanter. $275-300

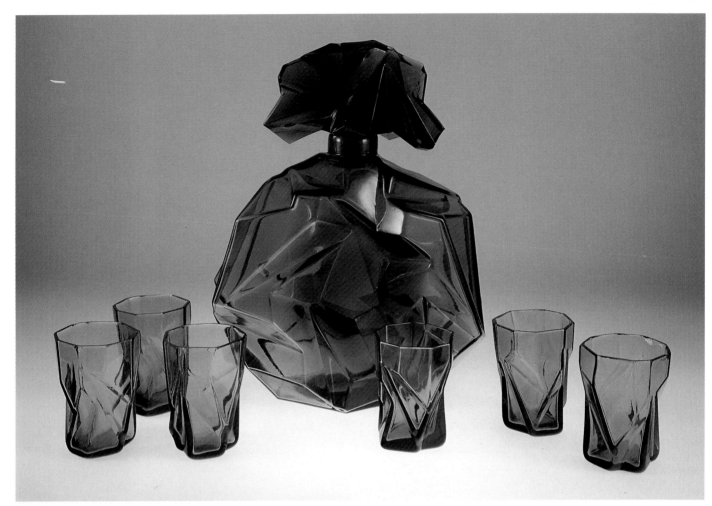

Consolidated
Ruba Rombic smokey topaz 9-inch
decanter and six shot glasses.
$1500-2000; $150-200 each

Label
RUBA ROMBIC AN EPIC IN
MODERN ART

Opposite page:
Top left: Consolidated
Ruba Rombic 9-inch decanter, jungle green. $1500-
2000

Top right: European (Yugoslavian or Czech)
Ruba Rombic look-alike in same green as decanter,
with short neck, missing stopper. $75-100

Bottom left: Morgantown
Melon 54-ounce 9-inch jug, frosted crystal with
ebony handle, **Aurora** etching. $1500-1800

Bottom right: Detail.

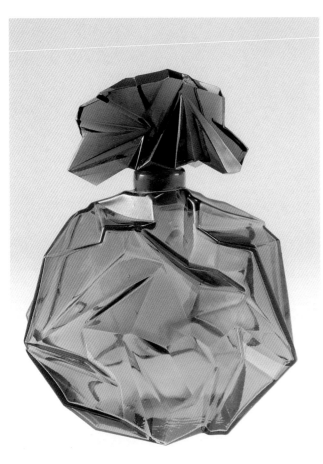

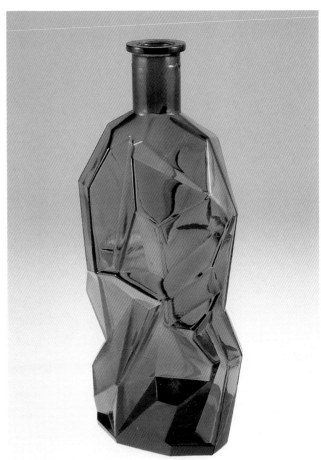

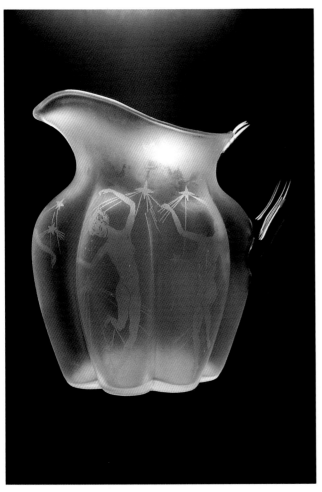

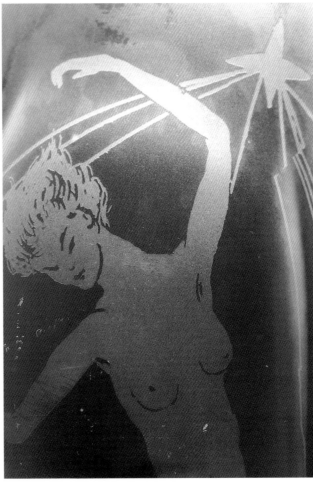

53

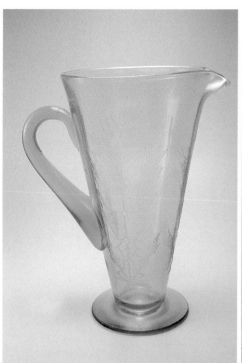

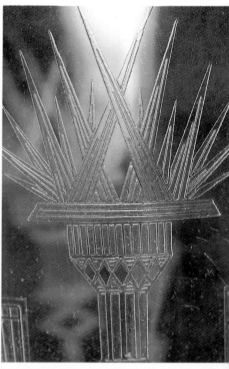
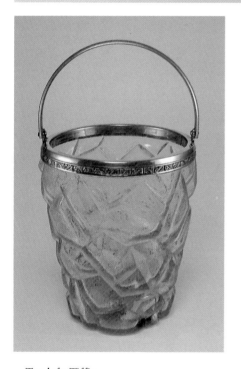
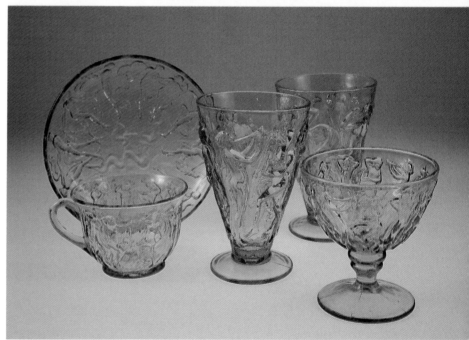

Top left: Tiffin
Modernistic etching on green 2-quart jug with Wide optic. $250-300

Top center: Detail.

Top right: Detail.

Bottom left: Westmoreland
Rocker green ice bucket with original silver insert, rim, and bail. $75-95

Bottom right: Consolidated
Dancing Nymph: teal cup and saucer; pink footed goblets (left crystal, right frosted); teal sherbet. $150-175; 150-175 each; $85-100

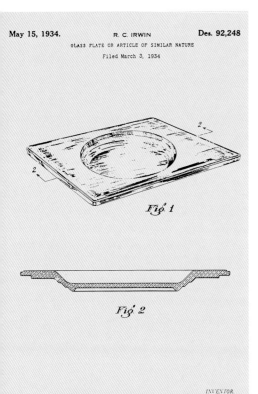

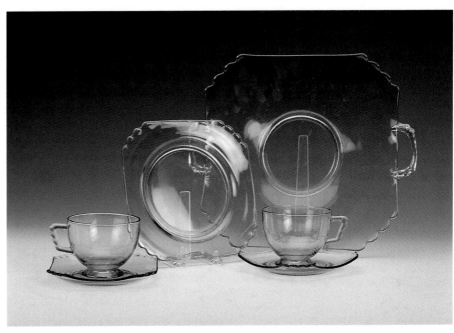

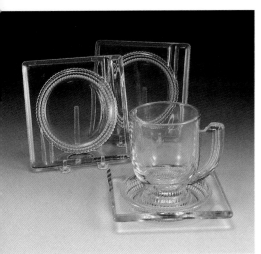

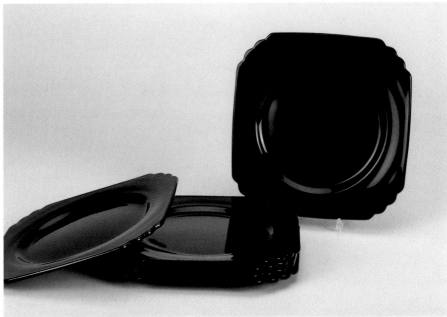

Top left: United States Patent Office drawing of Heisey **New Era** plate, designed by Rodney C. Irwin, filed March 3, 1934.

Top right: Fostoria
Mayfair designed by George Sakier: green cups and saucers; gold tint 10-inch handled cake plate; 7-inch plates. $15-20; $30-35; $10-15

Bottom left: Duncan
Terrace after dinner cup and saucer, with two ashtrays, crystal. $35-45; $25-30 each

Bottom right: Fostoria
Mayfair ebony 7-inch plates. $15-20 each

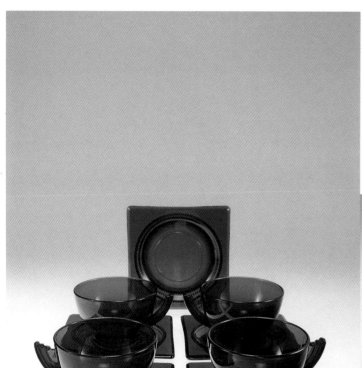

Top: Duncan
Terrace creamer and sugar, no lid, cobalt. $100-125 set; $150-175 with lid

Bottom: Detail of handle.

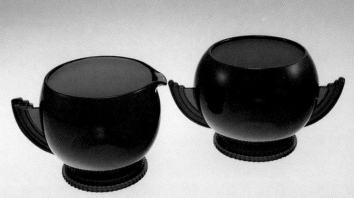

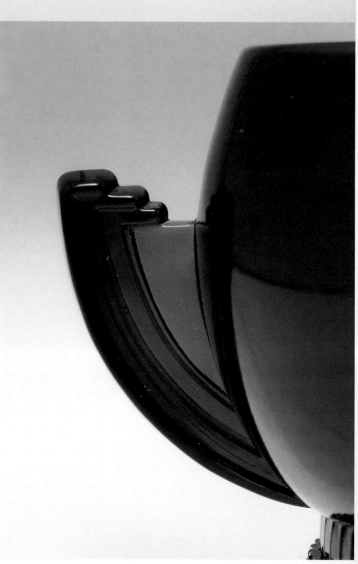

Top: Duncan
Terrace cups and saucers, and plate, cobalt. $50-75; $30-40

Bottom: Detail of terraced base.

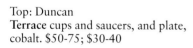

Duncan
Terrace red creamer and sugar with lid. $150-200 set

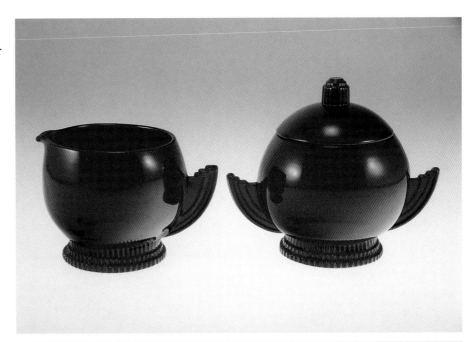

Duncan
Terrace sugar with lid and creamer. $50-75 set

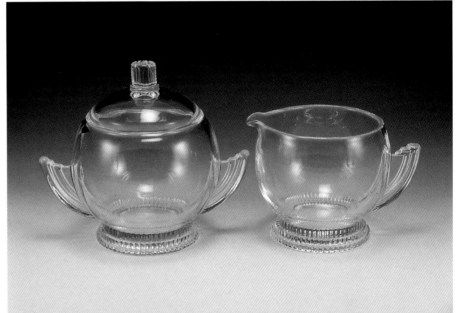

Fostoria
#4020 ebony base creamer and sugar with **Comet** cutting, 3-1/2 inches high, designed by George Sakier; with matching 7-ounce low sherbet and footed tumbler. $35-45 each piece

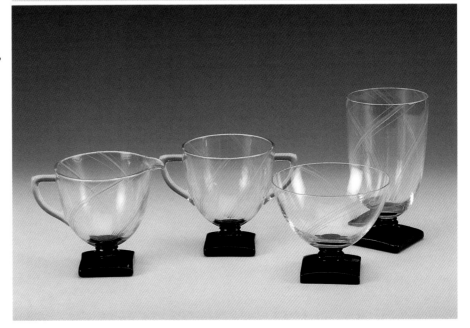

Feb. 1, 1938. R. A. KELLY Des. 108,205
CUP OR SIMILAR ARTICLE
Filed Nov. 11, 1937

Fig. 1

Fig. 2

INVENTOR
Robert A. Kelly
By Thomas B. Miller
his attorney

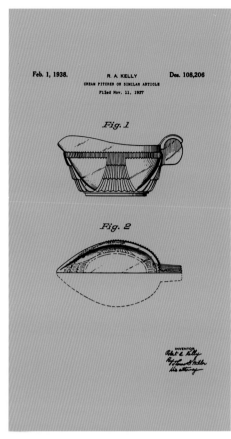

Feb. 1, 1938. R. A. KELLY Des. 108,206
CREAM PITCHER OR SIMILAR ARTICLE
Filed Nov. 11, 1937

Fig. 1

Fig. 2

INVENTOR
Robert A. Kelly
By Thomas B. Miller
his attorney

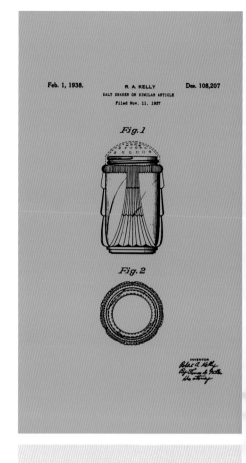

Feb. 1, 1938. R. A. KELLY Des. 108,207
SALT SHAKER OR SIMILAR ARTICLE
Filed Nov. 11, 1937

Fig. 1

Fig. 2

INVENTOR
Robert A. Kelly
By Thomas B. Miller
his attorney

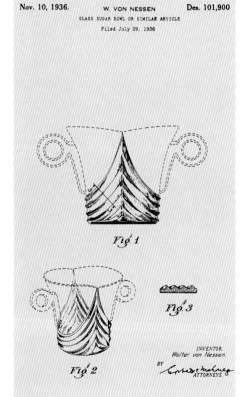

Nov. 10, 1936. W. VON NESSEN Des. 101,900
GLASS SUGAR BOWL OR SIMILAR ARTICLE
Filed July 29, 1936

Fig. 1

Fig. 3

Fig. 2

INVENTOR.
Walter von Nessen.
BY
ATTORNEYS.

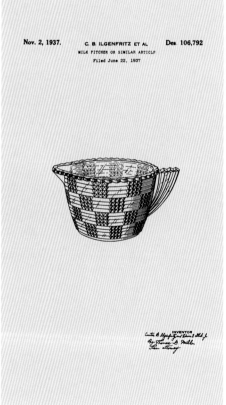

Nov. 2, 1937. C. B. ILGENFRITZ ET AL Des. 106,792
MILK PITCHER OR SIMILAR ARTICLE
Filed June 22, 1937

INVENTOR
By Thomas B. Miller
his attorney

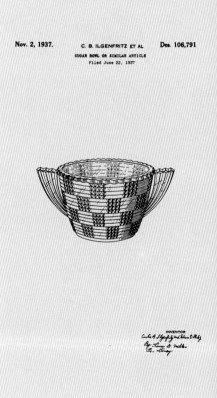

Nov. 2, 1937. C. B. ILGENFRITZ ET AL Des. 106,791
SUGAR BOWL OR SIMILAR ARTICLE
Filed June 22, 1937

INVENTOR
By Thomas B. Miller
his attorney

58

Opposite page:
Top left: United States Patent Office drawing of Tiffin **Cascade** cup, designed by Robert A. Kelly, filed November 11, 1937.

Top center: United States Patent Office drawing of Tiffin **Cascade** cream pitcher, designed by Robert A. Kelly, filed November 11, 1937.

Top right: United States Patent Office drawing of Tiffin **Cascade** salt shaker, designed by Robert A. Kelly, filed November 11, 1937.

Bottom left: United States Patent Office drawing of Heisey **Stanhope** creamer, designed by Walter von Nessen, filed July 29, 1936.

Bottom center: United States Patent Office drawing of Tiffin **Basquette** #15364 milk pitcher, designed by Curtis B. Ilgenfritz et al, filed June 22, 1937.

Bottom right: United States Patent Office drawing of Tiffin **Basquette** #15364 sugar bowl, designed by Curtis B. Ilgenfritz et al, filed June 22, 1937.

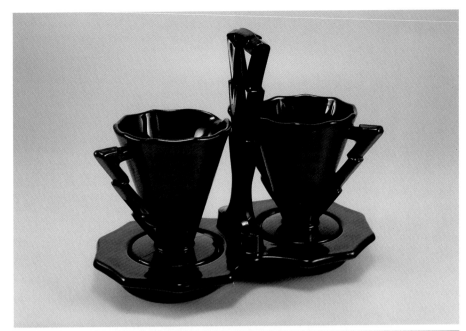

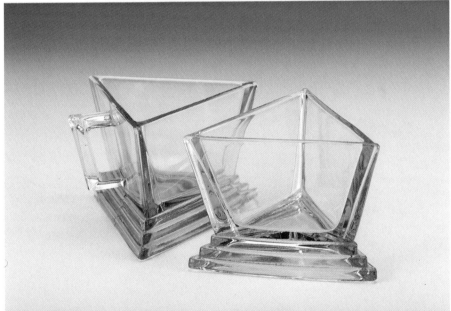

Top: Cambridge **Decagon** creamer, sugar, and 6-1/2 inch stand, all ebony. $70-90

Center: New Martinsville **Modernistic** #33 pink creamer and sugar, triangular form on stepped base, 2-3/4 inches high. $40-60 set

Bottom: Co-Operative Flint Turquoise creamer and sugar; Art Deco style with strong traditional influence. $30-40 set

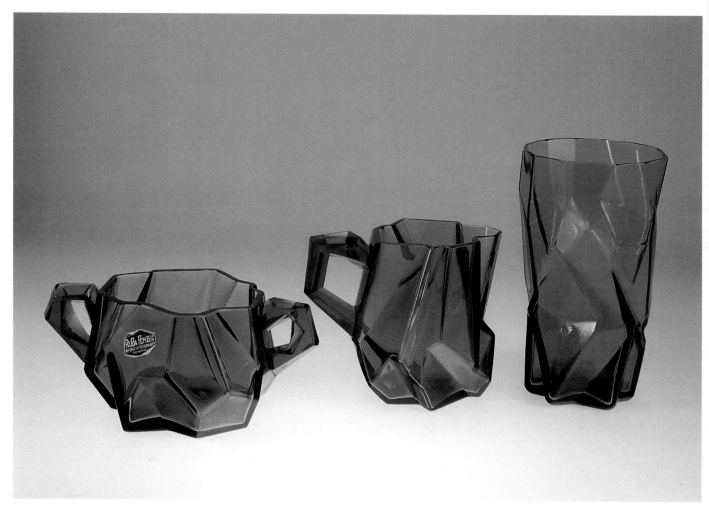

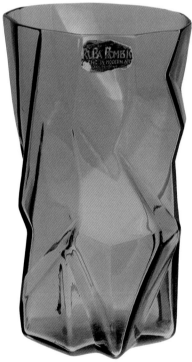

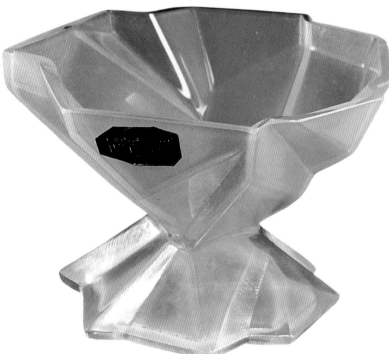

Top: Consolidated
Ruba Rombic sugar, creamer, and tumbler in smokey topaz. $500-700 set; $175-200

Bottom left: Consolidated
Ruba Rombic jungle green tumbler. $175-200

Bottom right: Consolidated
Ruba Rombic sunshine sundae. $225-275

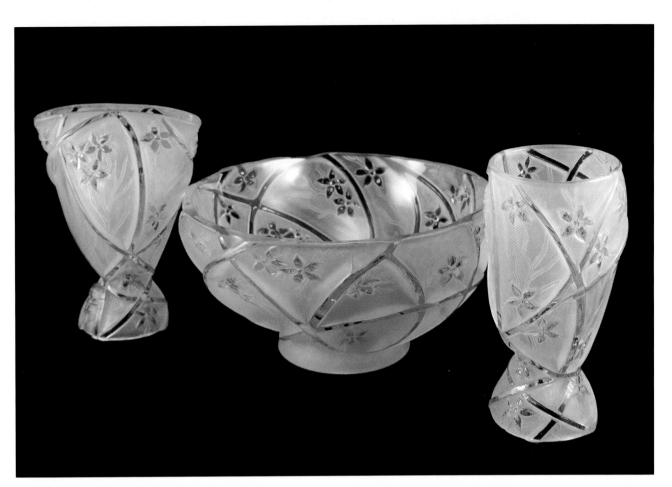

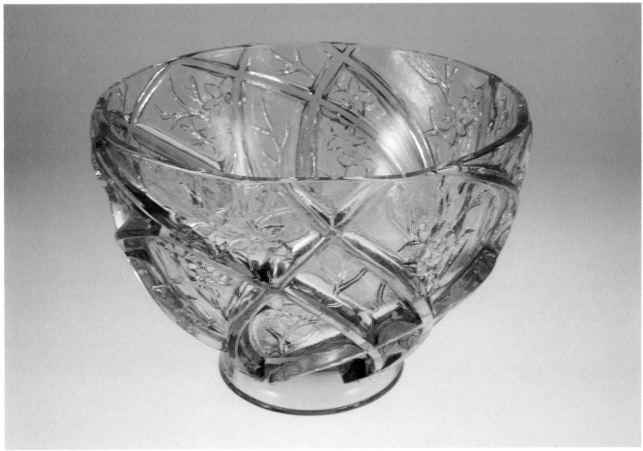

Top: Consolidated
Line 700 tan wash: 6-1/2 inch fan vase, 8-1/2 inch salad/fruit
bowl, and 10-ounce goblet. $80-100; $225-250; $80-100

Bottom: Consolidated
Line 700 blue punch bowl. $400-500

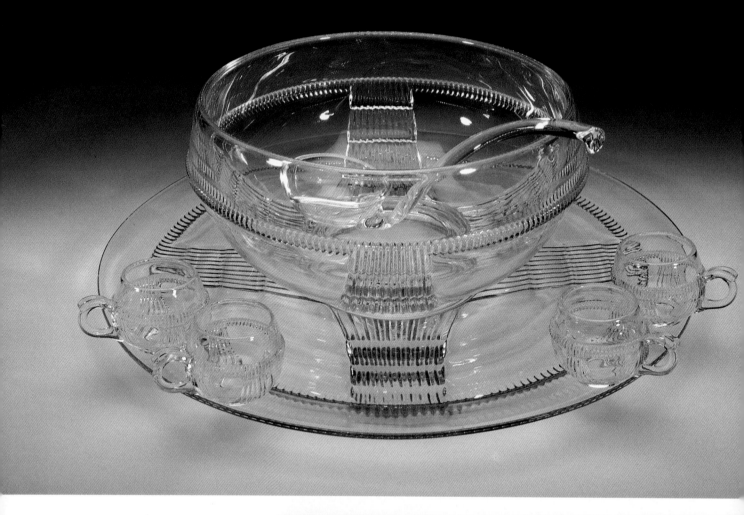

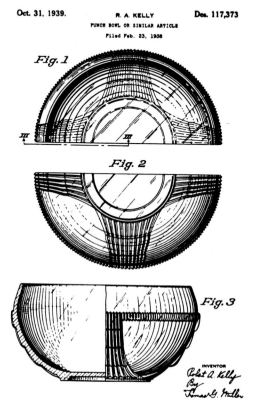

Oct. 31, 1939. R. A. KELLY Des. 117,373
 PUNCH BOWL OR SIMILAR ARTICLE
 Filed Feb. 23, 1938

Fig. 1

Fig. 2

Fig. 3

INVENTOR
Robert A. Kelly
By
Thomas G. Miller

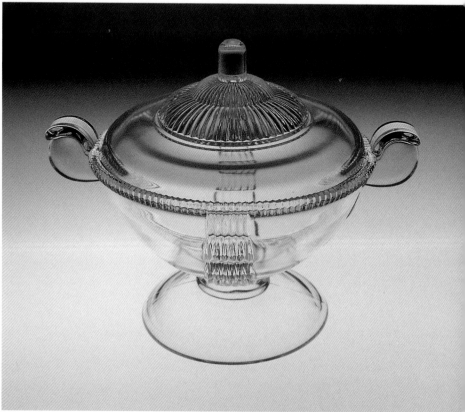

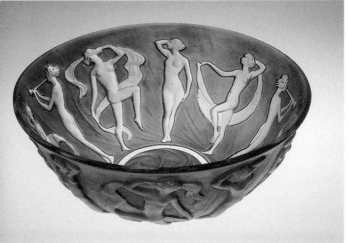

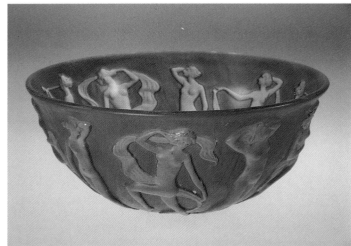

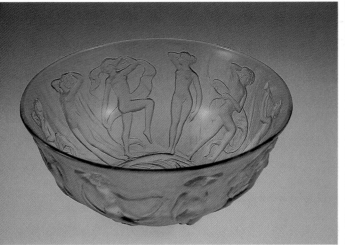

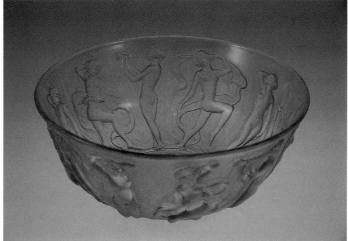

Top: Phoenix
Dancing Nymph Reuben line 8-inch master berry bowl. $450-600

Bottom: Consolidated
Dancing Nymph frosted teal green 8-inch master berry bowl. $275-325

Top: Another view.

Bottom: Consolidated
Dancing Nymph frosted pink 8-inch master berry bowl. $300-350

Opposite page:
Top: Tiffin
Cascade #15365 12-1/2 inch punch bowl on 12-inch plate, with punch cups. $100-125; $65-85; $10-15 each

Bottom left: United States Patent Office drawing of Tiffin
Cascade punch bowl, designed by Robert A. Kelly, filed February 23, 1938.

Bottom right: Tiffin
Cascade 9-inch cookie jar with cover. $100-125

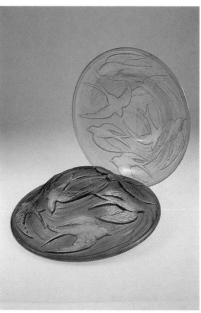

Consolidated
Swallows 9-inch bowls
showing interior (honey)
and exterior (dark
amethyst). $225-250 each

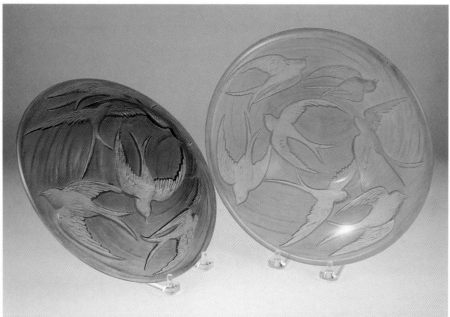

Consolidated
Swallows 9-inch bowls showing
interior (blue) and exterior
(sepia). $225-250 each

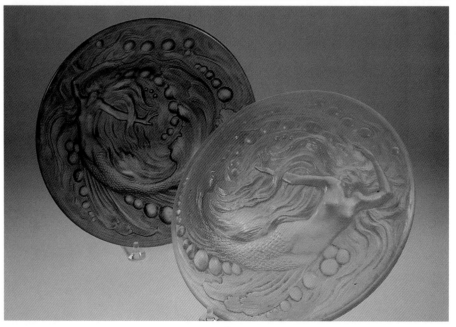

Consolidated
Mermaid 9-inch bowls showing
interior (sepia) and exterior
(amber). $350-400 each

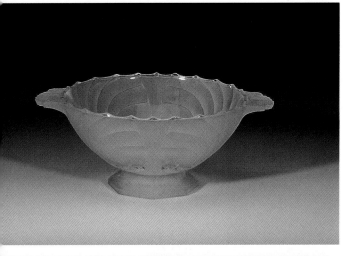

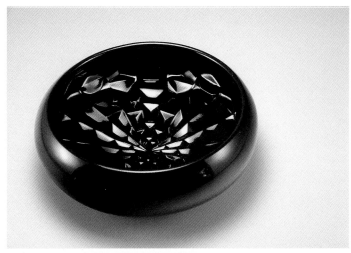

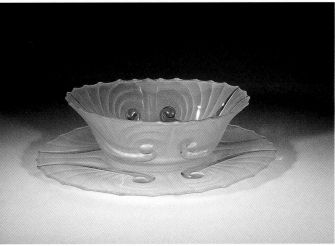

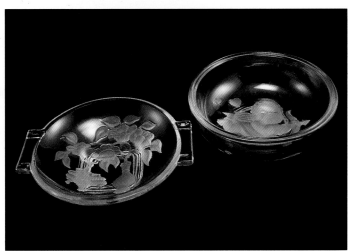

Top left: Tiffin
Velva crystal 7-3/4 inch handled bowl with satin finish. $45-65

Top right: Central
Frances black 5-inch candy dish with cubist pattern inside. $30-50

Center left: Tiffin
Velva crystal 11-inch oval bowl on 15-inch oval liner plate, satin finish. $85-115; 75-95

Center right: Verlys
Motif Chinois 6-1/2 inch handled dish; **Cupidon** 6-inch bowl, designed by Viktor Schreckengost. $100-125 each

Bottom right: Detail of **Cupidon**.

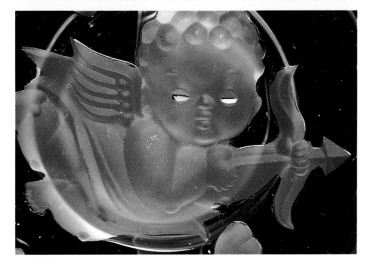

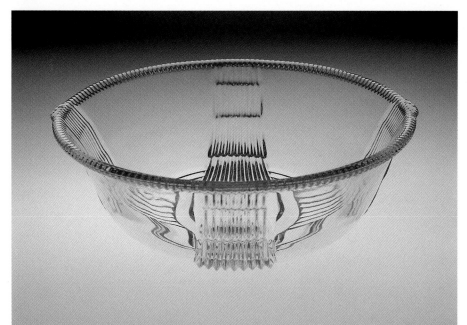

Tiffin
Cascade #15365 9-inch crystal
salad bowl. $40-60

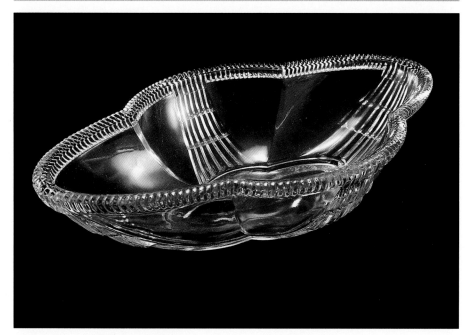

Tiffin
Cascade #15365 14-inch crystal
centerpiece/serving bowl. $40-60

United States Patent Office
drawing of Tiffin **Cascade**
salad bowl, designed by
Robert A. Kelly, filed
November 11, 1937.

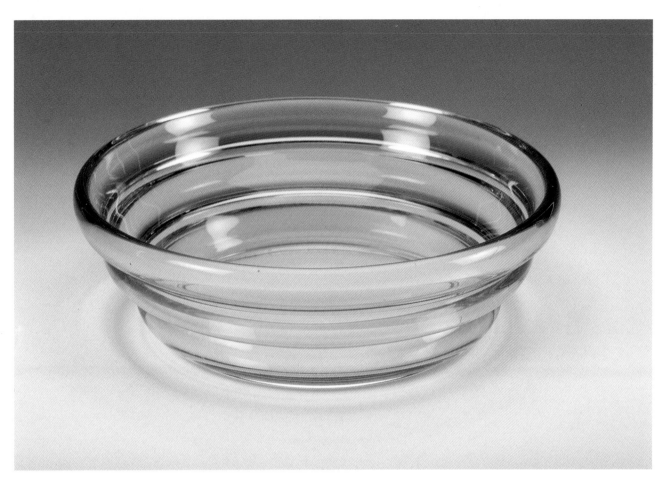

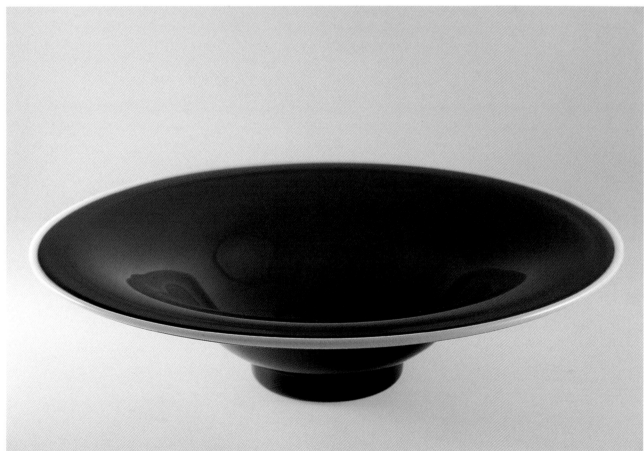

Top: Fostoria
Spool #2550, designed by George Sakier, round 9-1/2 inch salad bowl in gold tint. $100-125

Bottom: Morgantown
Janice #4355 13-1/2 inch console bowl, **Old Bristol** line - ritz blue with alabaster trim. $600-650

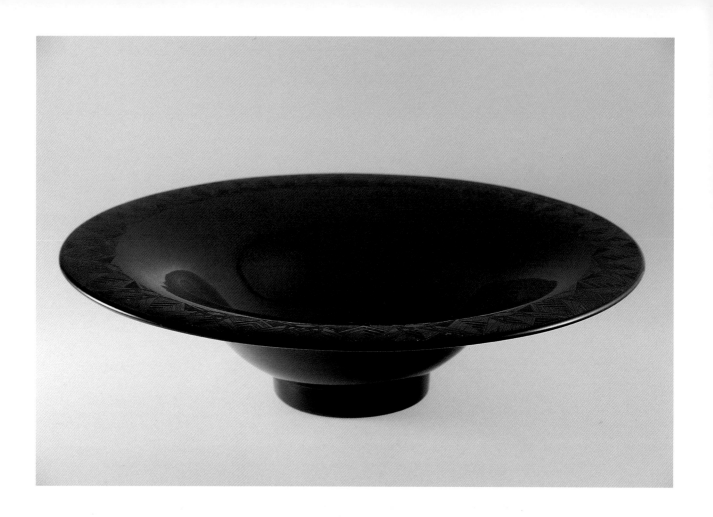

Top: Morgantown
Janice #4355 13-1/2 inch console bowl, ritz blue with **Le Mons** etching. $350-400

Bottom: Detail of **Le Mons.**

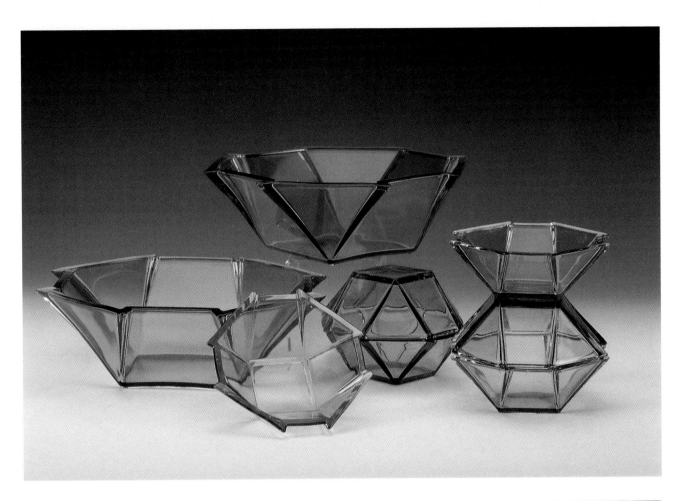

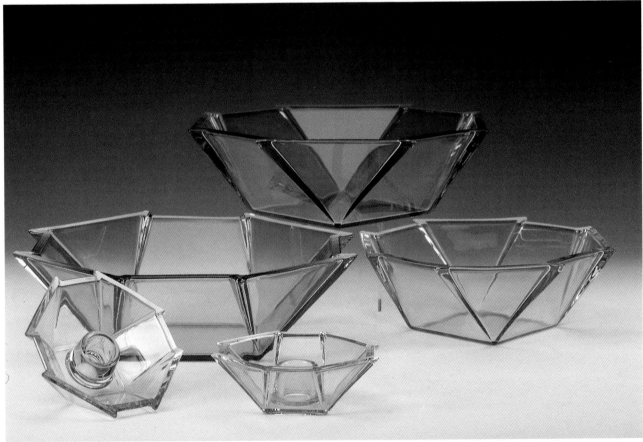

Top: Fostoria
#2402 geometric bowls, designed by George Sakier: 4-inch and 8-1/2 inch assortment in amber. $25-35; $60-90

Bottom: Fostoria
#2402 geometric bowls: rose 10-inch bowl; rose 8-1/2 inch bowl; azure 8-1/2 inch bowl (shown with pink candleholders). $100-150; $70-90; $75-100

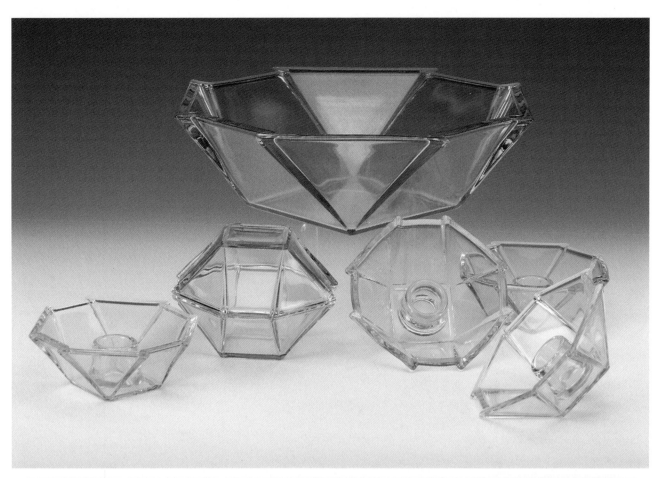

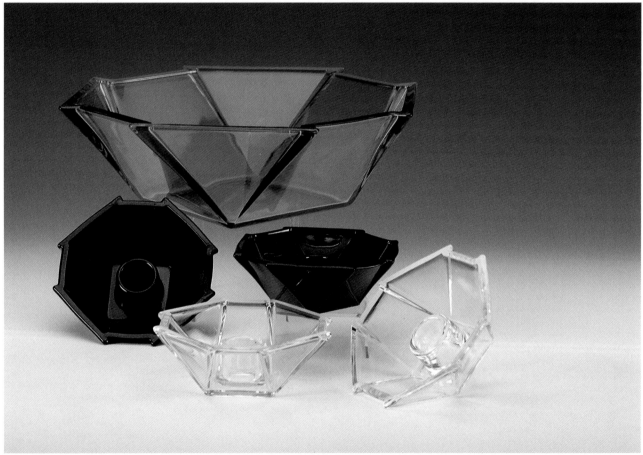

Top: Fostoria
#2402 geometric bowls: gold tint 10-inch and 4-inch bowls
(with candleholders). $90-140; $25-35

Bottom: Fostoria
#2402 green 10-inch geometric bowl (shown with candle-
holders). $100-150

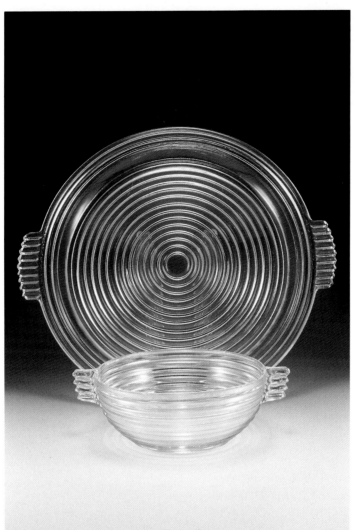

Anchor Hocking
Manhattan crystal 14-inch
handled relish tray with 9-1/2
inch handled bowl. $20-25;
$15-20

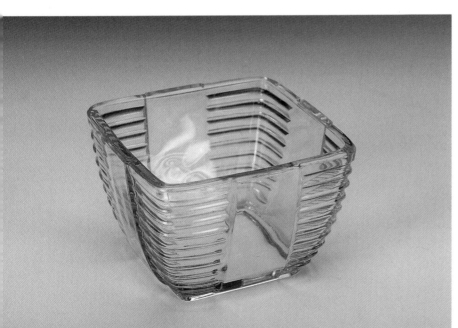

Fostoria
Quadrangle bowl, azure. $30-35

United States Patent Office
drawing of Fostoria **Quadrangle**
bowl, filed by Findley Williams
on November 11, 1936.

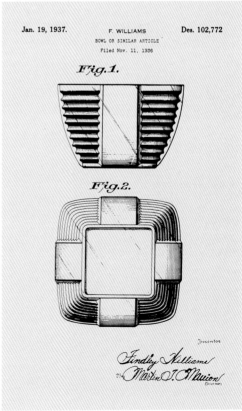

Jan. 19, 1937. F. WILLIAMS Des. 102,772
BOWL OR SIMILAR ARTICLE
Filed Nov. 11, 1936

Fig.1.

Fig.2.

Inventor

Findley Williams
Martin J. Marion
Attorney

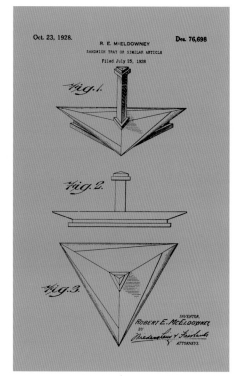

Top: United States Patent Office drawing of Tiffin **Cascade** relish tray, designed by Robert A. Kelly, filed November 11, 1937.

Bottom: United States Patent Office drawing of Tiffin **Cascade** salad plate, designed by Robert A. Kelly, filed December 2, 1937.

Top: United States Patent Office drawing of Tiffin **Cascade** tray, designed by Robert A. Kelly, filed November 11, 1937.

Bottom: United States Patent Office drawing of Heisey **Stanhope** plate, designed by Walter von Nessen, filed July 29, 1936.

Top: United States Patent Office drawing of Tiffin **Cascade** tray, designed by Robert A. Kelly, filed December 2, 1937.

Bottom: United States Patent Office drawing of New Martinsville **Modernistic** sandwich tray, designed by Robert E. McEldowney, filed July 25, 1928.

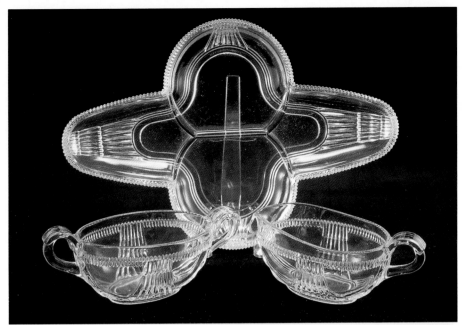

Tiffin
Cascade #15365 crystal 12-inch divided relish tray with four lobes, with sugar and creamer. $40-60; $25-35 each

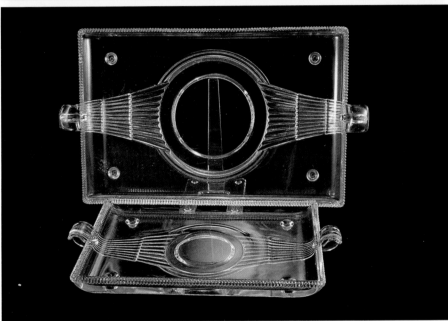

Tiffin
Cascade crystal hostess trays; top 14-3/4 inch, bottom 11-1/2 inch. $45-65 each

Nov. 2, 1937. C. B. ILGENFRITZ ET AL Des. 106,794
COMBINED BUTTER AND ALMOND TUB OR SIMILAR ARTICLE
Filed June 22, 1937

United States Patent Office drawing of Tiffin **Basquette** #15364 butter tub, designed by Curtis B. Ilgenfritz et al, filed June 22, 1937.

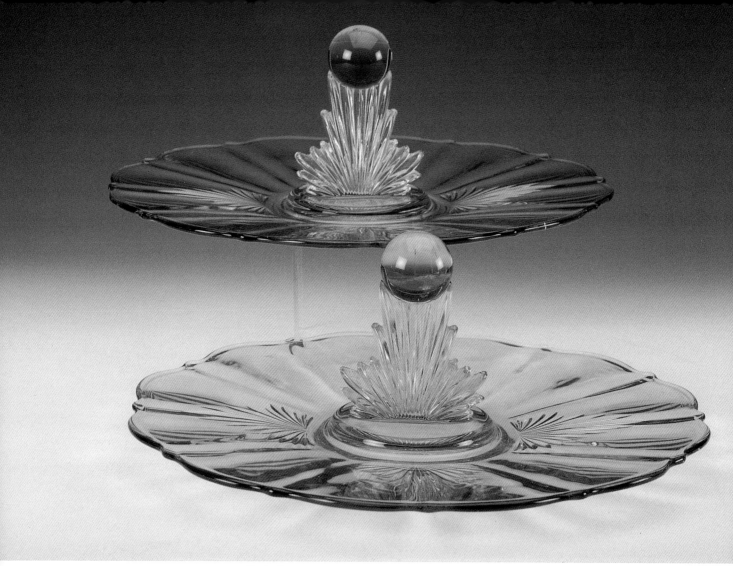

Fostoria
Flame #2545, by George Sakier: 11-1/2 inch handled
lunch trays in crystal and gold tint. $75-100

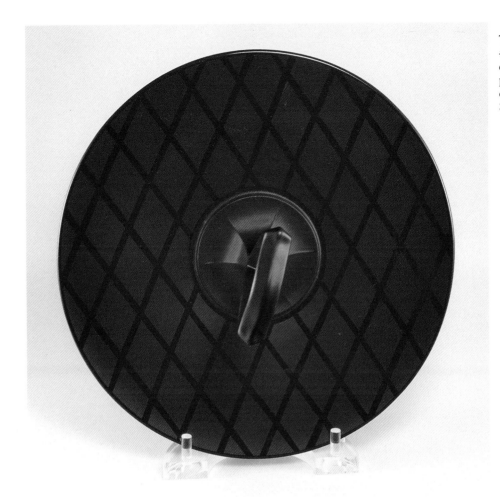

Tiffin
#178 10-inch
center handled cake
plate with **Kimberly**
decoration on ruby.
$175-200

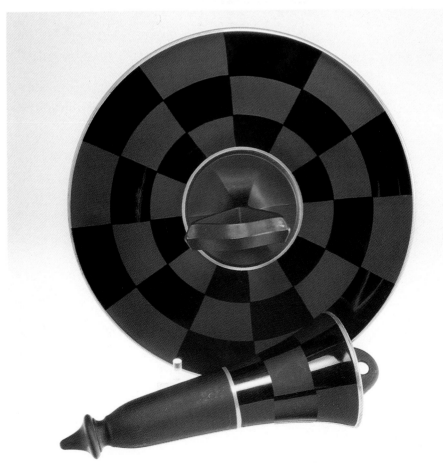

Tiffin
#15320 10-inch
center handled cake
plate with checker-
board **Echec**
decoration, with
matching
wallpocket. $100-
125; $110-135

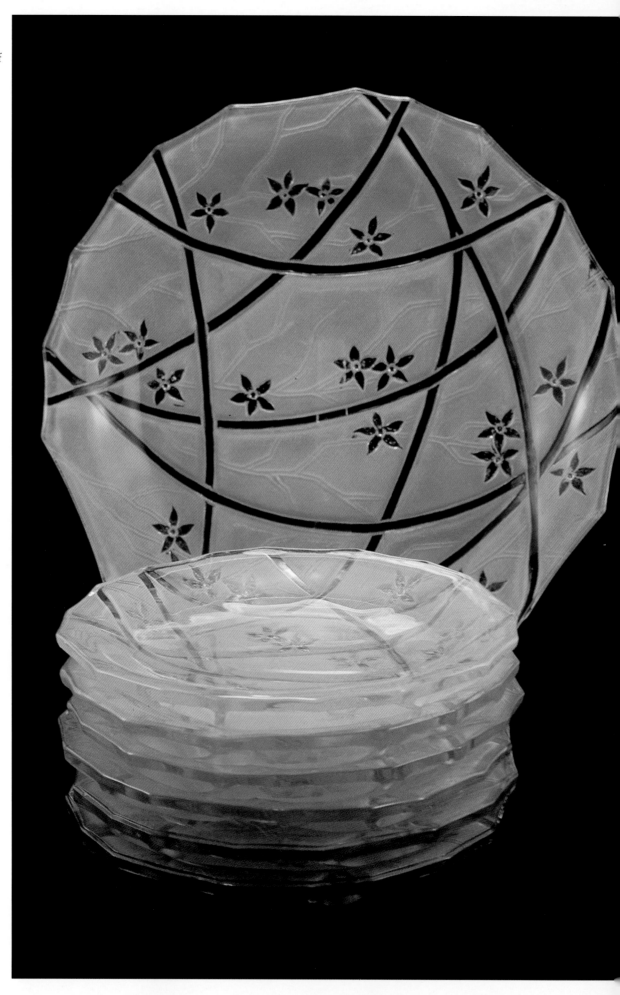

Consolidated **Line 700** 10-inch plate with stack of 6-inch plates, green stain. $85-100; $40-50 each

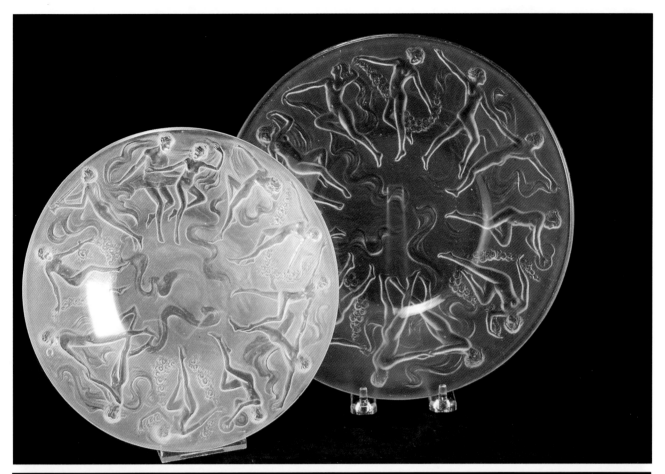

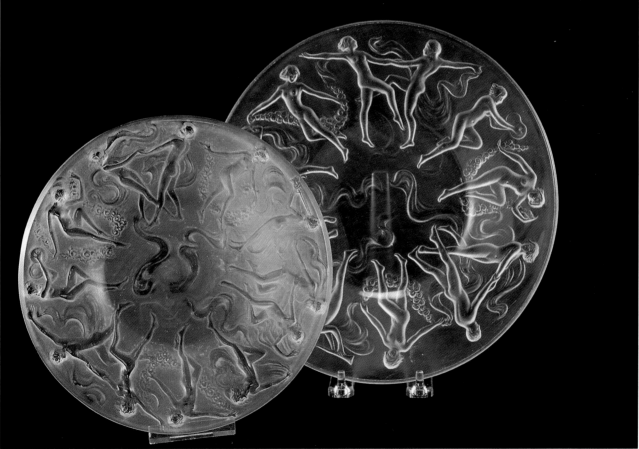

Top: Consolidated
Dancing Nymph light green 8-inch plate with pink 10-in plate.
$100-125; $200-250

Bottom: Consolidated
Dancing Nymph light blue 8-inch plate with frosted crystal
10-inch plate. $100-125; $150-175

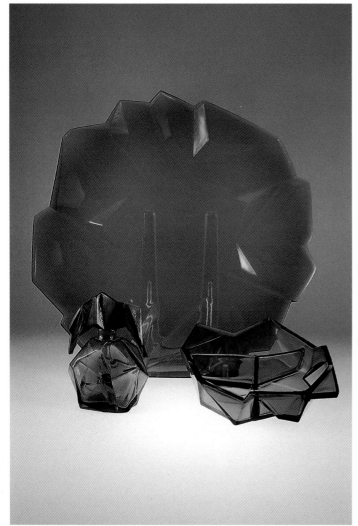

Consolidated
Ruba Rombic smokey topaz: 15-inch charger; 4-3/4 inch scent bottle; 8-inch 3-part bonbon. $800-1500; $1200-1500; $325-375

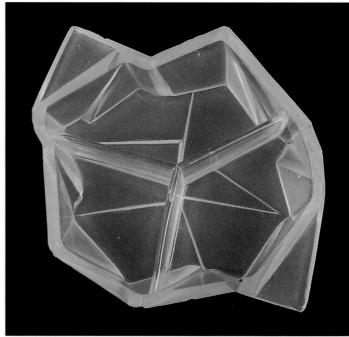

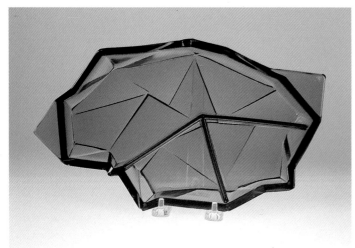

Consolidated
Ruba Rombic jungle green 12-inch 3-part relish. $800-1000

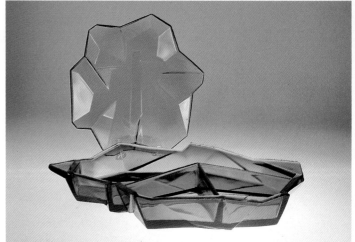

Top: Consolidated
Ruba Rombic sunshine 8-inch 3-part bonbon. $400-450

Bottom: Consolidated
Ruba Rombic jungle green 8-inch plate and 12-inch 3-part relish. $150-175

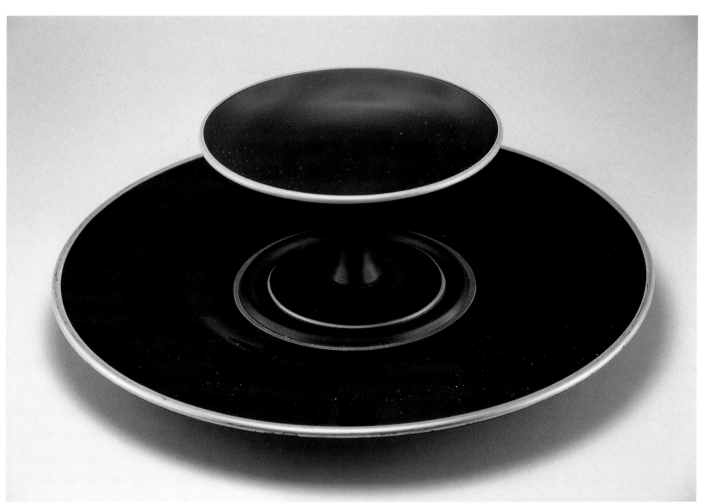

Tiffin
#320 black cheese dish on 10-inch cracker plate with center indentation and **Echec** decoration. $100-125

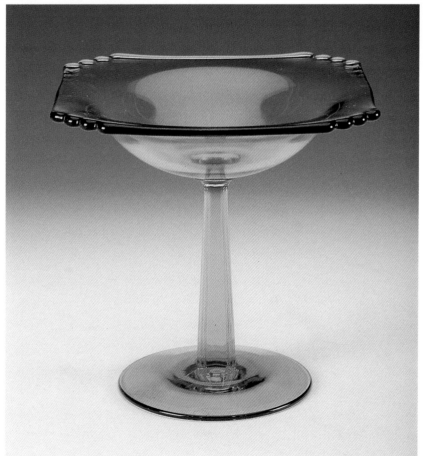

Fostoria
Mayfair #2419, designed by George Sakier, green 5-1/2 inch compote. $50-65

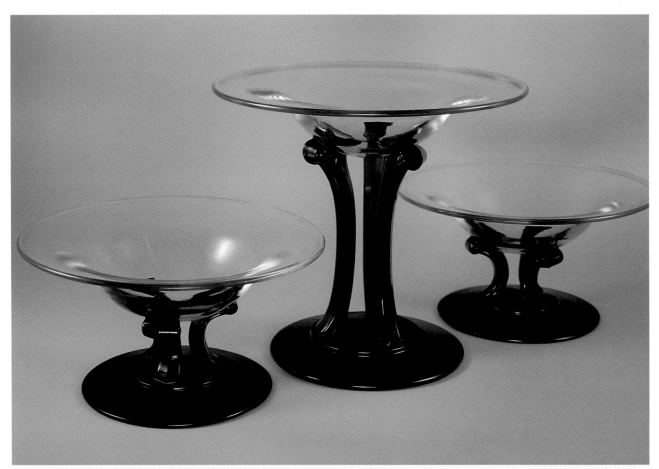

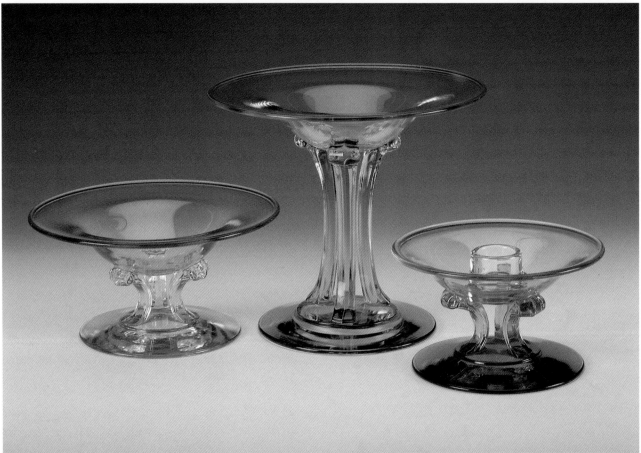

Top: Fostoria
#2433 3-inch and 6-inch compotes, designed by George Sakier, crystal with ebony base. $50-75 each

Bottom: Fostoria
#2433 3-inch compote with gold tint bowl and crystal base; 6-inch compote with crystal bowl and green base; with candle holder. $50-75 each

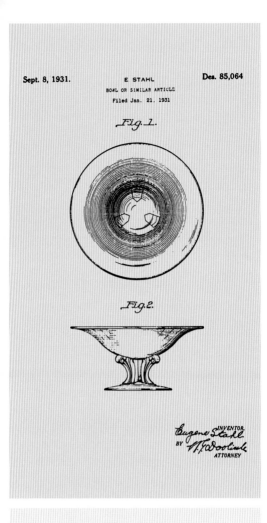

Sept. 8, 1931. E STAHL Des. 85,064

BOWL OR SIMILAR ARTICLE
Filed Jan. 21, 1931

Fig.1.

Fig.2.

INVENTOR.
Eugene Stahl
BY
M.F.Doolittle
ATTORNEY.

April 2, 1940. E. W. FUERST Des. 119,745

COMPORT
Filed Jan. 26, 1940

Fig.1.

Fig.2.

F. W Fuerst
INVENTOR
BY Rule & Hoge
ATTORNEYS

Top left: United States Patent Office drawing of Fostoria **#2433** footed bowl, designed by George Sakier, patent filed by Eugene Stahl January 21, 1931.

Top right: United States Patent Office drawing of Libbey compote, designed by E. W. Fuerst, filed January 26, 1940.

April 2, 1940. E. W. FUERST Des. 119,746

BOWL OR SIMILAR ARTICLE
Filed Jan. 26, 1940

Fig.1.

Fig.2.

E.W Fuerst
INVENTOR
BY Rule & Hoge
ATTORNEYS

June 25, 1929. R. E. McELDOWNEY Des. 78,835

COMPOTE OR SIMILAR ARTICLE
Filed Dec. 24, 1928

Fig.1.

Fig.2.

Fig.3.

INVENTOR:
ROBERT E. McELDOWNEY
BY Medersheim &
Fairbanks
ATTORNEYS.

Bottom left: United States Patent Office drawing of Libbey footed bowl, designed by E. W. Fuerst, filed January 26, 1940.

Bottom right: United States Patent Office drawing of New Martinsville **Modernistic** compote, designed by Robert E. McEldowney, filed December 24, 1928.

Vases

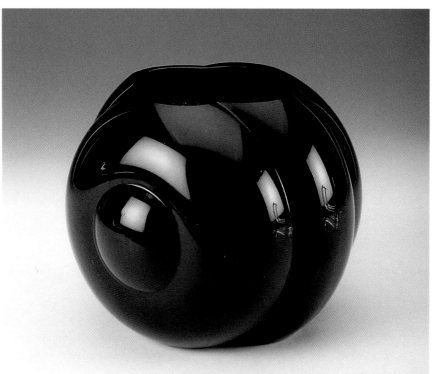

Fostoria
#2404 "fishbowl" vase, a Sakier design, in ebony, 6-1/2 inch diameter. $150-250

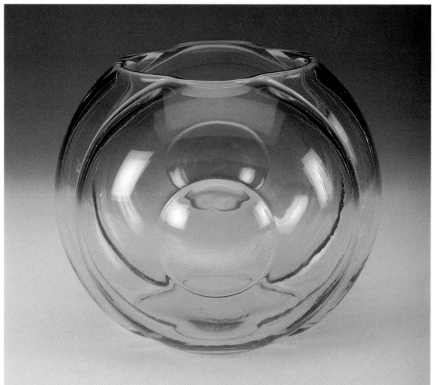

Fostoria
#2404 "fishbowl" vase, in gold tint, 6-1/2 inch diameter. $150-250

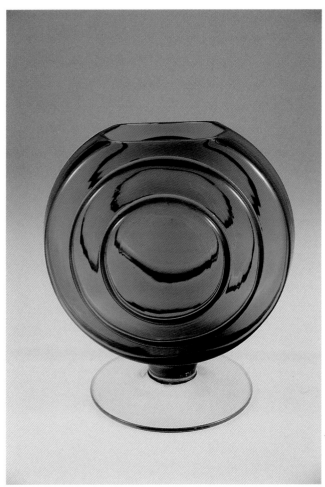

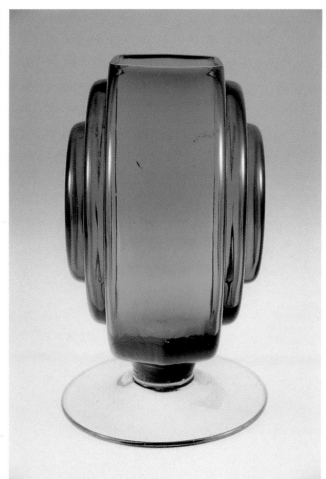

Top left: Morgantown
#73 6-inch **Radio** vase, Stiegel green with crystal foot.
$250-300

Top right: Side view.

Bottom right: Three-quarter view.

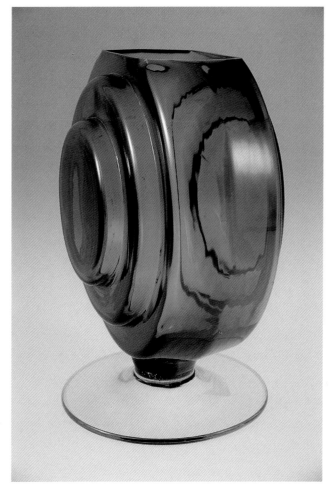

Fostoria
#2409 8-inch
vase, an Art Deco
Sakier design,
ebony produced
through 1950s.
$200-250

#2409 8-inch
vase in green
(shown with
ebony). $200-250

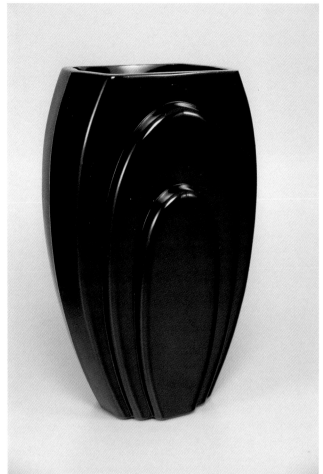
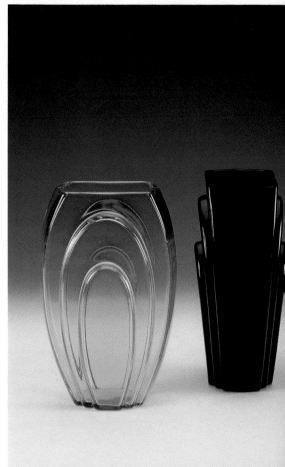

Possibly
Morgantown
Stiegel green
angular 8-inch
vase. $200-250

Three-quarter
view.

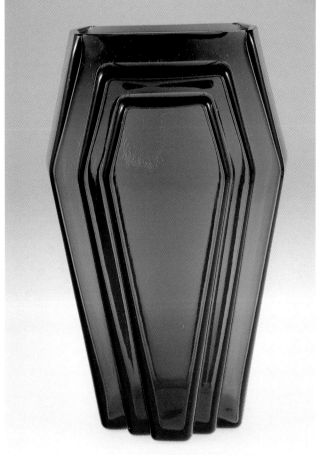
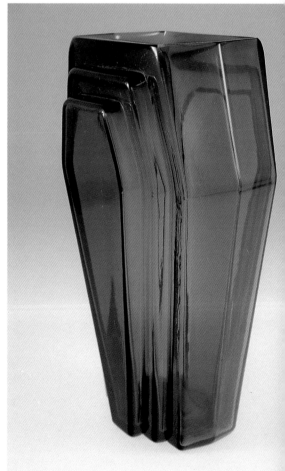

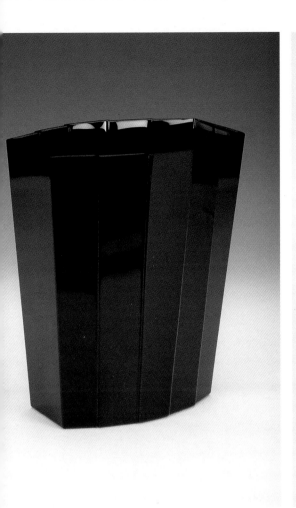

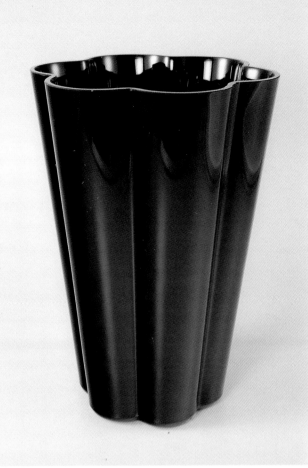

Top left: Fostoria **#2425** rectilinear vase, a Sakier design, ebony. $250-300

Top right: Fostoria **#2387** flared and scalloped vase, by Sakier, in ebony. $200-250

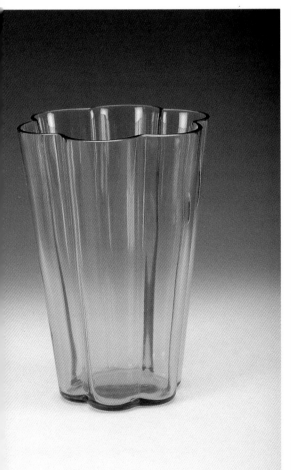

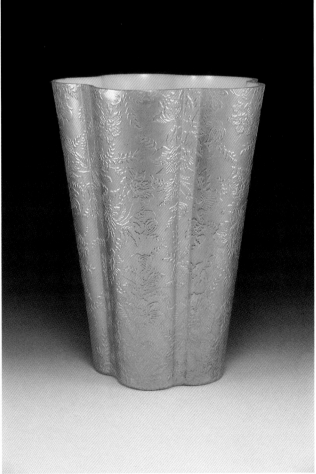

Bottom left: **#2387** in green. $200-250

Bottom right: Consolidated Rare **L'Ora** flared and scalloped 8-1/4 inch vase, with **#2202** shape and gold finish, gold L'Ora signature on base. $600-800

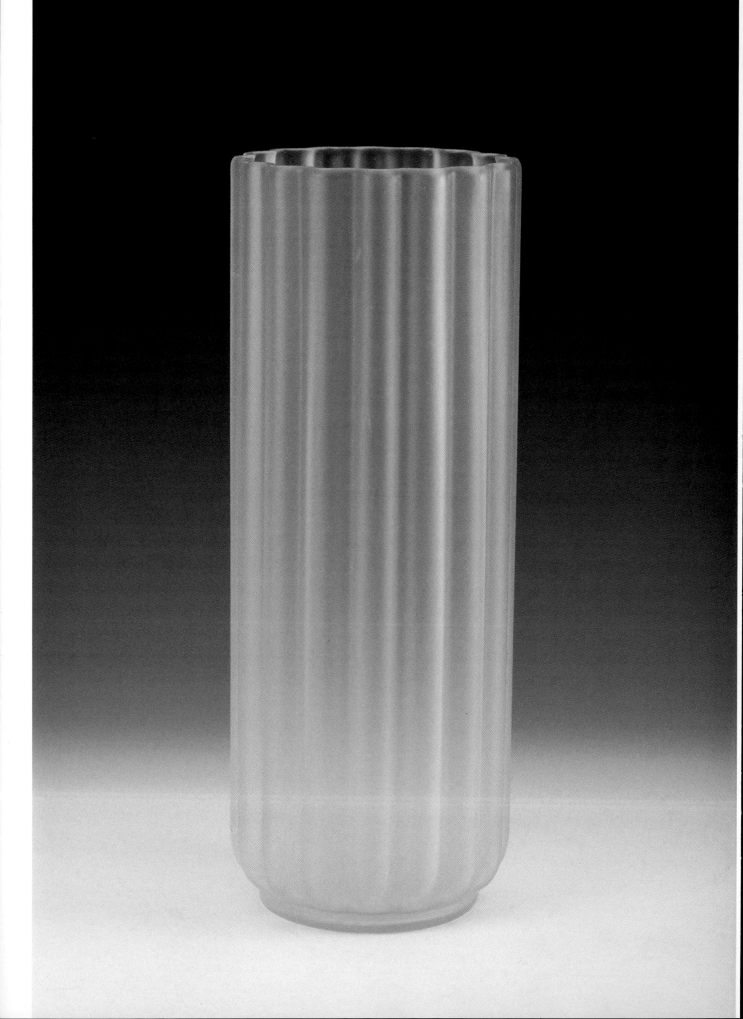

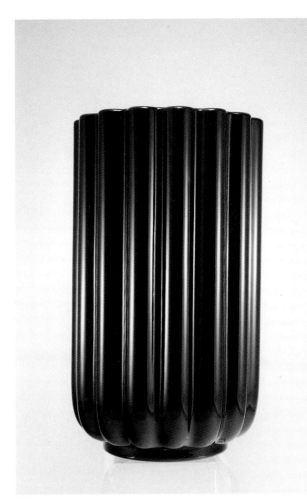

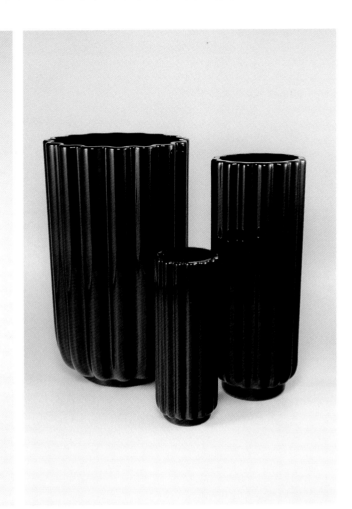

Top left: Fostoria
#2428 ebony **Lotus** vase. $ 250-275

Top right: Fostoria
#2428 ebony **Lotus** vases, 10-inch (left), 6-1/4
inch (center), 9-1/4 inch (right). $150-325

Bottom right: New Martinsville
Black vase with slightly bulbous sides. $75-100

Opposite page:
Fostoria
#2428 13-inch **Lotus** vase in silver mist, a Sakier design.
$400-600

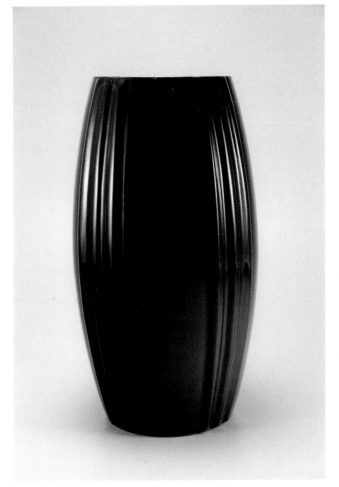

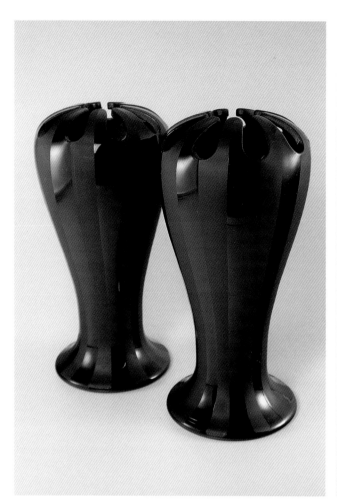

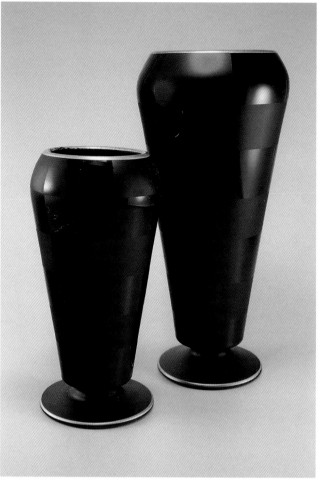

Top left: Tiffin
#16261 8-1/2 inch flower holders with **Satin Ribbon** decoration. $100-125 each

Top right: Tiffin
#15151 8-inch and 10-1/2 inch cupped dahlia vases with **Echec** decoration. $100-125; $125-150

Bottom left: Tiffin
#15151 8-inch cupped dahlia vase with **Satin Ribbon** decoration. $100-125

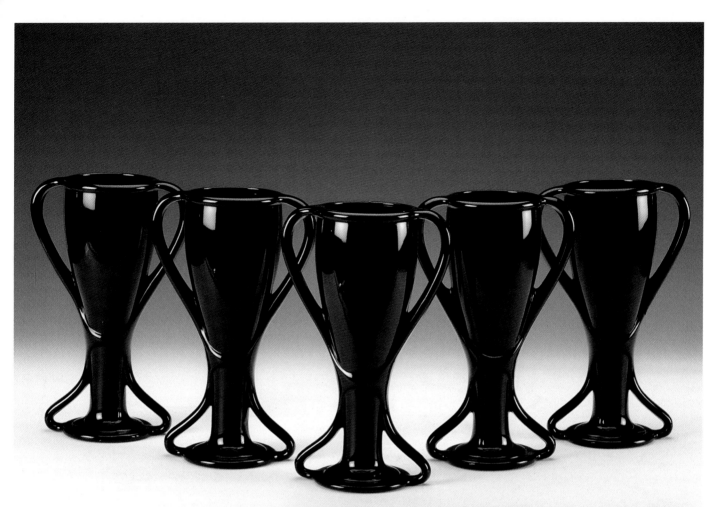

Fostoria
Tut #2288 vases in ebony. $60-80 each

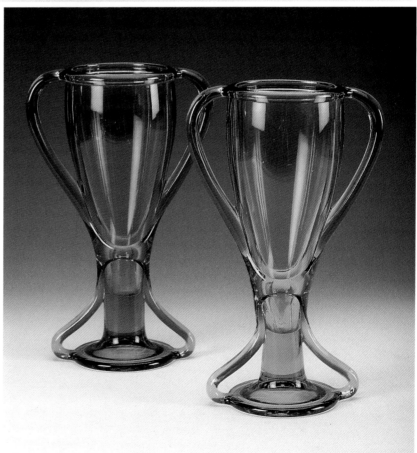

Fostoria
Tut vases in amber and green. $60-80 each

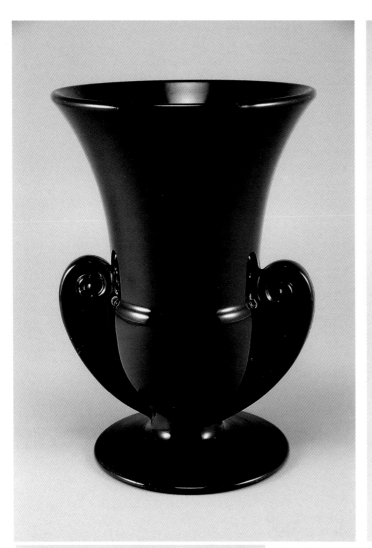

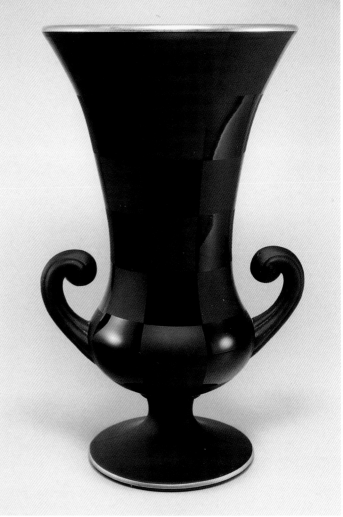

May 26, 1936. T. C. HEISEY Des. 99,798

GLASS VASE OR SIMILAR ARTICLE OF GLASSWARE

Filed Feb. 26, 1936

Fig. 1 Fig. 3

Fig. 2

INVENTOR.
T. Clarence Heisey.
BY
Larier + Mahoney
ATTORNEYS.

Top left: Fostoria
#2467 7-1/2 inch vase in ebony. $125-150

Top right: Tiffin
#15319 10-inch two handled vase with **Echec** decoration.
$150-175

Bottom left: United States Patent Office drawing of Heisey
Ridgeleigh vase, designed by T. Clarence Heisey, filed February
26, 1936.

Opposite page:
Top left: Heisey
Ridgeleigh #1469-1/2 Sahara 8-inch vase. $100-125

Top right: Morgantown
Opaque yellow bud vase with tapering rings. $150-175

Bottom left: Fostoria
Spool #2550, by Sakier, 6-inch vase in gold tint. $150-175

Bottom right: Dunbar (attributed to)
Cylindrical black 8-1/2 inch vase with five rings. $40-60

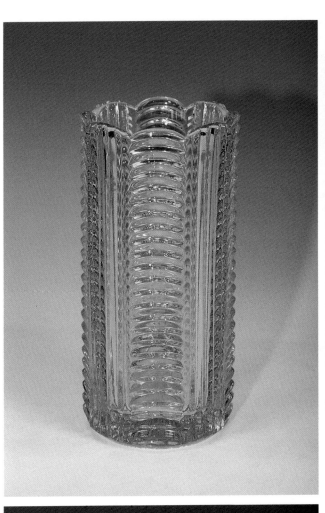

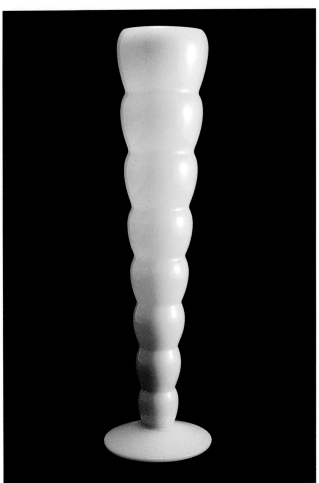

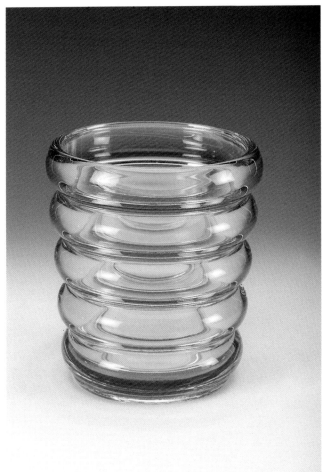

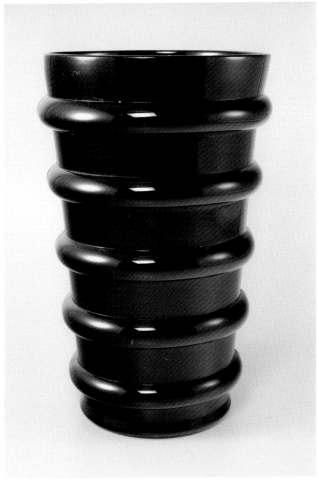

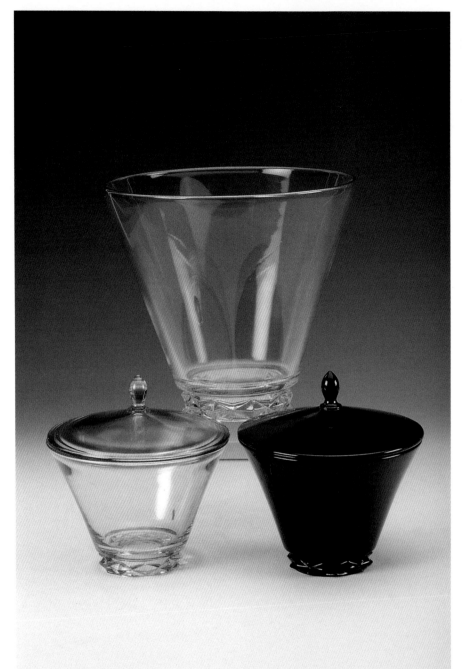

Fostoria
Diadem #2430, a
Sakier design, 6-inch
covered jars in rose
and ebony; with 8-inch
gold tint flared vase.
$80-100; $125-150

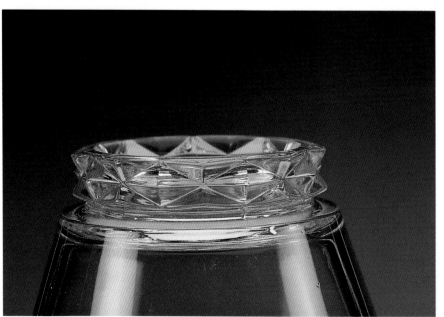

Detail.

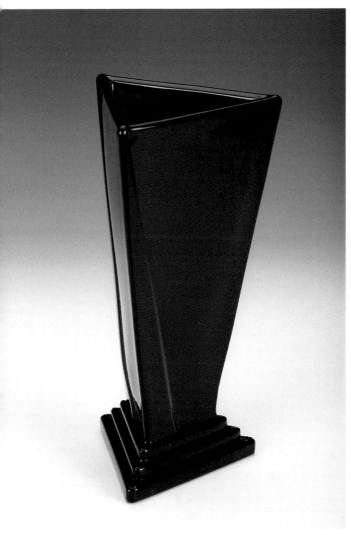

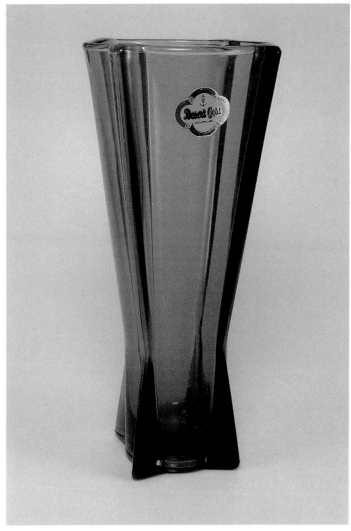

New Martinsville
Modernistic black triangular 8-1/2 inch vase with a
stepped base. $90-120

Anchor Hocking
Desert gold 9-inch **"Rocket vase."** $20-30

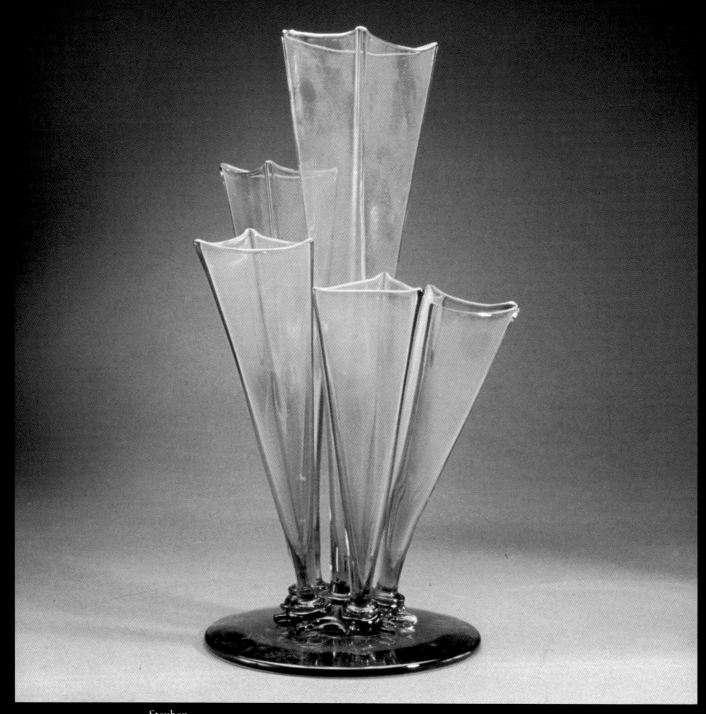

Steuben
#7129 Spanish green 14-1/2 inch six-prong vase, designed by Frederick Carder;
six applied triangular vases on a disc base, with fleur-de-lis mark. *Photo courtesy of Skinner, Inc.* $1000-1500

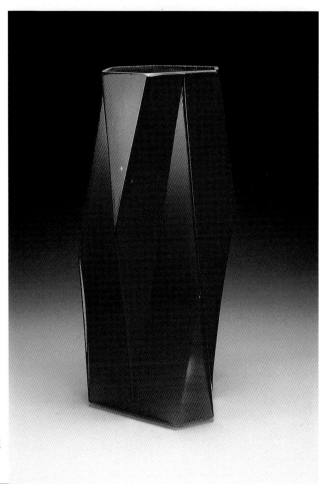

Kopp
Modernistic 6-3/4 inch red
vase. $150-200

Consolidated
Ruba Rombic jungle green and sunshine 6-1/2
inch vases. $700-900; $850-1000

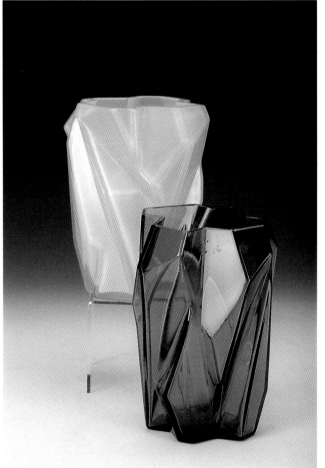

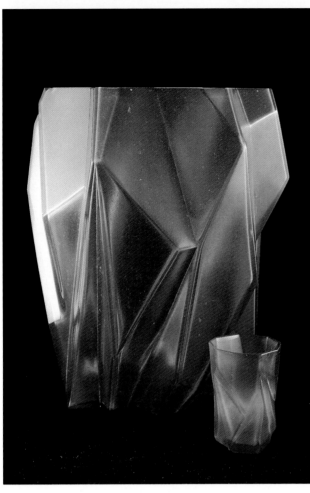

Consolidated
Ruba Rombic 9-inch silver vase;
with lilac shot glass. $1500-2500;
$200-225

Consolidated
Ruba Rombic sunshine 6-1/2
inch vase. $850-1000

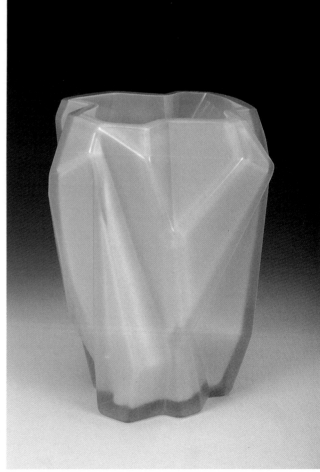

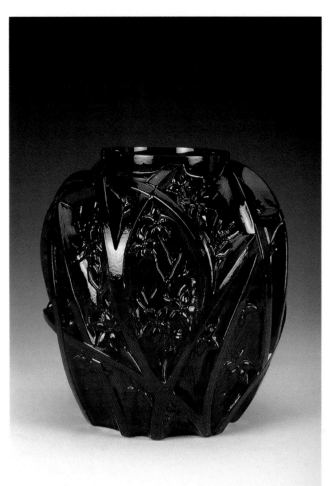

Consolidated
Line 700 red 10-inch vase.
$800-1000

Consolidated
Line 700 red frosted 6-1/2
inch vase. $600-750

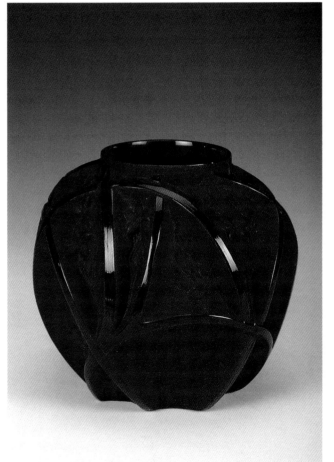

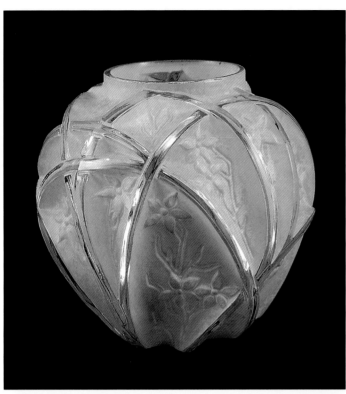

Top left: Consolidated
Line 700 caramel 6-1/2 inch vase. $195-225

Top right: Consolidated
Line 700 blue 6-1/2 inch vase; with candle holder. $300-350; $50-70

Bottom: Consolidated
Line 700 6-1/2 inch vase in red stain on crystal, with coronation blue vase; (with sundae). $200-250; $125-150

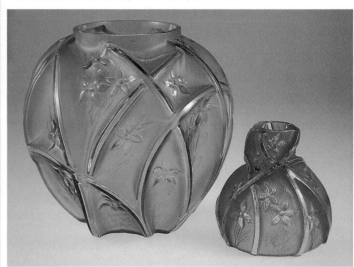

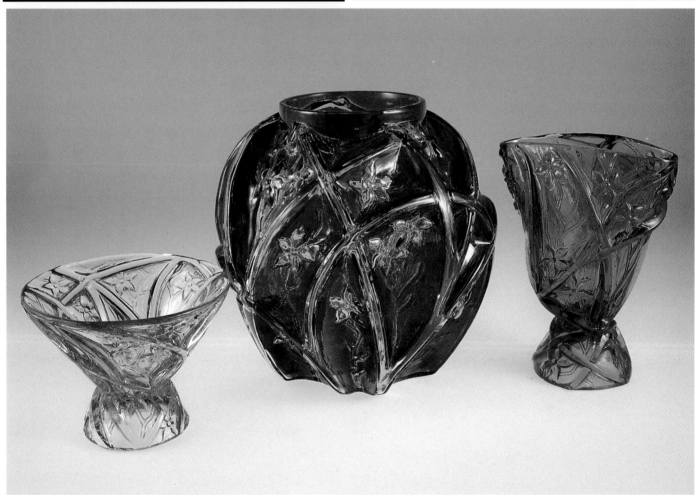

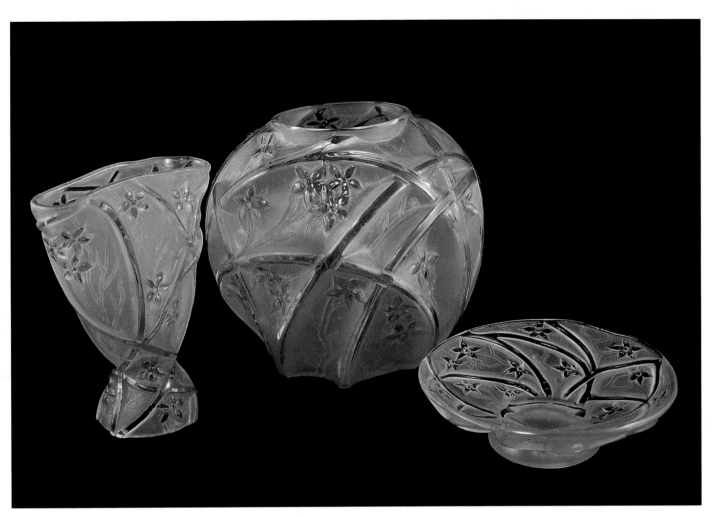

Consolidated
Line 700, light green fan vase, light green
6-1/2 inch vase, with flared dish. $80-
100; $195-225; $50-75

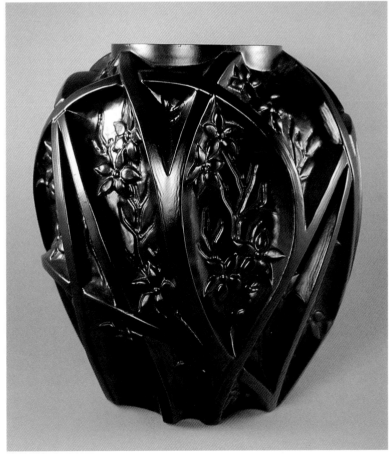

Consolidated
Line 700 10-inch black vase.
$1200-1500

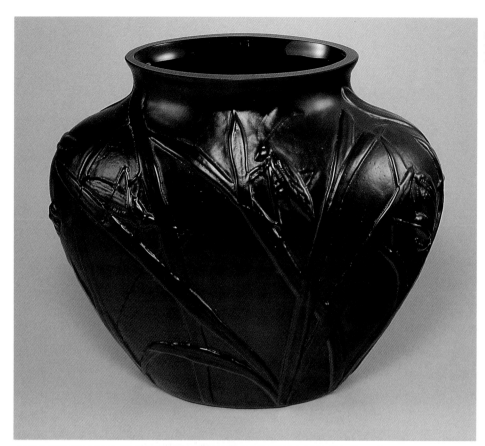

Consolidated **Katydid** black pillow vase. $1000-1200

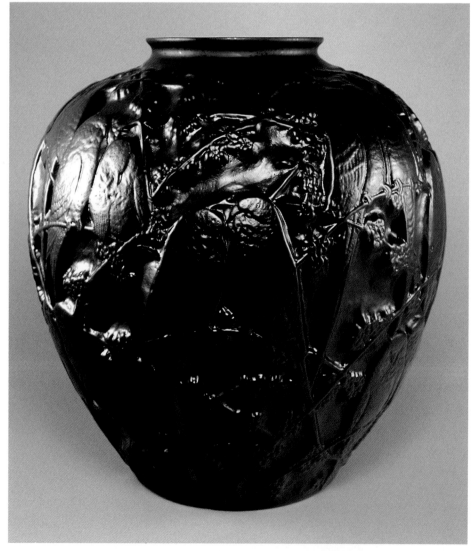

Consolidated **Lovebirds**, black. $1200-1500

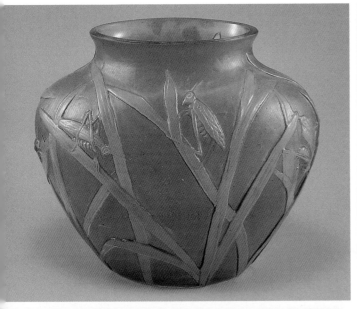

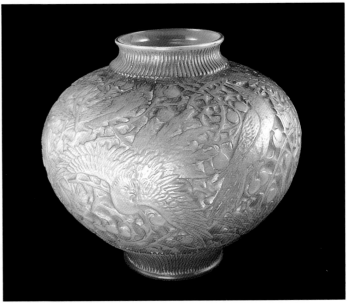

Top left: Consolidated
Katydid green pillow vase. $300-350

Top right: Consolidated
Cockatoo, cased amethyst. $750-900

Bottom left: Consolidated
Lovebirds, caramel custard. $750-900

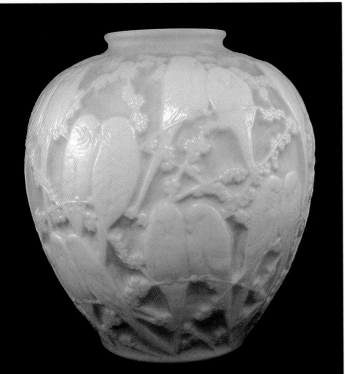

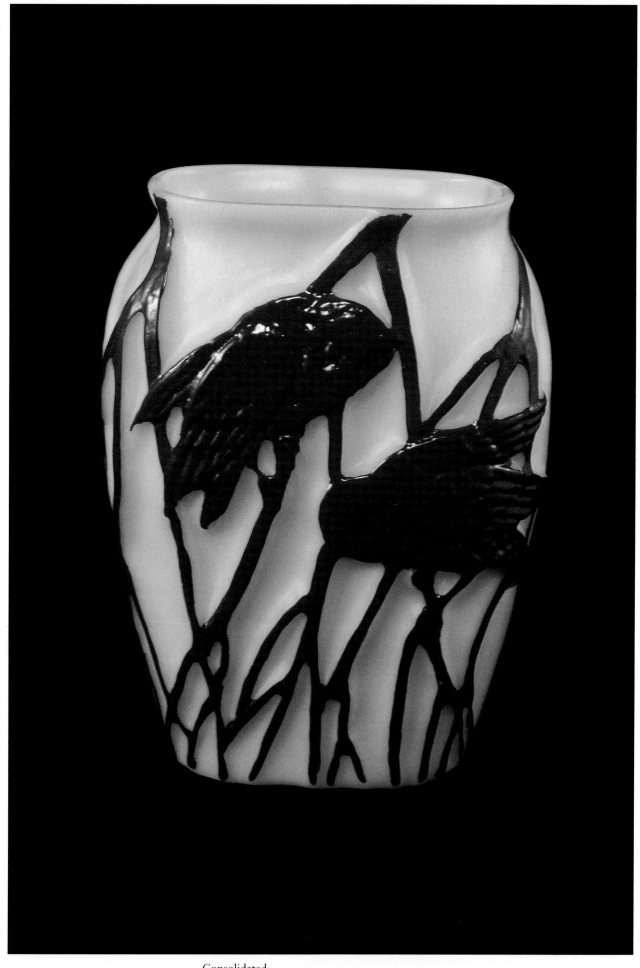

Consolidated
Screech Owl, red enamel on cream. $295-325

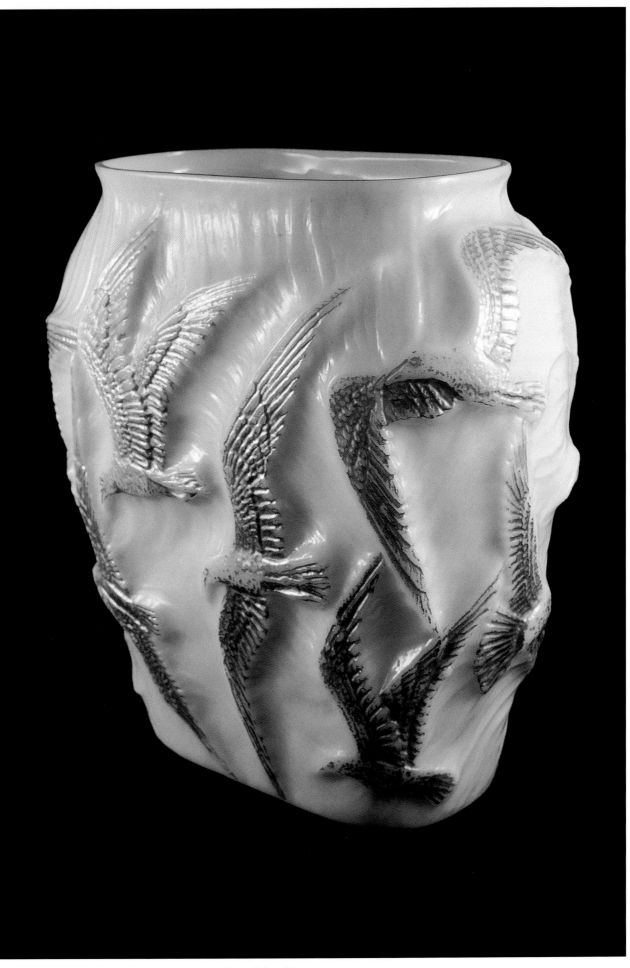

Consolidated
Seagulls, gold on custard. $500-750

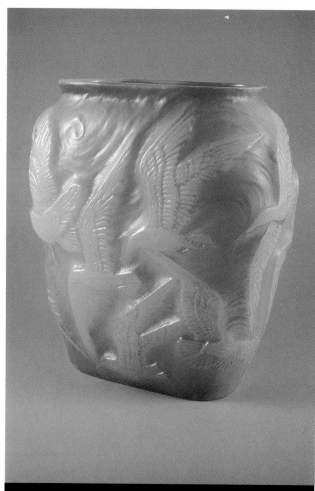

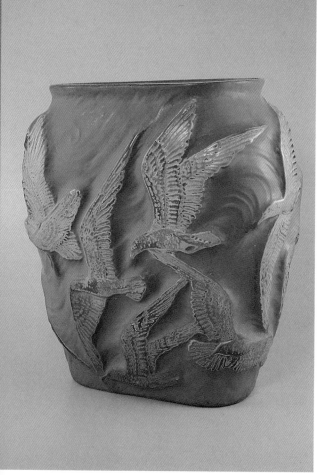

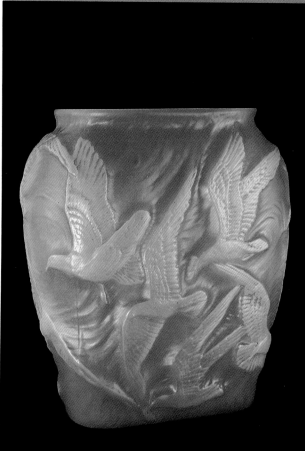

Top left: Consolidated
Seagulls, cased green. $500-750

Top right: Consolidated
Seagulls, crystal birds on blue ceramic stain.
$500-600

Bottom left: Consolidated
Seagulls, sepia wash. $500-600

Opposite page:
Top left: Consolidated
Dancing Nudes, also known as **"Pan,"** 11-1/2
inch vase, red stain on crystal. $600-800

Top right: Consolidated
Dancing Nudes, sepia wash on crystal. $600-800

Bottom left: Consolidated
Dancing Nudes, blue-green wash on crystal.
$600-800

Bottom right: Consolidated
Dancing Nudes, light blue. $600-800

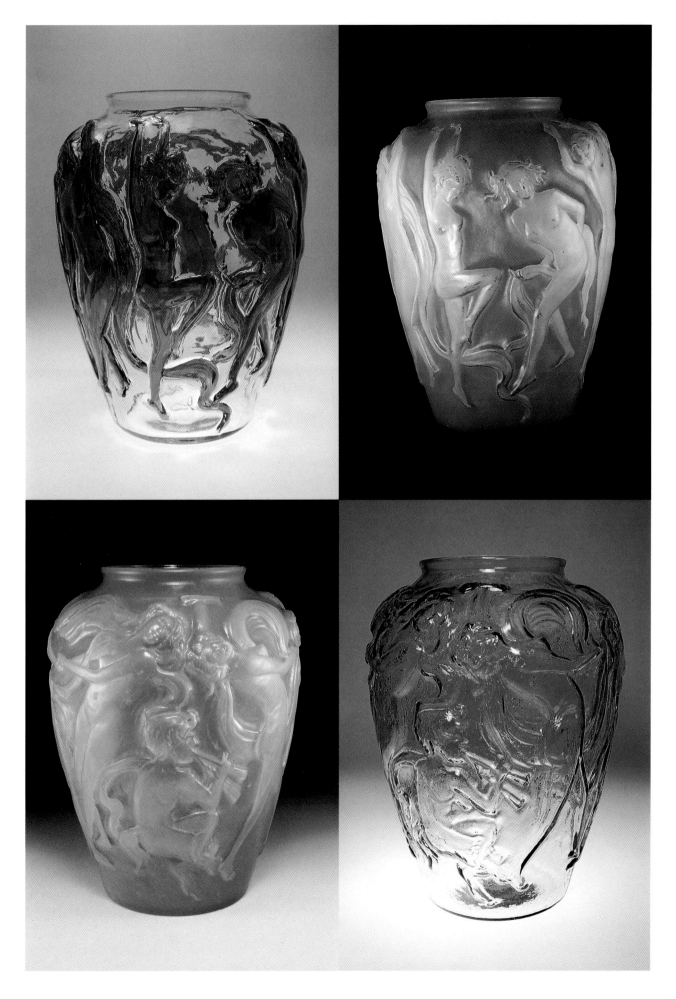

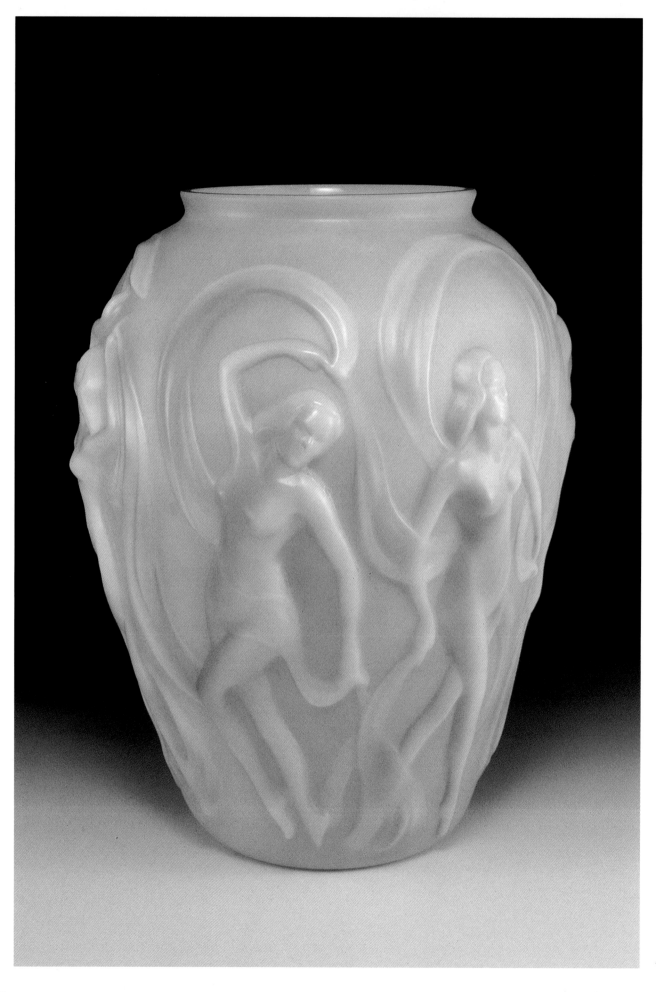

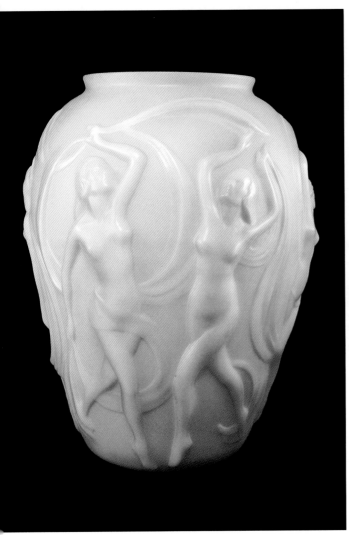

Phoenix
Dancing Girl, different view.

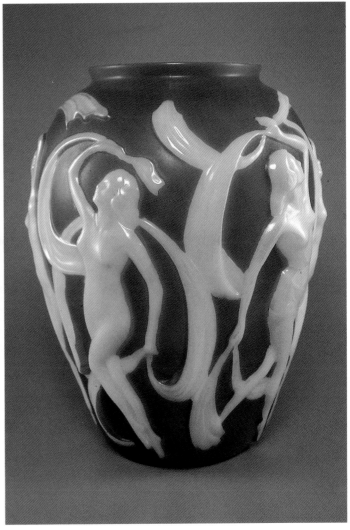

Phoenix
Dancing Girl, slate grey on milk glass, with iridized mother-of-pearl figures, Reuben Line label on bottom. $550-750

Opposite page: Phoenix
Dancing Girl, 11-3/4 inch vase, tan shadow on milk glass. $700-900

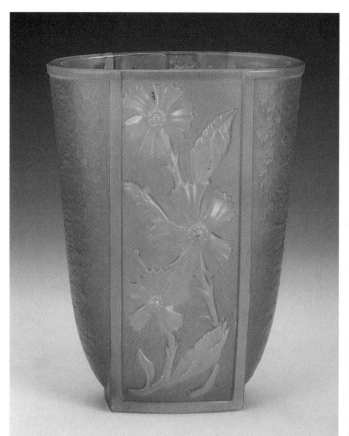

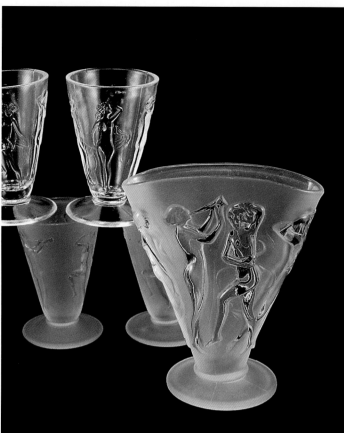

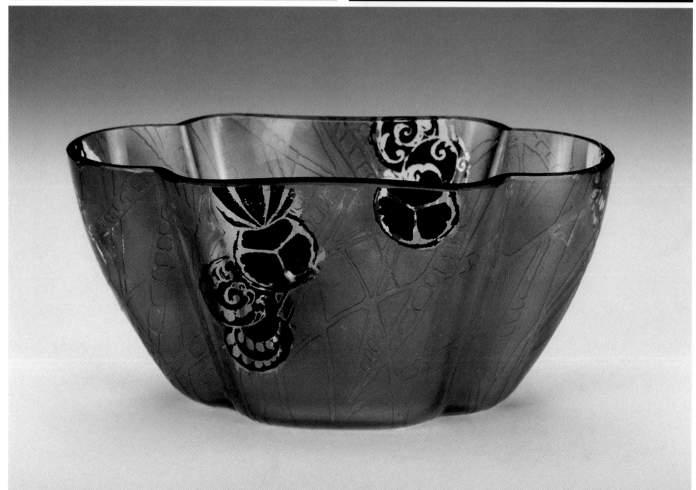

Top left: Phoenix
Very rare **Bachelor Button**, 6-1/2 inch vase, lavender wash on crystal. $600-800

Top right: Consolidated
Dancing Nymph fan vase, French crystal. $150-200

Bottom: Consolidated
Chintz, black design on amethyst wash. $600-800

108

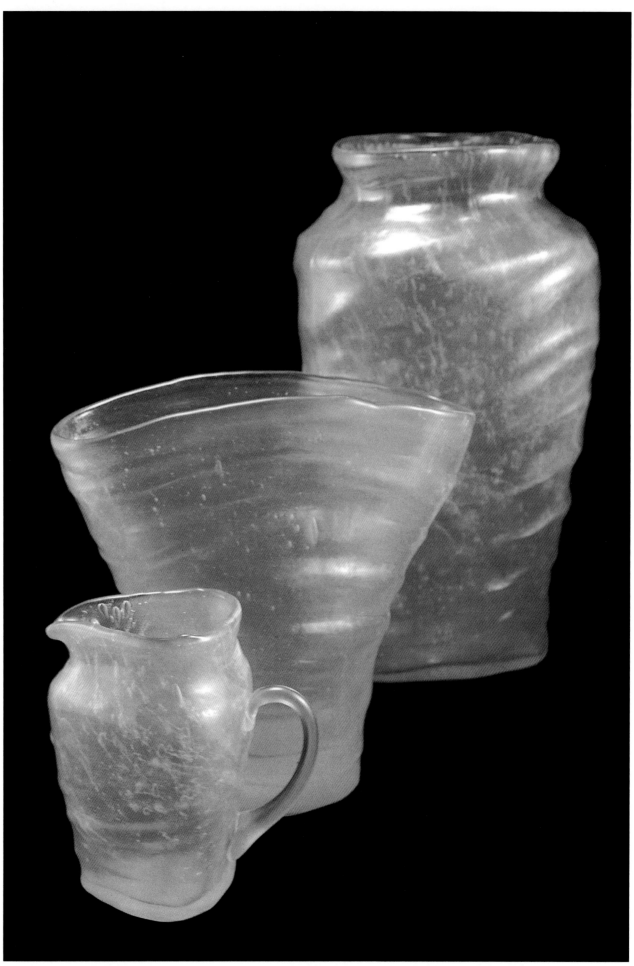

Consolidated
Catalonian cream jug; 8-inch fan vase; 10-inch tri-cornered vase. $35-60; $80-100; $135-160

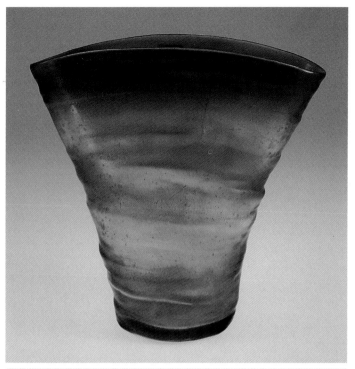

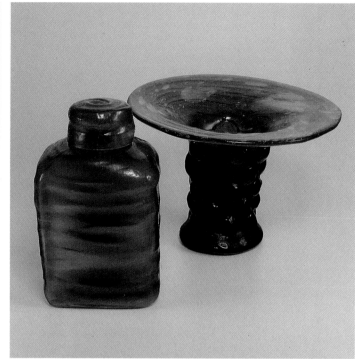

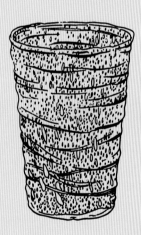

May 28, 1929. R. HALEY 1,715,130
BUBBLE OR BLISTER GLASS
Filed Oct. 7, 1927 2 Sheets-Sheet 1

FIG. 1.

INVENTOR
Reuben Haley
BY Green & McCalpster
His ATTORNEYS.

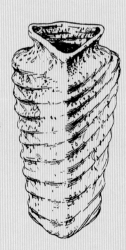

Jan. 15, 1929. Des. 77,482
R. HALEY
GLASS VASE
Filed June 29, 1928

Fig. 1.

Fig. 2. Fig. 3.

Inventor
Reuben Haley
Green & McCallister
Attorney

110

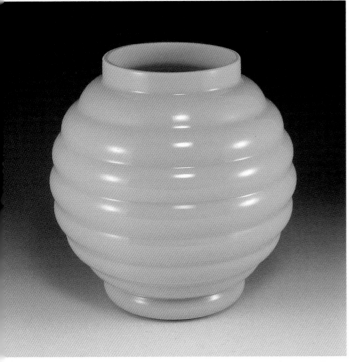

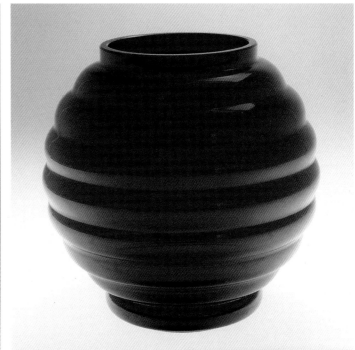

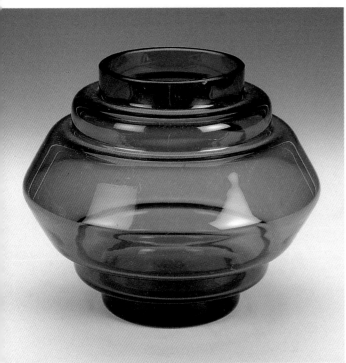

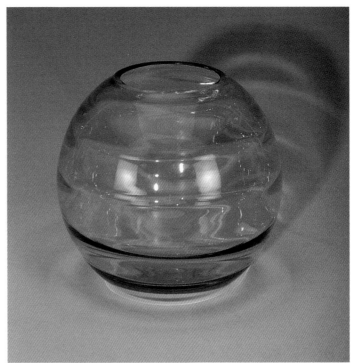

Top left: Morgantown
Saturn 6-inch jade vase. $300-350

Top right: Morgantown
Saturn 6-inch red vase. $225-275

Bottom left: Morgantown
Jupiter Stiegel green vase. $225-275

Bottom right: Heisey
Saturn limelight 3-3/4 inch violet vase, designed by Walter von Nessen. $150-175

Opposite page:
Top left: Consolidated
Catalonian rainbow vase, with graduated shading. $225-275

Top right: Consolidated
Catalonian Reuben line toilet bottle, shown with **Spanish Knobs** bride's basket. $275-350 each

Bottom left: United States Patent Office drawing of invention by Reuben Haley of bubble or blister glass, filed October 7, 1927.

Bottom right: United States Patent Office drawing of Consolidated **Catalonian** vase, designed by Reuben Haley, filed June 29, 1928.

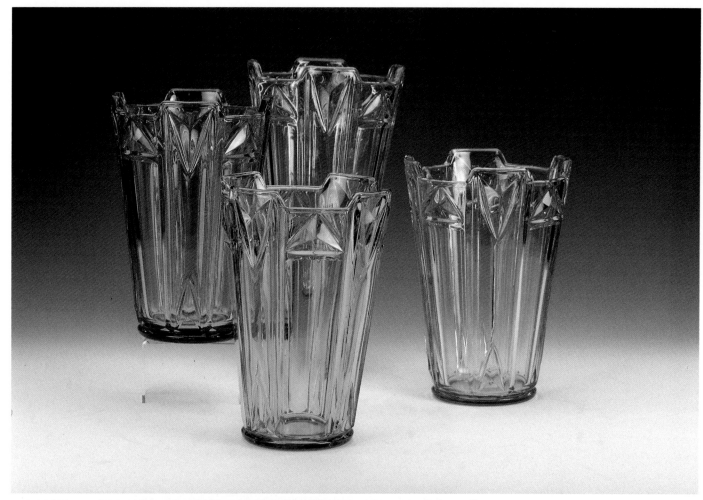

Duncan
Vogue 8-1/2 inch vases in amber, crystal, pink, and green. $75-125 each

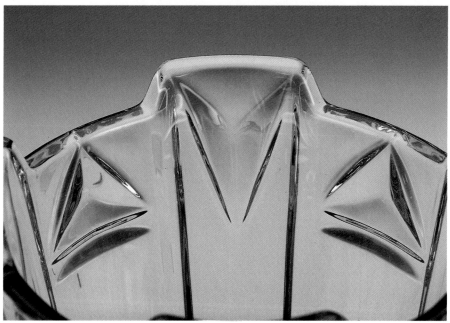

Opposite page:
Top left: Tiffin
Cascade #15365 10-inch vase. $70-90

Top right: Steuben **#7482** 12-inch vase, designed by Walter Dorwin Teague, with **Empire** moon and star engraved decoration, star-cut base inscribed Steuben. *Photo courtesy of Skinner, Inc.* $800-1000

Bottom: Steuben
Walter Dorwin Teague designs: **#9498** 6-1/2 inch globe with T-107 engraved moon and star decoration; with **#7499** 6-inch vase/goblet with engraved stylized wheat decoration. *Photo courtesy of Skinner, Inc.* $400-500; 300-400

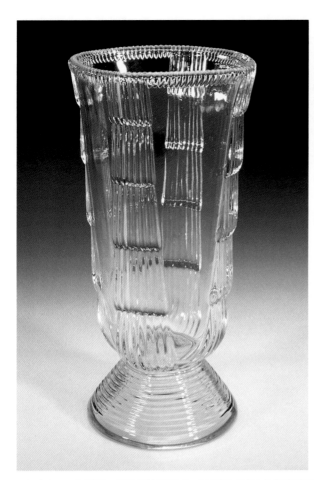

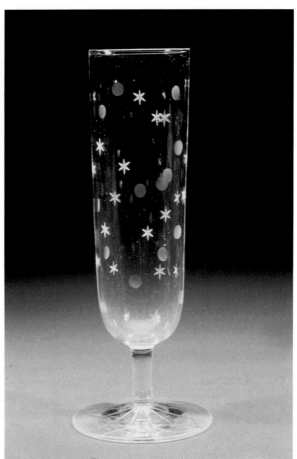

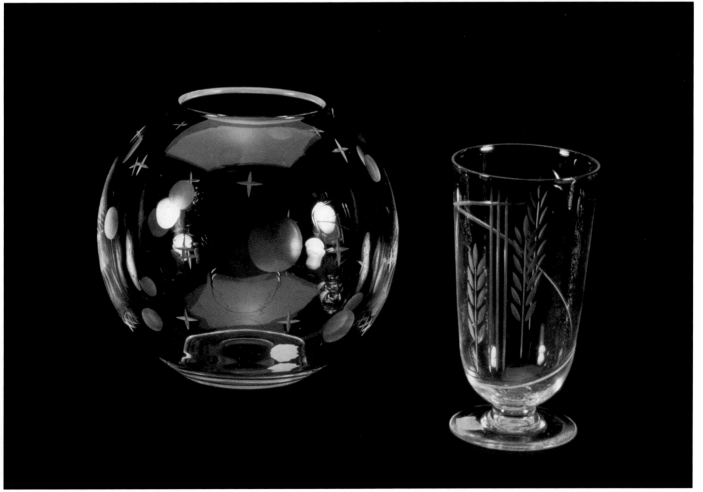

Unidentified
Sandblasted design on Consolidated blank, 7-inches high. $300-350

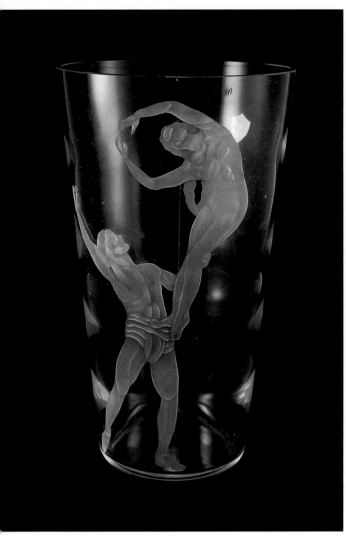

Tiffin
#5859 14-inch flip vase with sand carved nudes. $550-650

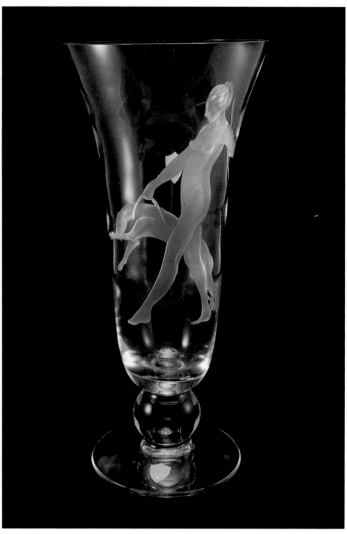

Tiffin
#17350 12-1/2 inch flared footed vase with sand carved nudes.
$550-650

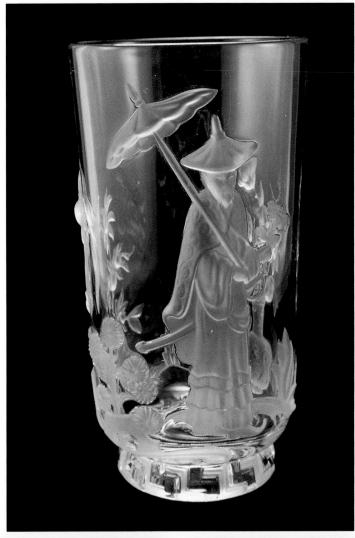

Verlys
Mandarin frosted on 9-1/2 inch crystal vase. $400-450

Detail

Detail

116

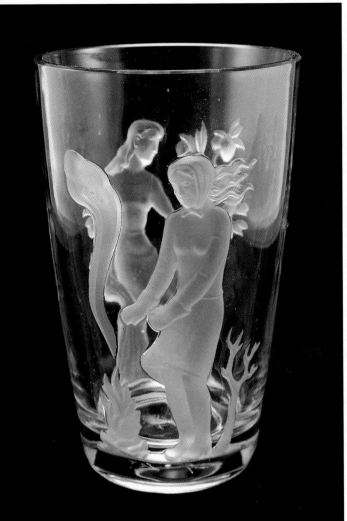

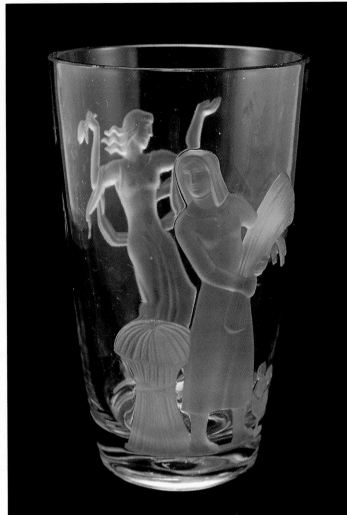

Top: Verlys
Seasons vase depicting summer and winter, designed by American sculptor Carl Schmitz. $300-350

Bottom: Detail.

Top: Verlys
Seasons vase depicting spring and autumn, designed by Schmitz. $300-350

Bottom: Detail.

117

Candleholders & Accessories

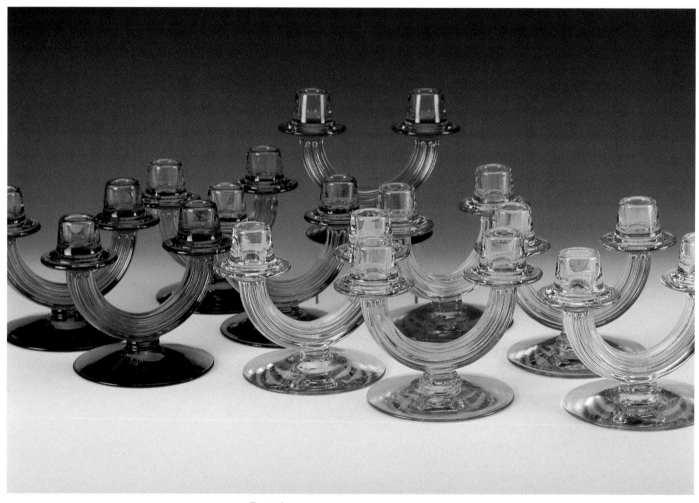

Fostoria
Assortment of **#2447** duo candleholders, by
George Sakier. $85-125 pair

Fostoria
#2447 ebony duo
candleholders. $100-125

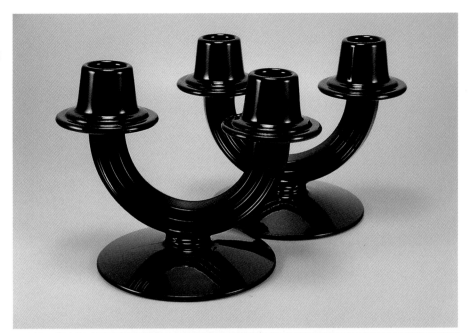

Fostoria
#2447 duo candleholders,
rose. $100-125

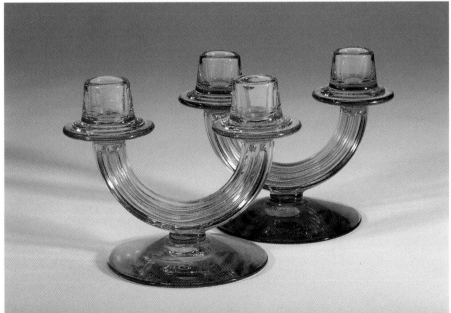

Fostoria
#2447 duo candleholders,
green. $90-110

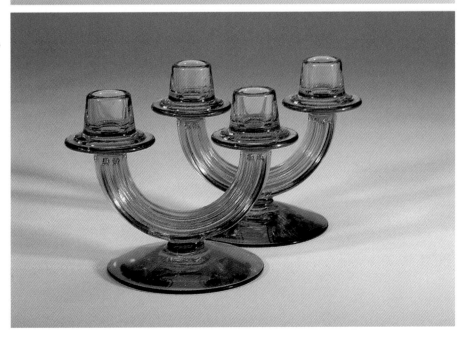

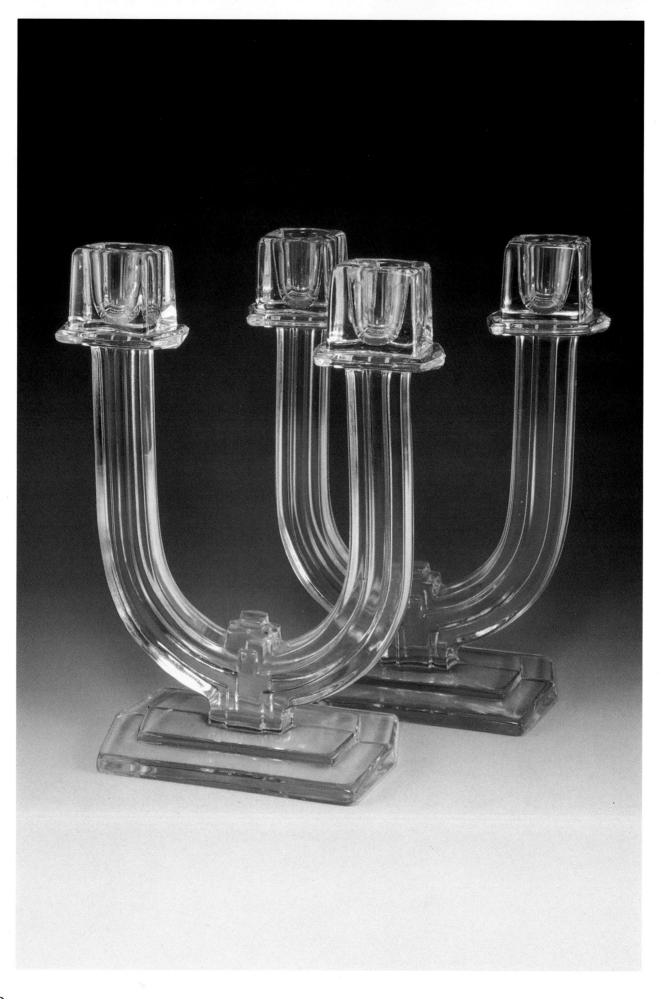

Opposite page: Heisey
New Era candleholders, crystal; reissued by Imperial from 1958 to 1972. $100-125 pair

United States Patent Office drawing of Fostoria candlestick, designed by George Sakier, filed December 28, 1949

Fostoria
Sunray #2510 6-1/2 inch candleholders, by Sakier. $125-175 pair

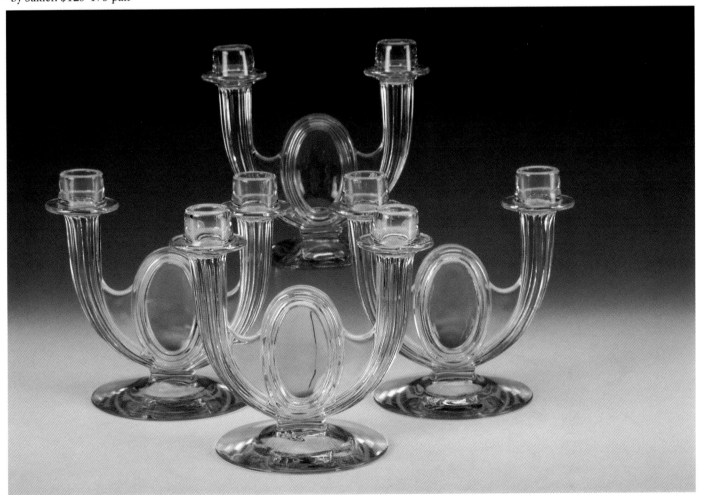

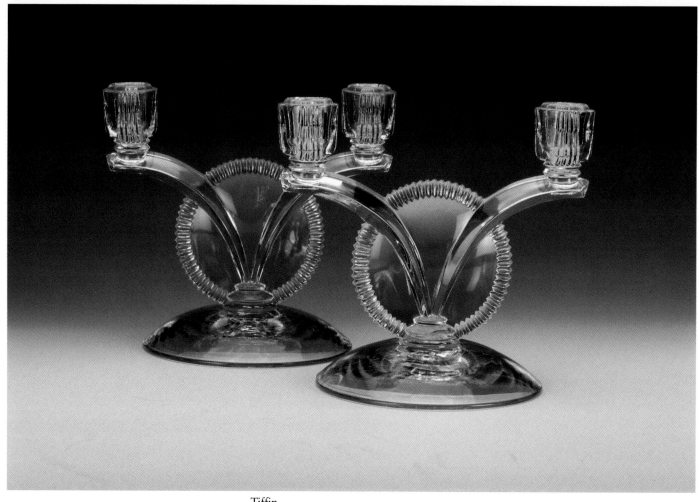

Tiffin
Cascade #15365, crystal, 9-inch two-light candleholders. $125-150 pair

Fig. 1

Fig. 2

INVENTOR
Robert A. Kelly

United States Patent Office drawing of Tiffin **Cascade** candlestick, designed by Robert A. Kelly, filed November 11, 1937.

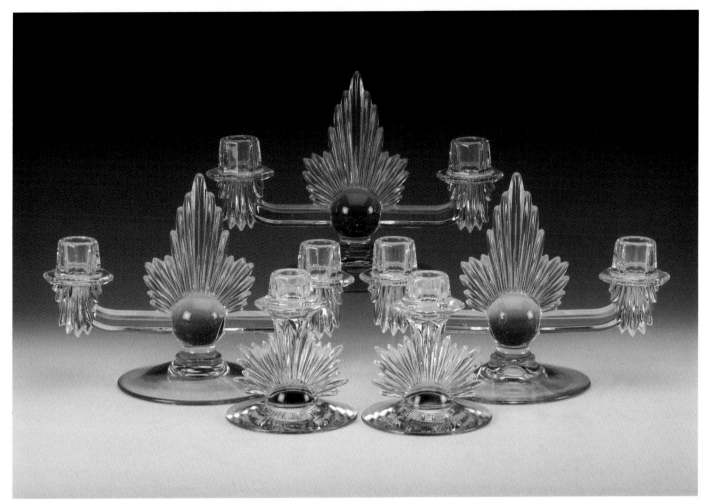

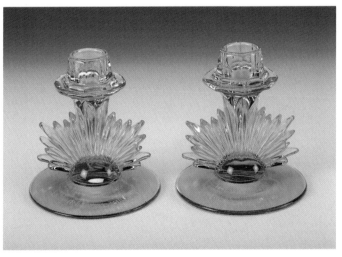

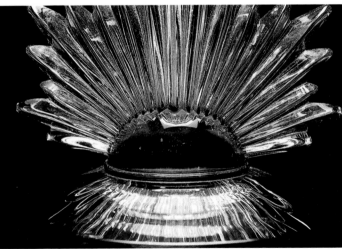

Top: Fostoria
Flame #2545, azure and crystal duo candleholders with crystal singles, by Sakier. $200-250 azure duo pair; $150-175 crystal duo pair; $80-100 crystal single pair

Bottom left: Fostoria
Flame azure single candle. $125-150 pair

Bottom right: Detail.

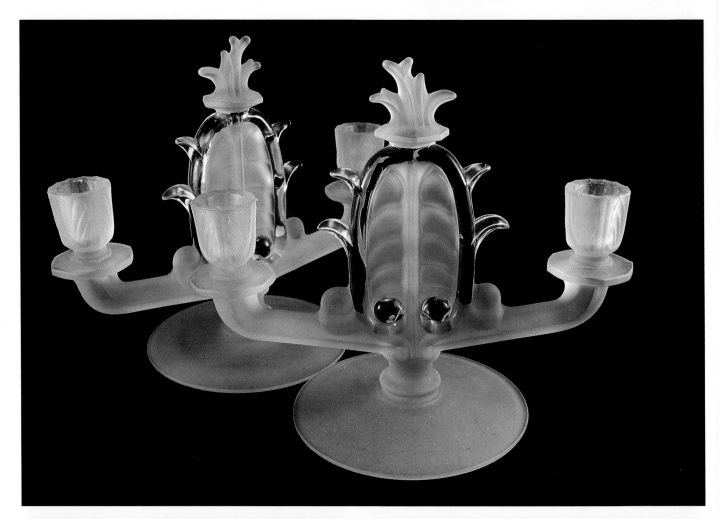

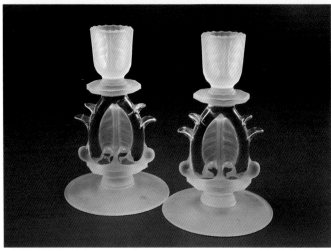

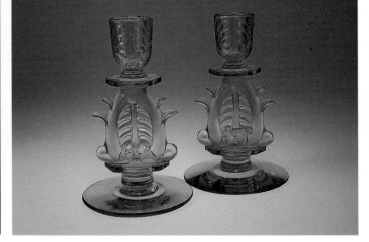

Top: Tiffin
Velva duo candleholder in satin finish with bright accent, 10-inch width. $200-250 pair

Bottom left: Tiffin
Velva single candleholders in satin finish with bright accent. $120-140 pair

Bottom right: Tiffin
Velva single candleholders in blue bright finish. $125-150 pair

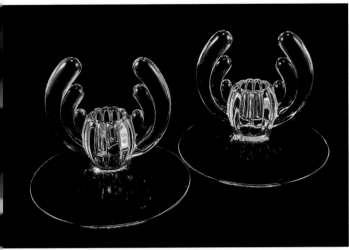

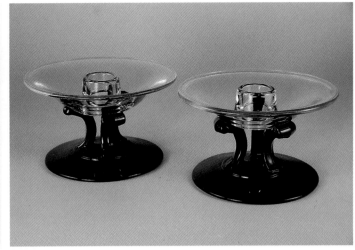

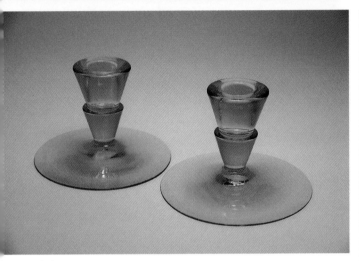

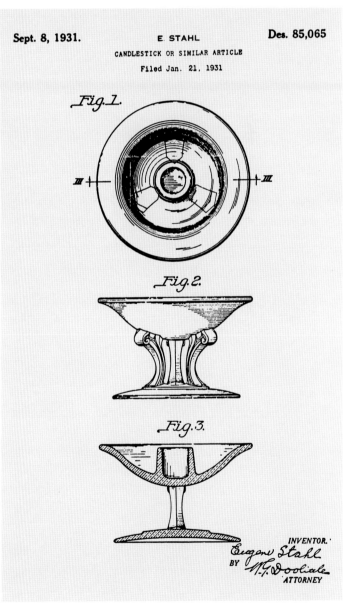

Top left: Heisey
#1503 4-inch crystal single candleholders. $40-60 pair

Top right: Fostoria
#2433 modern classical candleholders, crystal bowls with ebony bases. 125-150 pair

Bottom left: Heisey
Pink #128 3-inch single candleholders. $50-60 pair

Bottom right: United States Patent Office drawing of Fostoria #2433 candlestick, designed by George Sakier, but patented by Eugene Stahl, filed January 21, 1931.

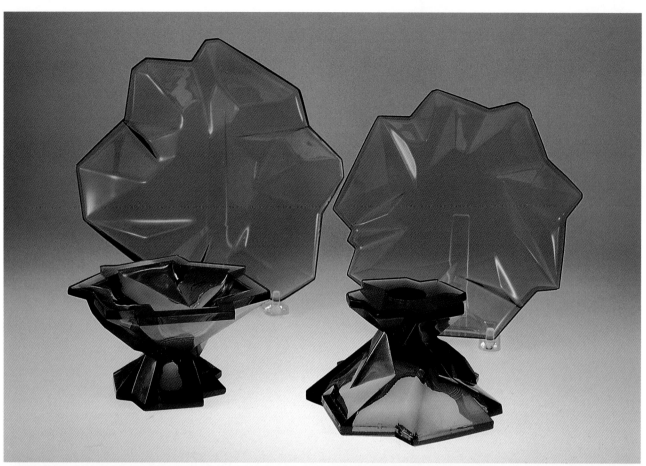

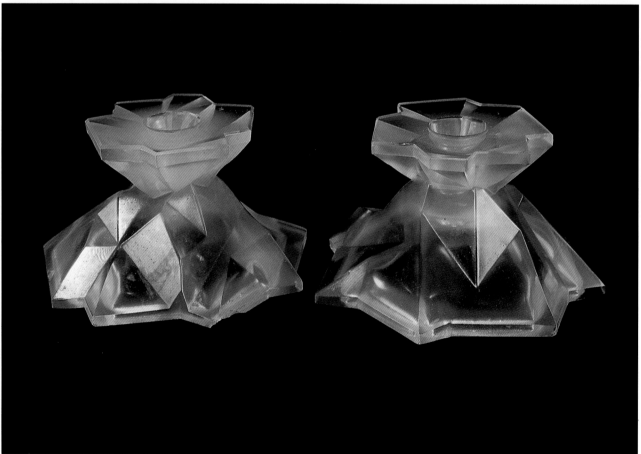

Top: Consolidated
Ruba Rombic smokey topaz 2-1/2 inch single
candleholders, with plates. $500-600 pair; 100-120 each

Bottom: Consolidated
Ruba Rombic 2-1/2 inch jade candleholders. $650-750 pair

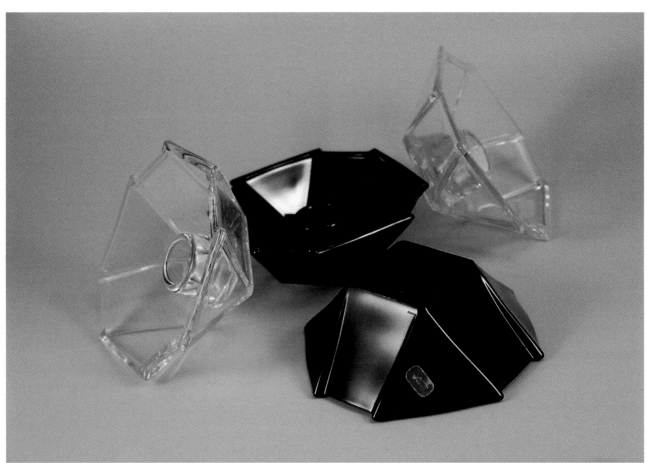

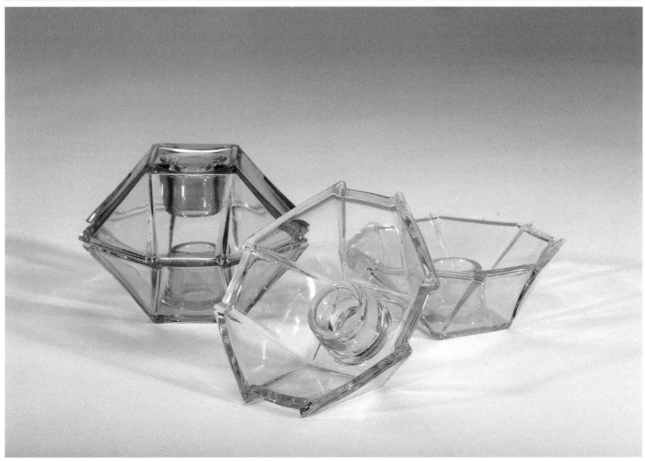

Top: Fostoria
#2402 single candleholders in crystal and ebony, by Sakier.
$60-80 crystal pair; $80-100 ebony

Bottom: Fostoria
#2402 candleholders, rose and yellow tint. $70-90 pair

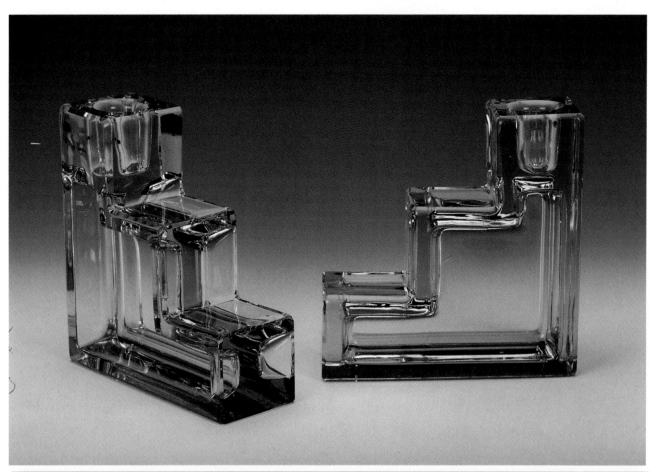

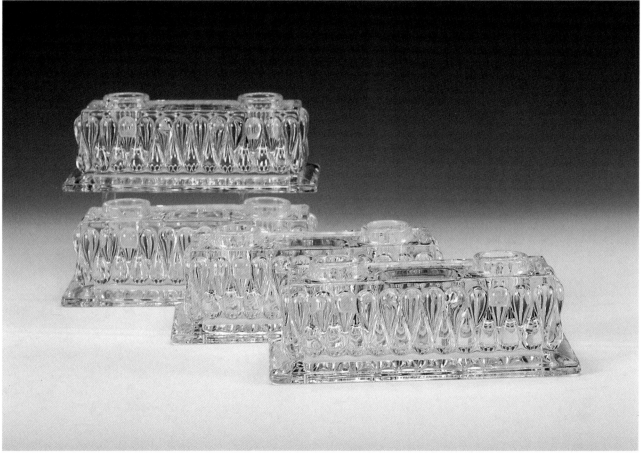

Top: Cambridge
Pristine Table Architecture, 5-inch crystal stepped
candleholders. $250-300 pair

Bottom: Fostoria
Myriad #2592, block candleholders, by Sakier.
$125-150 pair

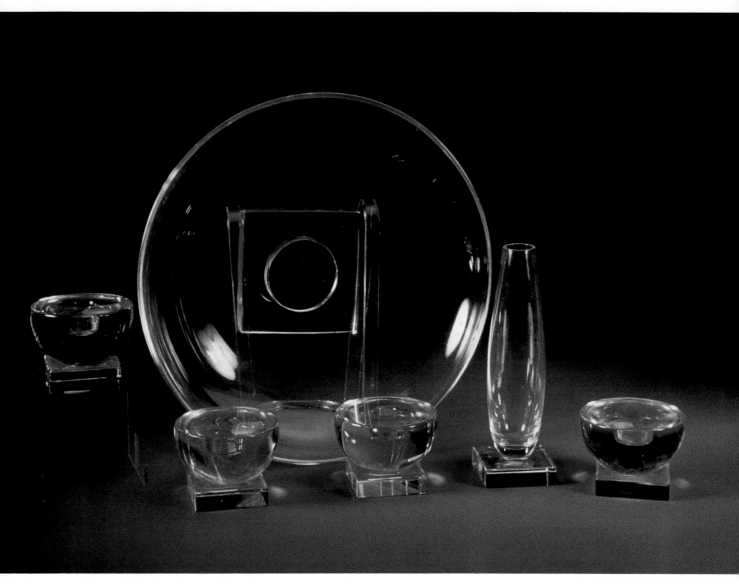

Libbey
Knickerbocker single candleholders with #9735 12-inch center bowl and #9747 7-1/4 inch bud vase. *Photo courtesy of Skinner, Inc.* $400-600

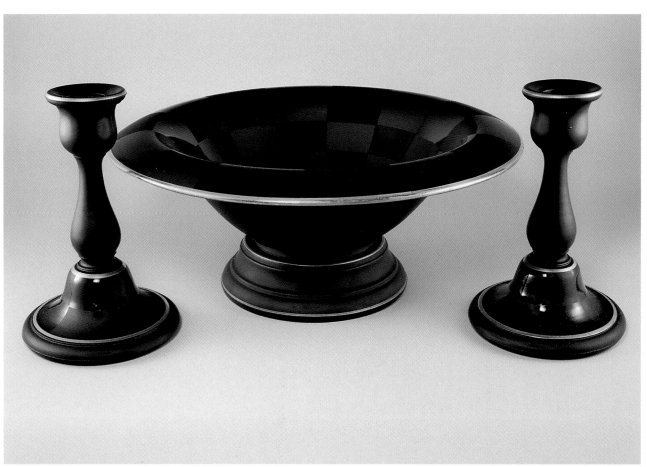

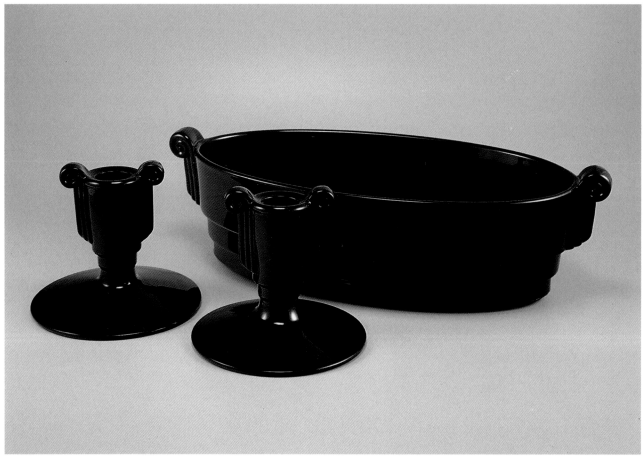

Top: Tiffin
Console bowl with candleholders, **Echec** decoration. $125-150; $100-125 pair

Bottom: Fostoria
Console set **#2443**, ebony 10-inch oval bowl with 3-inch candlesticks. $125-150; $50-75

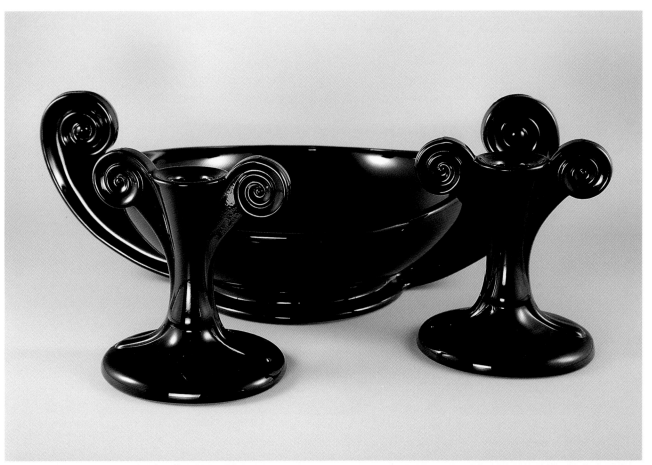

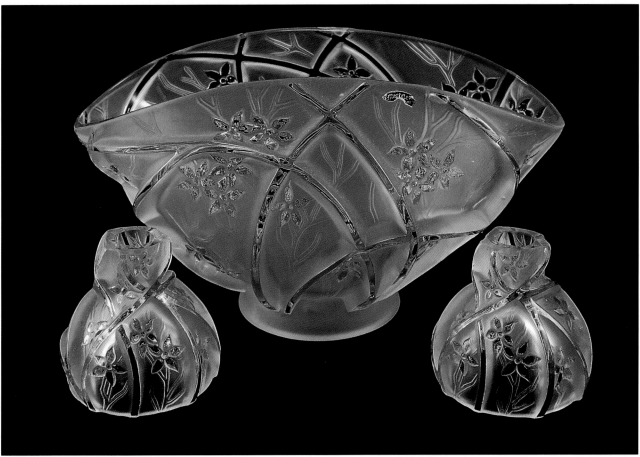

Top: Fostoria
Ebony **#2395** 10-inch bowl, with **#2395-1/2** 5-inch ebony candlesticks, attributed to Sakier. $75-125; $50-75

Bottom: Consolidated
Line 700 French crystal 13-inch banana boat with candle holders. $250-300; $100-125 pair

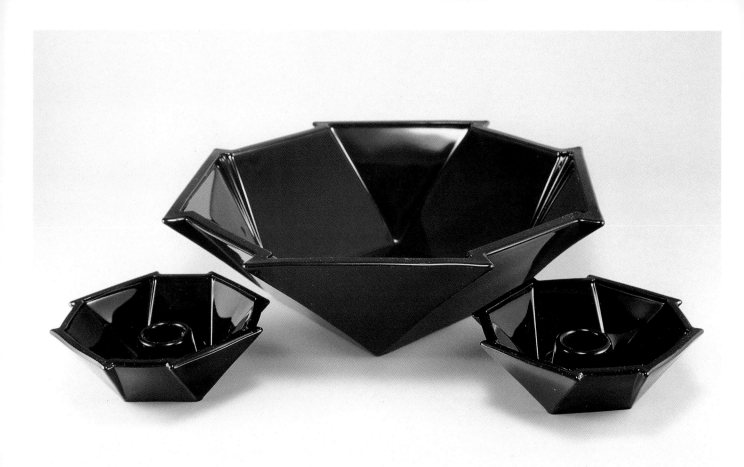

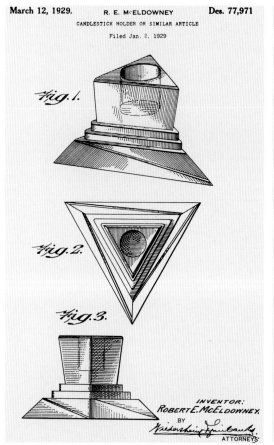

March 12, 1929.

R. E. McELDOWNEY

Des. 77,971

CANDLESTICK HOLDER OR SIMILAR ARTICLE

Filed Jan. 2, 1929

Fig. 1.

Fig. 2.

Fig. 3.

INVENTOR:
ROBERT E. McELDOWNEY.
BY
ATTORNEYS.

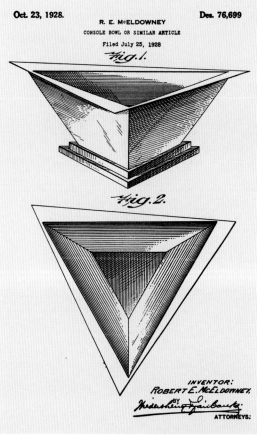

Oct. 23, 1928.

R. E. McELDOWNEY

Des. 76,699

CONSOLE BOWL OR SIMILAR ARTICLE

Filed July 25, 1928

Fig. 1.

Fig. 2.

INVENTOR:
ROBERT E. McELDOWNEY.
BY
ATTORNEYS.

Top: Fostoria #2402 10-inch ebony bowl with candleholders, by Sakier. $125-150; $60-80 pair

Bottom left: United States Patent drawing of New Martinsville **Modernistic** candleholder, designed by Robert E. McEldowney, filed January 2, 1929.

Bottom right: United States Patent drawing of New Martinsville **Modernistic** console bowl, designed by Robert E. McEldowney, filed July 25, 1928.

Duncan
#16 green 12-inch flared oval bowl with Deco wings; 6-inch winged candleholders. $100-125; $50-75

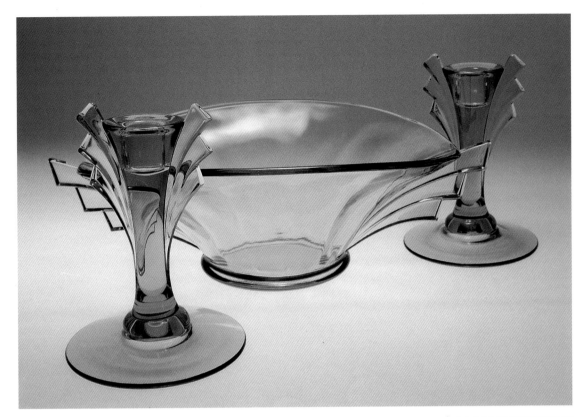

Duncan
#16 ebony 14-inch flared oval bowl, Deco wings; 6-inch candleholders. $175-200; $60-80

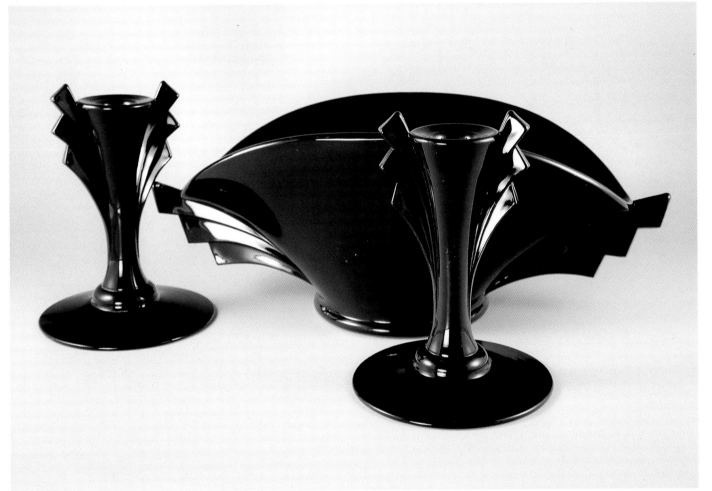

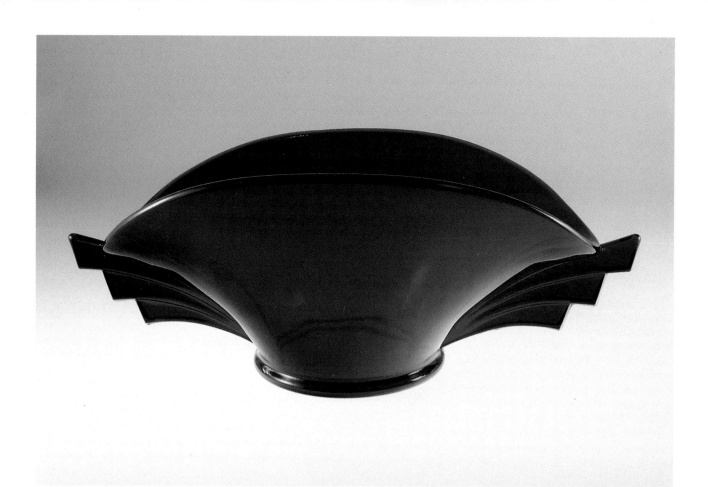

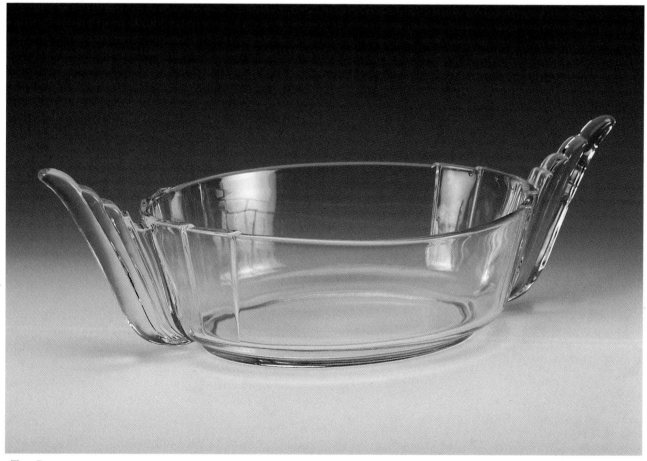

Top: Duncan
#16 cobalt 14-inch flared oval bowl, Deco wings. $200-225

Bottom: Fostoria
Viking #2563 bowl with winged handles, designed by Sakier, 14-3/4 inches long. $80-100

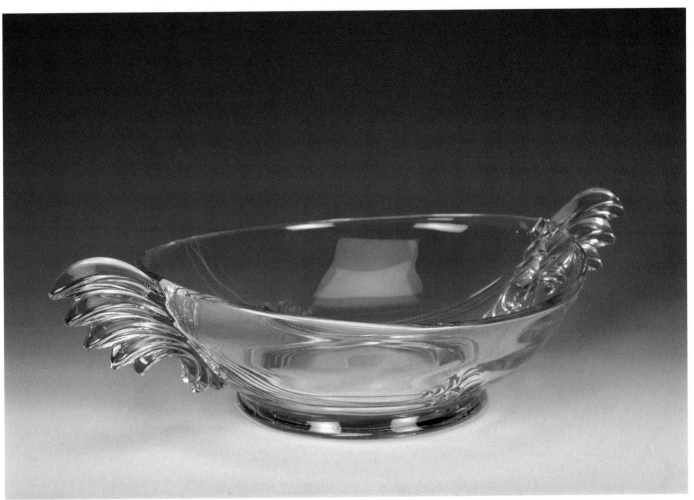

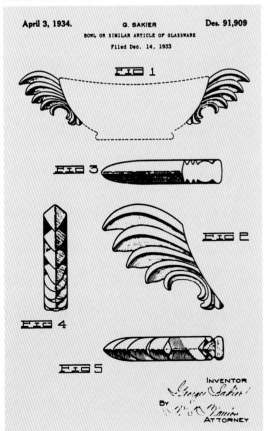

FIG 1

FIG 3

FIG 4

FIG 2

FIG 5

INVENTOR
George Sakier
BY
ATTORNEY

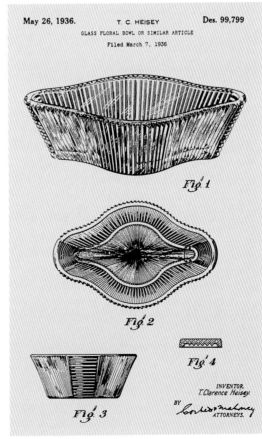

Fig. 1

Fig. 2

Fig. 3

Fig. 4

INVENTOR.
T. Clarence Heisey.
BY
ATTORNEYS.

Top: Fostoria **Baroque** #2484 10-inch handled bowl, by Sakier. $60-80

Bottom left: United States Patent Office drawing of Fostoria **Baroque** bowl, designed by George Sakier, filed December 14, 1933.

Bottom center: United States Patent Office drawing of Heisey floral bowl, designed by T. Clarence Heisey, filed March 7, 1936.

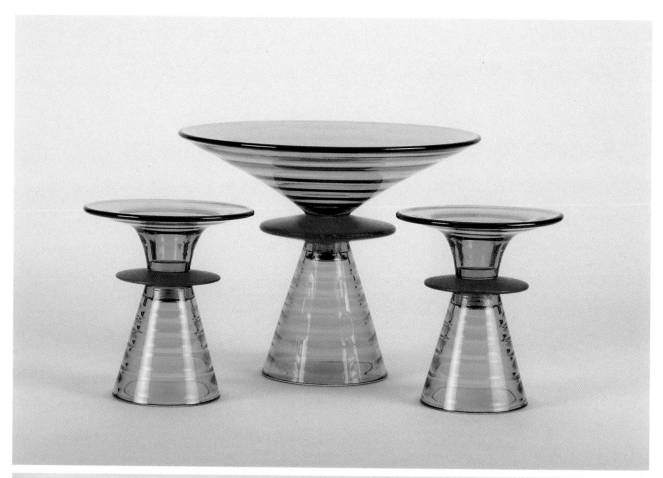

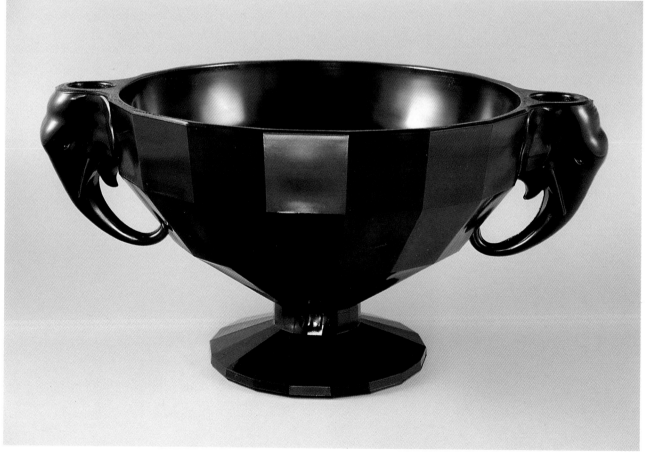

Top: Duncan
Festive #155 aqua 7-1/2 inch console bowl with 5-1/2 inch candleholders, both with wooden discs. $200-250 set

Bottom: Unidentified
One-piece console set, the ebony elephant head handles are built-in candleholders on a 12-inch bowl. $90-115

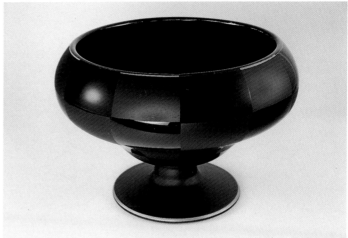

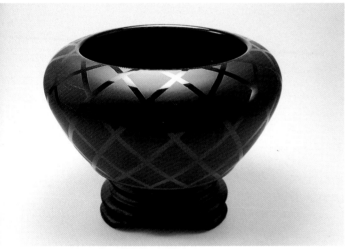

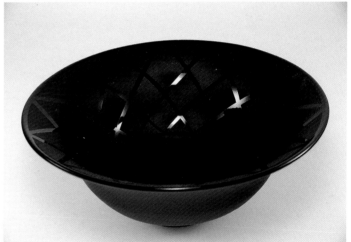

Top: Tiffin
Echec decorated #8098, 7-1/2 inch footed rose bowl on undecorated base. $100-125

Bottom: Tiffin
Kimberly decoration on black cupped bowl. $80-100

Top: Tiffin
Echec decorated #15179, 8-inch cupped footed bowl. $100-125

Bottom: Tiffin
Kimberly decoration on black #320 9-inch console bowl. $75-95

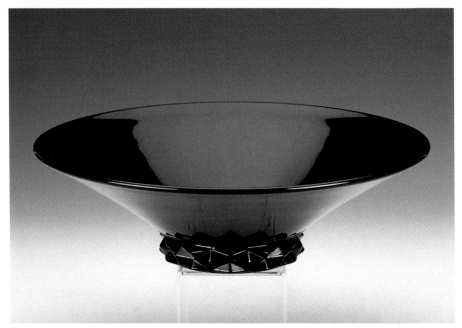

Fostoria
Diadem #2430 ebony 10-1/2 inch
console bowl, by Sakier. $125-150

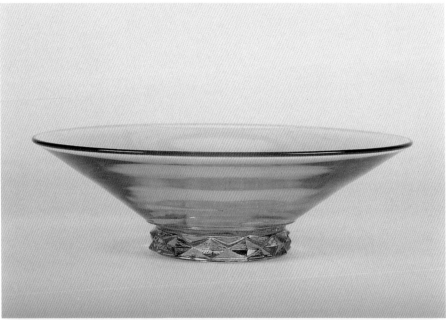

Fostoria
Diadem #2430 gold tint 10-1/2 inch
console bowl. $100-125

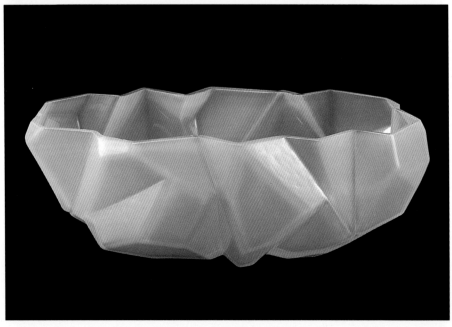

Consolidated
Ruba Rombic jade oval 12-inch bowl.
$1700-2200

Consolidated
Ruba Rombic, jade cupped 8-inch bowl. $1500-2000

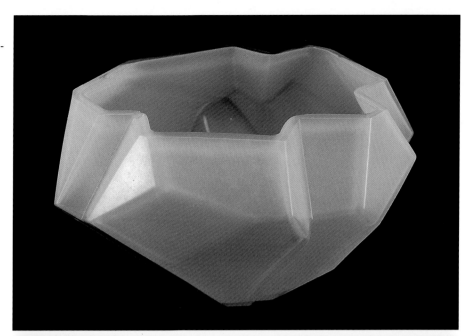

Consolidated
Ruba Rombic lilac cupped 8-inch bowl. $1500-2000

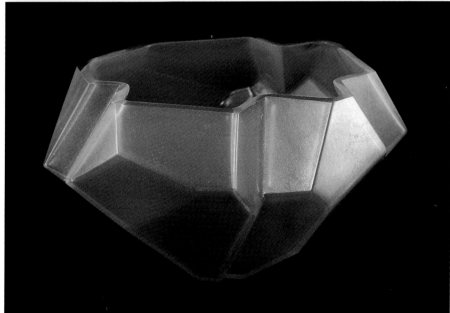

Consolidated
Ruba Rombic silver cupped 8-inch bowl. $1500-2000

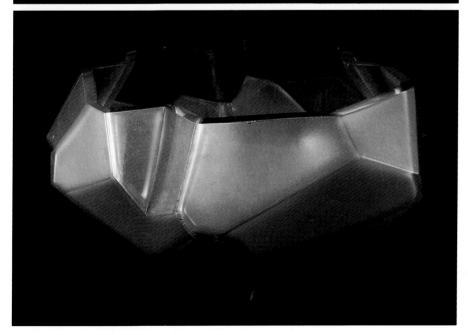

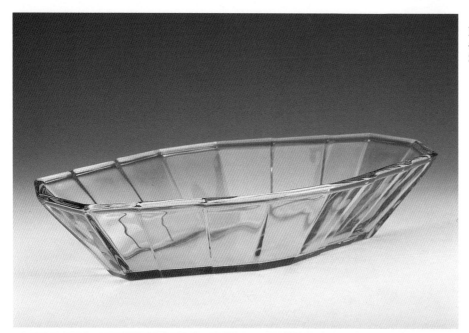

Fostoria
#2425 rose 13-inch oblong bowl, by Sakier.
$125-150

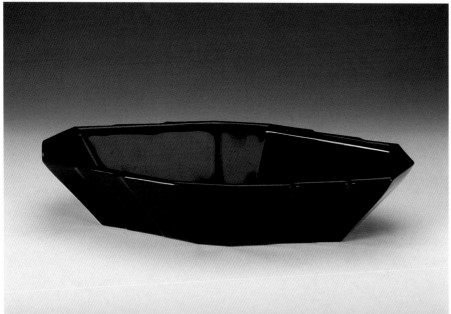

Fostoria
#2425 ebony 13-inch oblong
bowl, by Sakier. $175-225

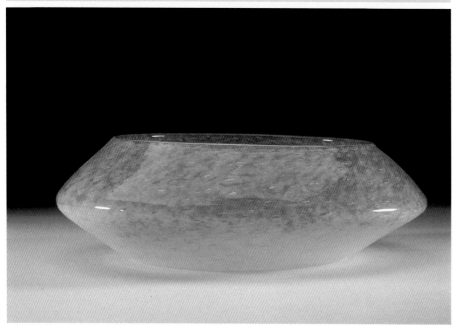

Steuben
Cluthra #6887 12-inch center bowl,
pink shaded to white, designed by
Frederick Carder. *Photo courtesy of
Skinner, Inc.* $900-1200

Verlys
"Sacred Mountain" interpretation of Tianshan mountains in China, crystal etched 8-inch bowl, designed by Ted Mehrer. $250-300

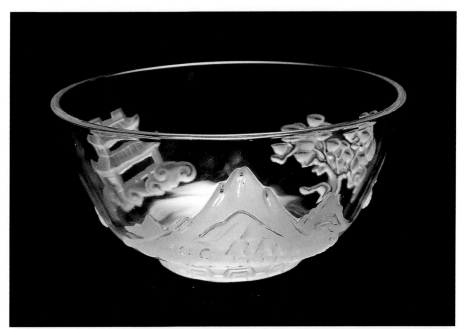

Detail.

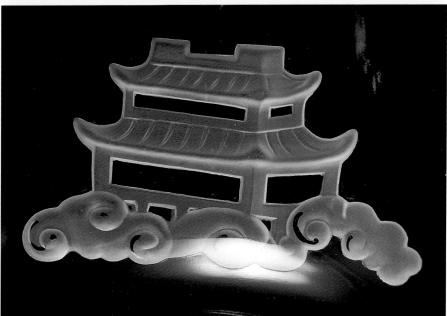

Detail.

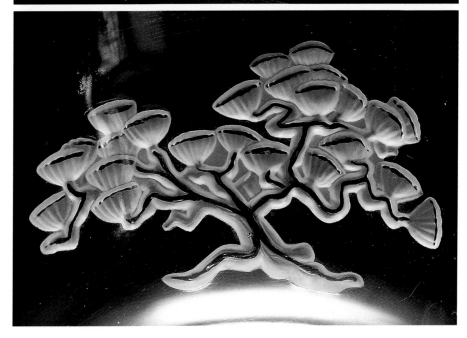

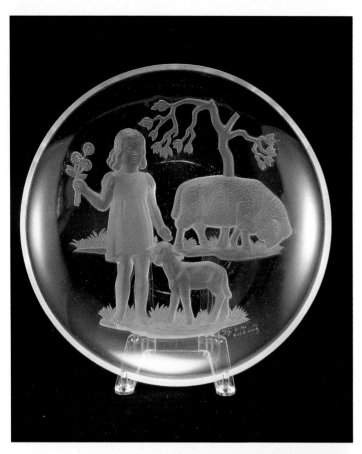

Verlys
"Mary and Her Lamb" 13-inch crystal etched bowl, designed and signed by Carl Schmitz in 1940. $400-500

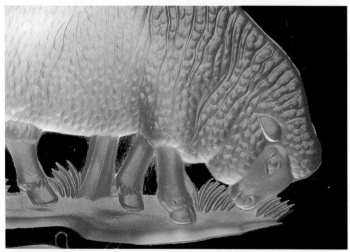

Detail.

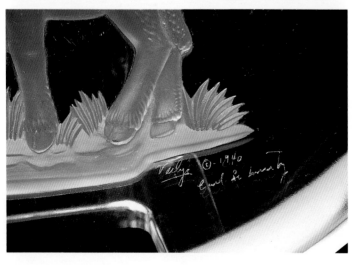

Signature.

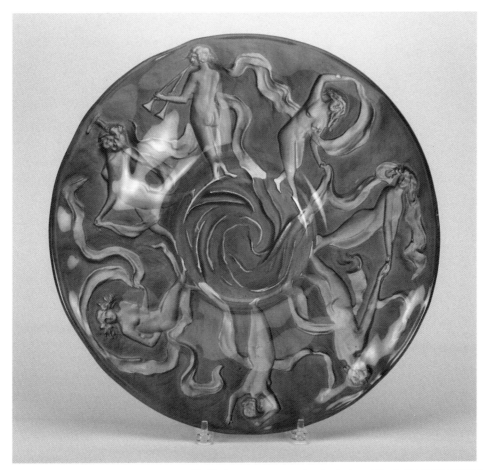

Phoenix
Dancing Nymph
17-3/4 inch palace
platter, Reuben
blue. $2200-2500

Detail.

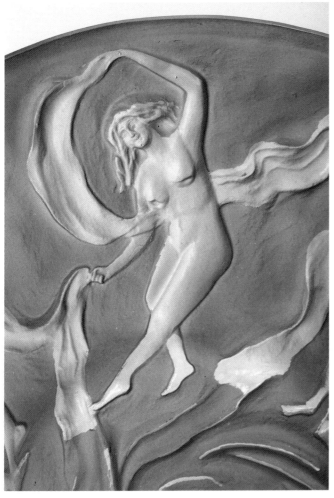

Detail.

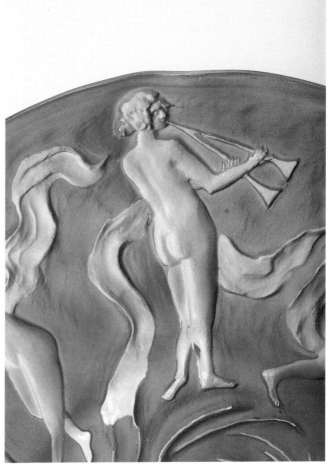

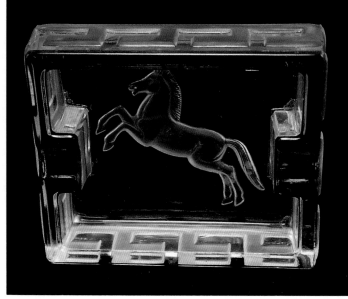

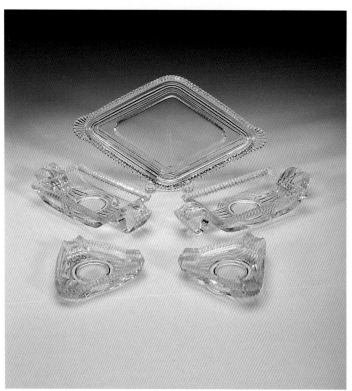

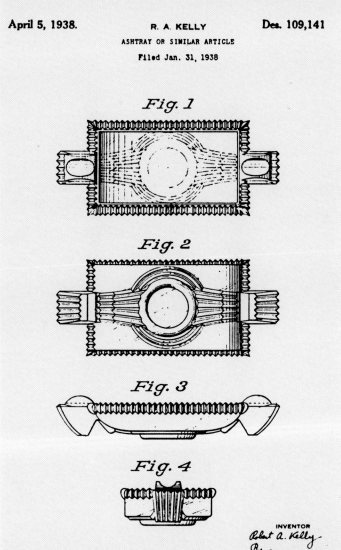

April 5, 1938. R. A. KELLY Des. 109,141
 ASHTRAY OR SIMILAR ARTICLE
 Filed Jan. 31, 1938

Fig. 1

Fig. 2

Fig. 3

Fig. 4

INVENTOR
Robert A. Kelly
By Thomas G. Miller
His attorney

Top left: Tiffin
Echec decoration on black card holder. $175-200

Top right: Verlys
Greek Horse 4-inch crystal etched ashtray, designed by Carl Schmitz. $50-75

Bottom left: Tiffin
Cascade 7-inch diamond ashtray; 5-inch oblong ashtrays; 3-inch triangular ashtrays. $15-25 each

Bottom right: United States Patent Office drawing of Tiffin **Cascade** ashtray, designed by Robert A. Kelly, filed January 31, 1938.

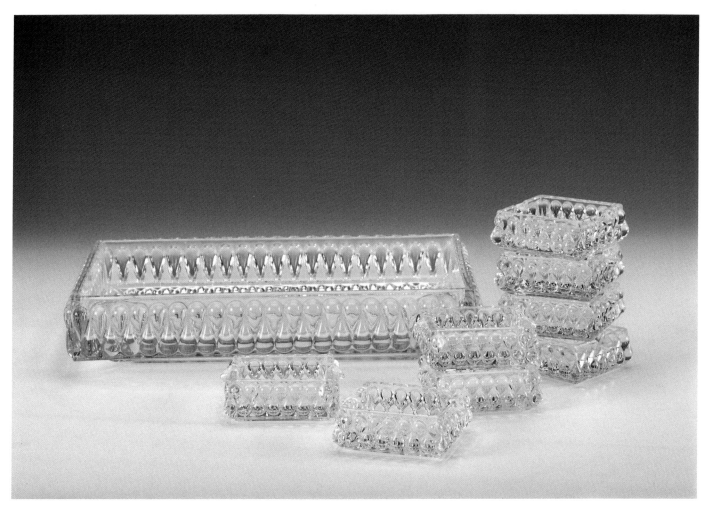

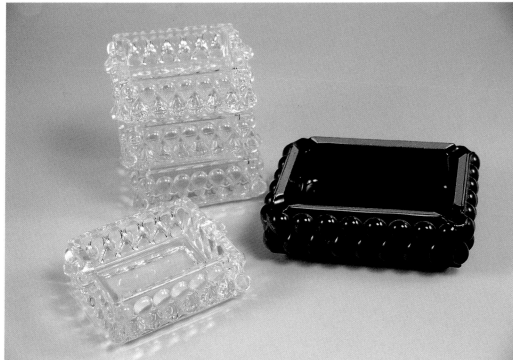

Fostoria
Myriad by Sakier, 10-1/2 inch lily pond with individual ashtrays. $80-100; $15-20 each

Fostoria
Myriad individual ashtrays, crystal and ebony. $15-20; $20-30

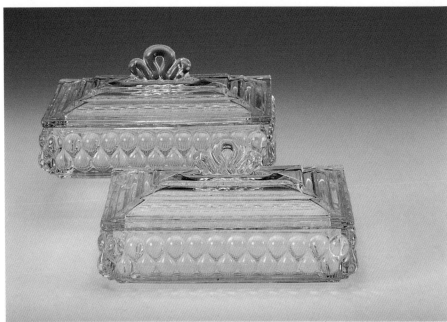

Top: Fostoria
Myriad 6-1/2 inch covered
cigarette boxes. $60-90

Center: Detail.

Bottom: Detail.

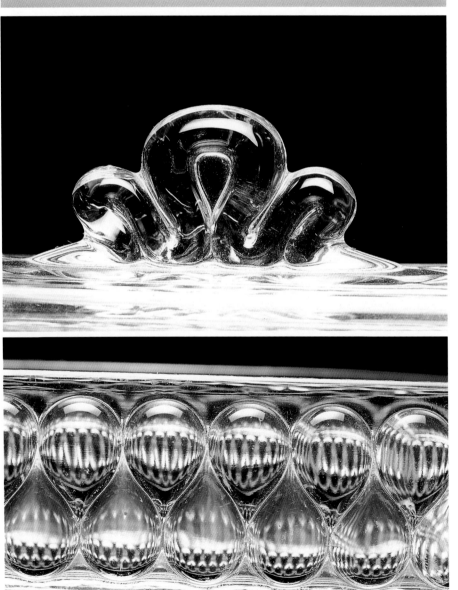

Opposite page:
Top: Tiffin
Cascade 8-1/2 inch covered cigarette
box. $50-70

Bottom left: United States Patent
Office drawing of Tiffin **Cascade**
covered dish, designed by Robert A.
Kelly, filed November 11, 1937.

Bottom center: United States Patent
Office drawing of Heisey **Ridgeleigh**
cigarette box, designed by T. Clarence
Heisey, filed January 24, 1936.

Bottom right: United States Patent
drawing of New Martinsville **Modern-
istic** puff box, designed by Robert E.
McEldowney, filed September 7, 1928.

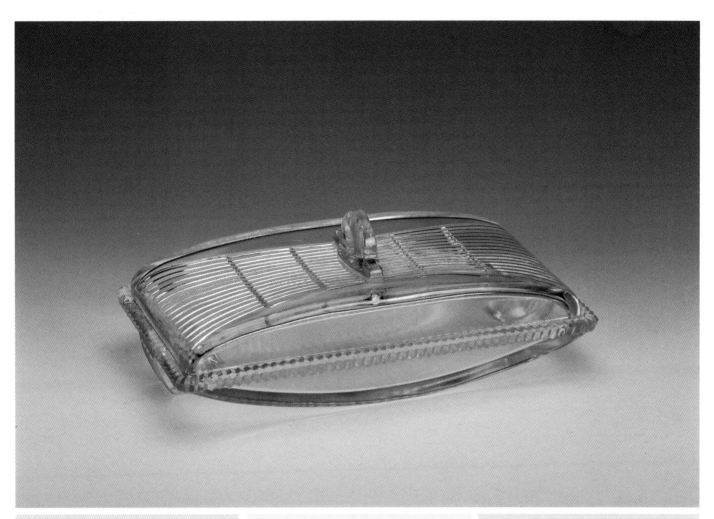

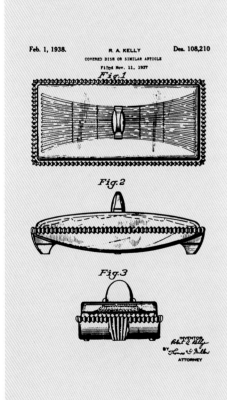

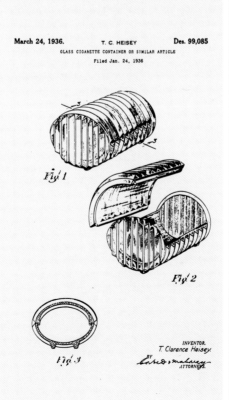

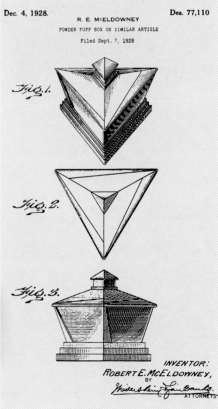

147

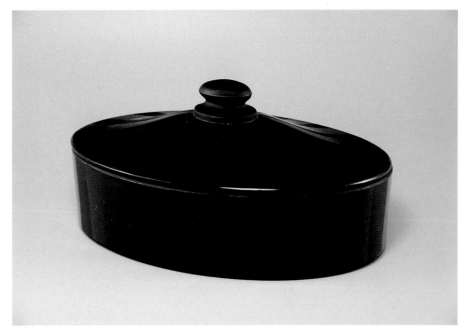

Tiffin
Satin Ribbon decoration on oval 8-1/2 inch covered candy box. $175-225

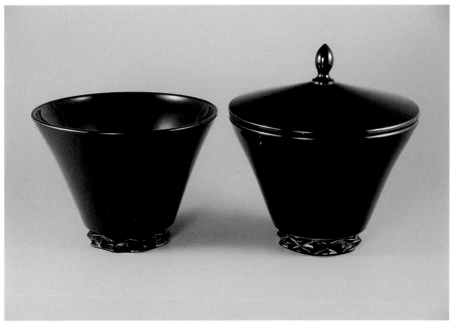

Fostoria
Diadem candy jars, with and without lid. $50-70; $70-90

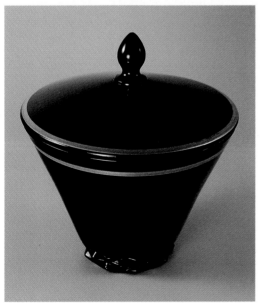

Fostoria
Diadem 6-inch covered candy jar with gold trim. $75-100

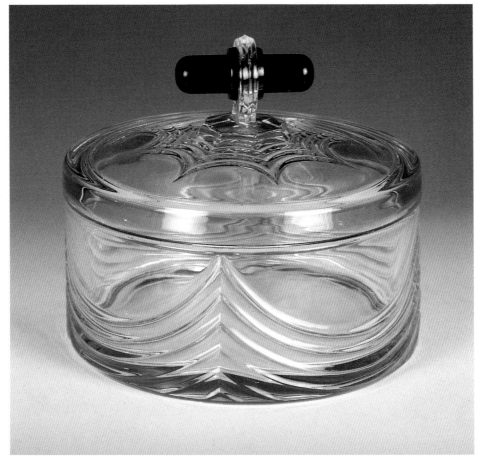

Duncan
Terrace cobalt 10-1/2 inch
covered candy urn. $350-400

Heisey
Stanhope covered
candy box, crystal
with black Bakelite
finial, designed by
Walter von Nessen.
$350-400

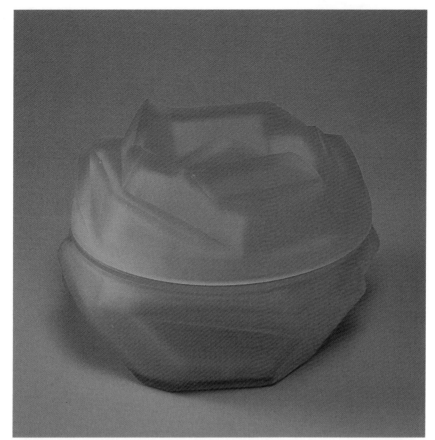

Kopp
Modernistic frosted green
covered box. $75-100

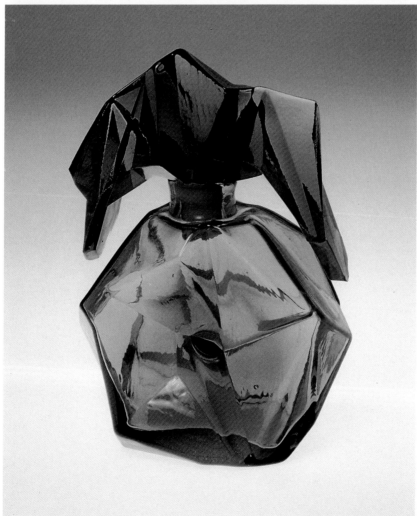

Consolidated
Ruba Rombic smokey topaz
scent bottle. $1200-1500

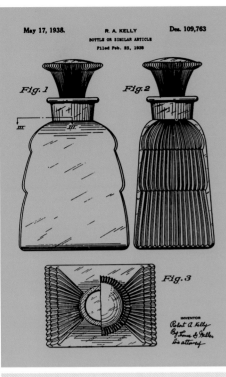

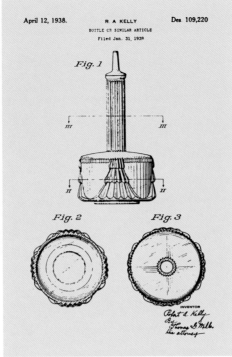

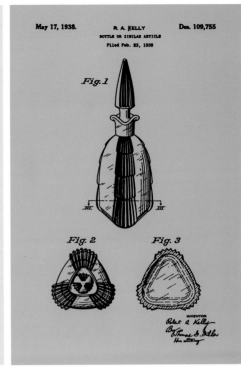

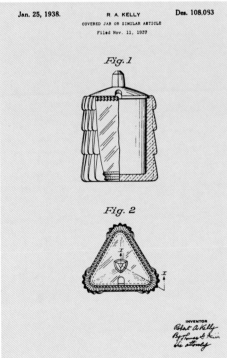

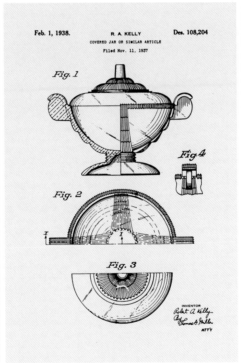

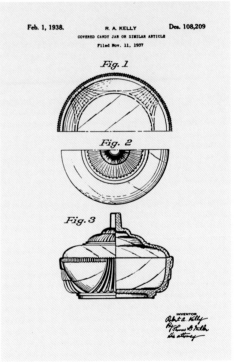

Top: United States Patent Office drawing of Tiffin **Cascade** bottle, designed by Robert A. Kelly, filed February 23, 1938.

Bottom: United States Patent Office drawing of Tiffin **Cascade** covered jar, designed by Robert A. Kelly, filed November 11, 1937.

Top: United States Patent Office drawing of Tiffin **Cascade** bottle, designed by Robert A. Kelly, filed January 31, 1938.

Bottom: United States Patent Office drawing of Tiffin **Cascade** covered jar, designed by Robert A. Kelly, filed November 11, 1937.

Top: United States Patent Office drawing of Tiffin **Cascade** bottle, designed by Robert A. Kelly, filed February 23, 1938.

Bottom: United States Patent Office drawing of Tiffin **Cascade** covered candy jar, designed by Robert A. Kelly, filed November 11, 1937.

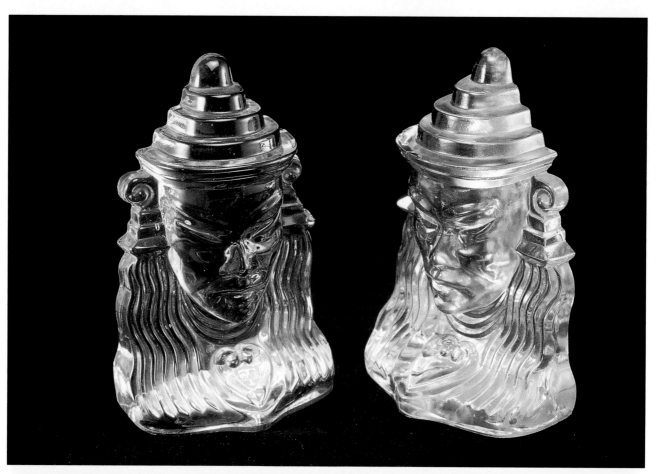

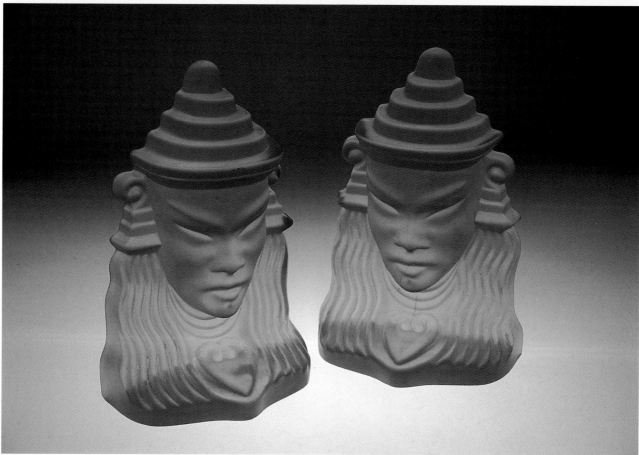

Top: Tiffin
Burmese #6320, 7-1/2 inch bookends, Deco style produced in 1952, crystal. $200-225

Bottom: Tiffin
Burmese #6320, 7-1/2 inch frosted bookends, shown with different lighting than on the facing page. $250-300 pair

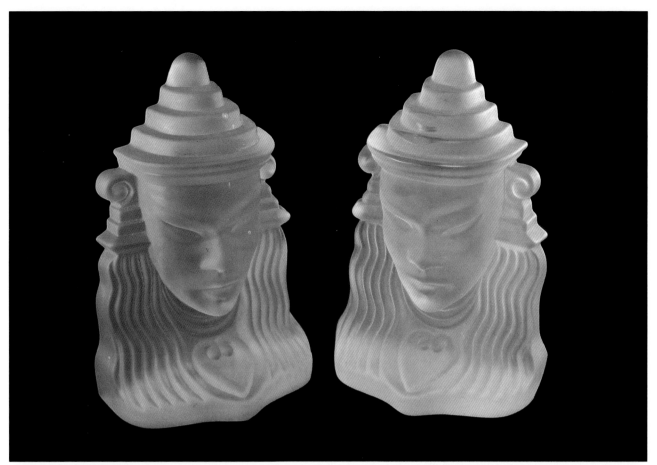

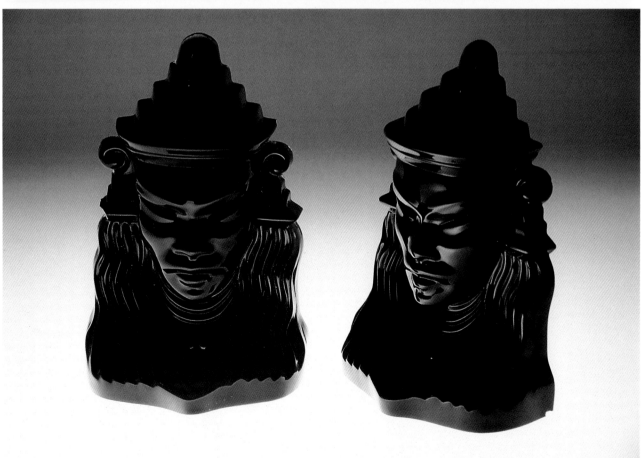

Top: Tiffin
Burmese #6320, 7-1/2 inch bookends, frosted.
$250-300 pair

Bottom: Tiffin
Burmese #6320, 7-1/2 inch bookends, "black" (actually thick
Killarney green), reveals red face and green edges when held
up to strong light. $600-800 pair

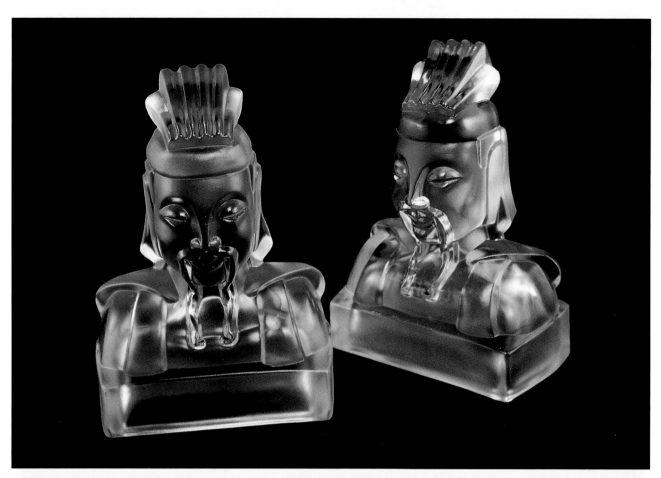

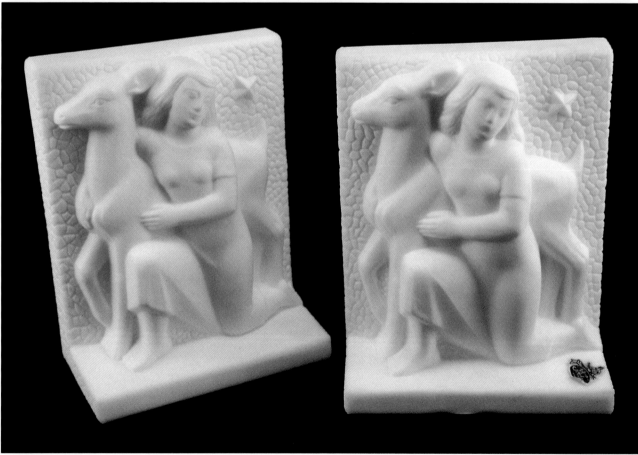

Top: Imperial
Cathay line, **Emperor** frosted 7-1/2 inch bookends, signed Virginia B. Evans. $300-350 pair

Bottom: Fenton
Later Fenton production of Verlys **Girl and Deer** 6-1/2 inch bookends. $300-350

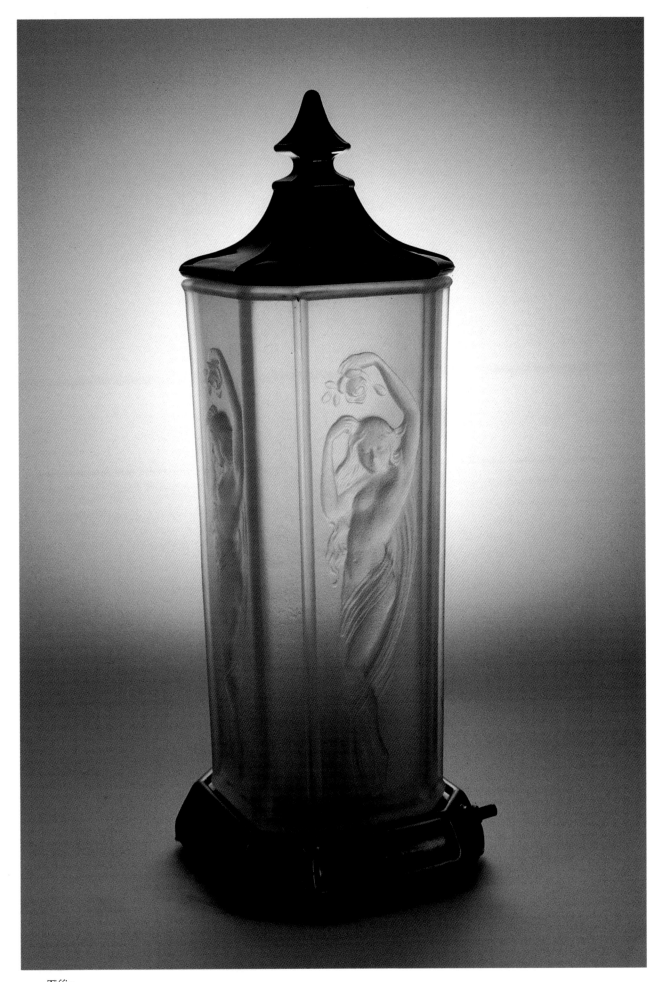

Tiffin
#16265 13-inch 4-panel torchiere lamp with nude figures, in frosted pink with black bright finish top. $300-400

Selected Bibliography

Arnold, Scott K. "Nicholas Kopp, Jr.: Glassmaker Extraordinaire." *Glass Collector's Digest* 4 (Oct/Nov 1990): 43-51.

Barnett, Gerald D. *Paden City, the Color Company.* Astoria, Illinois: Stevens Publishing, 1978.

Bredehoft, Neila. *The Collector's Encyclopedia of Heisey Glass 1925-1938.* Paducah, Kentucky: Collector Books, 1986.

Bredehoft, Tom. "Color and Crystal in American Pressed Tableware 1870-1950." *Glass Collector's Digest* 2 (Aug/Sept 1988): 71-79.

Bredehoft, Tom & Neila. *Fifty Years of Collectible Glass 1920-1970, Volume I: Tableware, Kitchenware, Barware, and Water Sets.* Dubuque, Iowa: Antique Trader Books, 1997.

China, Glass and Lamps. various issues 1920s-1940s.

Corning Museum of Glass. Trade catalogs in microfiche collection, Rakow Library, Corning Museum, Corning, New York.

Crockery & Glass Journal. Various issues 1920s-1940s.

Dawes, Nicholas M. *Lalique Glass.* New York: Crown, 1986.

Duncan, Alastair. *American Art Deco.* New York: Harry N. Abrams, 1986.

Dimitroff, Charles R., et al. *Frederick Carder and Steuben Glass: American Classic.* Atglen, Pennsylvania: Schiffer Publishing Ltd., 1998.

Fauster, Carl. *Libbey Glass Since 1818: Pictorial History and Collector's Guide.* Toledo, Ohio: Len Beach Press, 1979.

Felt, Tom. "Something Old, Something New: A. H. Heisey & Company in the 1930s." *Glass Collector's Digest* 4 (Aug/Sept 1990): 62-77.

Florence, Gene. *Elegant Glassware of the Depression Era.* 7th edition. Paducah, Kentucky: Collector Books, 1997.

————. *Stemware Identification Featuring Cordials with Values 1920s-1960s.* Paducah, Kentucky: Collector Books, 1997.

————. *Collectible Glassware of the '40s, '50s, '60s.* 4th ed. Paducah, Kentucky: Collector Books, 1998.

Garmon, Lee. "Cathay Crystal – A Jewel for Imperial's Crown." *Glass Collector's Digest* 3 (April/May 1990): 58-62.

Goshe, Ed, Ruth Hemminger, & Leslie Piña. *Depression Era Stems & Tableware: Tiffin.* Atglen, Pennsylvania: Schiffer Publishing Ltd., 1998.

H. C. Fry Glass Society. *The Collector's Encyclopedia of Fry Glassware.* Paducah, Kentucky: Collector Books, 1990.

Heacock, William. *The Glass Collector.* Issues 1-6. Marietta, Ohio: Antique Publications, 1982-83.

————. *Collecting Glass.* Vol. 1, 2, & 3. Marietta, Ohio: Antique Publications, 1984-86.

Kelly, Kathy. "An Identity Crisis: Phoenix or Consolidated?" *Glass Collector's Digest* 3 (Aug/Sept 1989): 78-82.

Kovel, Ralph & Terry. *Kovels' Antiques and Collectibles.* 30th ed. New York: Crown, 1998.

Krause, Gail. *The Encyclopedia of Duncan Glass.* Tallahassee, Florida: Father & Son Associates, 1976.

Long, Milbra, & Emily Seate. *Fostoria Stemware: The Crystal for America.* Paducah, Kentucky: Collector Books, 1994.

Madarasz, Anne. *Glass: Shattering Notions.* Pittsburgh: Historical Society of Western Pennsylvania, 1998.

Madigan, Mary Jean. *Steuben Glass: An American Tradition in Crystal.* New York: Harry N. Abrams, 1982.

McPeak, Carole & Wayne. *Verlys of America Decorative Glass 1935-1951.* Newark, Ohio: Coyne Printing, 1992 (revised).

Measell, James. *New Martinsville Glass 1900-1994.* (enlarged revised ed. of Miller's *The New Martinsville Glass Story I & II*.) Marietta, Ohio: Antique Publications, 1994.

Measell, James, & Berry Wiggins. *Great American Glass of the Roaring '20s and Depression Era.* Marietta, Ohio: Glass Press, 1998.

National Cambridge Collectors, Inc. *Colors in Cambridge Glass.* Paducah, Kentucky: Collector Books, 1984.

Page, Bob, & Dale Frederiksen. *Tiffin is Forever: A Stemware Identifiction Guide.* Greensboro, North Carolina: Page-Frederiksen, 1994.

————. *A Collection of American Crystal, a Stemware Identification Guide: Glastonbury – Lotus, Libbey – Rock Sharpe, and Hawkes.* Greensboro, North Carolina: Page-Frederiksen, 1995.

Piña, Leslie. *Fostoria: Serving the American Table 1887-1986.* Atglen, Pennsylvania: Schiffer Publishing Ltd., 1995.

————. *Fostoria Designer George Sakier.* Atglen, Pennsylvania: Schiffer Publishing Ltd., 1996.

Piña, Leslie, & Jerry Gallagher. *Tiffin Glass.* Atglen, Pennsylvania: Schiffer Publishing Ltd., 1996.

Schroy, Ellen Tischbein. *Warman's Glass.* Radnor, Pennsylvania: Wallace Homestead, 1992.

————. *Warman's Antiques and Collectibles Price Guide.* 32nd ed. Iola, Wisconsin: Krause Publications, 1998.

Snyder, Jeffrey B. *Morgantown Glass: From Depression Glass through the 1960s.* Atglen, Pennsylvania: Schiffer Publishing Ltd., 1998.

United States Patent Office. Design and invention patent drawings, on microfilm.

Weatherman, Hazel Marie. *Fostoria: the First Fifty Years.* Springfield, Missouri: The Weathermans, 1972.

————. *Colored Glassware of the Depression Era 2.* Ozark, Missouri: Weatherman Glass Books, 1974.

Whitmyer, Margaret & Kenn. *Fenton Art Glass 1907-1939.* Paducah, Kentucky: Collector Books, 1996.

Wilson, Jack D. *Phoenix and Consolidated Art Glass 1926-1980.* Marietta, Ohio: Antique Publications, 1989.

Index

Pattern names are listed both alphabetically and under the respective company. Line numbers are indexed under company name if no pattern name is given.